PAINTING THE ELEMENTS

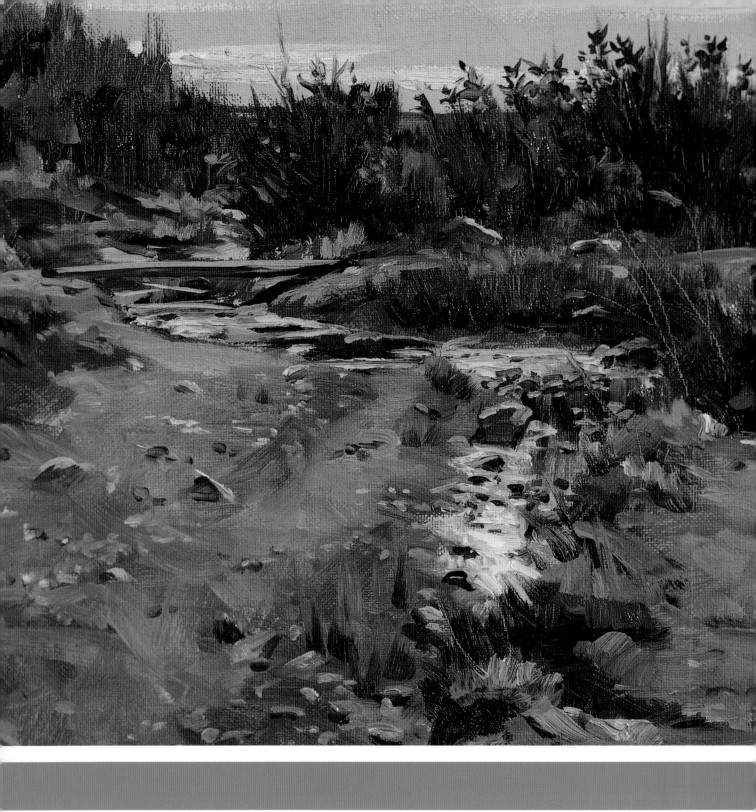

PAINTING THE ELEMENTS

WEATHER EFFECTS
IN OIL, ACRYLIC AND WATERCOLOR

**EDITED BY
KELLY MESSERLY**

NORTH LIGHT BOOKS
CINCINNATI, OHIO
www.artistsnetwork.com

Art from page 2: **End of the Creek** Oil • 14" × 11" (36cm × 28cm) • Craig Nelson

ACKNOWLEDGMENTS
The people who deserve special thanks, and without whom this book would not be possible, are the artists whose work appears in this book. They are: Sean Dye, Hugh Greer, Jane R. Hofstetter, Margaret Kessler, Craig Nelson, Barbara Nuss, John Seerey-Lester and Mark and Mary Willenbrink.

DEDICATION
To the many talented individuals aspiring to become great painters. May you always chase your dreams with passion and achieve success in all your artistic endeavors.

fw
F+W PUBLICATIONS, INC.

Other fine North Light Books are available from your local bookstore, art supply store or direct from the publisher.

10 09 08 07 06 5 4 3 2 1

DISTRIBUTED IN CANADA BY FRASER DIRECT
100 Armstrong Avenue
Georgetown, ON, Canada L7G 5S4
Tel: (905) 877-4411

DISTRIBUTED IN THE U.K. AND EUROPE BY DAVID & CHARLES
Brunel House, Newton Abbot, Devon, TQ12 4PU England
Tel: (+44) 1626 323200, Fax: (+44) 1626 323319
E-mail: mail@davidandcharles.co.uk

DISTRIBUTED IN AUSTRALIA BY CAPRICORN LINK
P.O. Box 704, S. Windsor NSW, 2756 Australia
Tel: (02) 4577-3555

Library of Congress Cataloging in Publication Data
Painting the elements: weather effects in oil, acrylic and watercolor / Edited by Kelly Messerly
 p. cm
Includes index.
ISBN-13: 978-1-58180-887-2 (pbk.)
ISBN-10: 1-58180-887-9
1. Weather in art. 2. Painting—Technique. I. Messerly, Kelly C., 1977–

ND1460 .W43P35 2007
751.4—dc22 2006046378

Editor: Kelly Messerly
Production editors: Jeffrey Blocksidge and Jason Feldman
Art direction by: Wendy Dunning
Designed by: Kelly N. Kofron
Production coordinated by: Matt Wagner

METRIC CONVERSION CHART

TO CONVERT	TO	MULTIPLY BY
INCHES	CENTIMETERS	2.54
CENTIMETERS	INCHES	0.4
FEET	CENTIMETERS	30.5
CENTIMETERS	FEET	0.03
YARDS	METERS	0.9
METERS	YARDS	1.1

ABOUT THE CONTRIBUTORS

Sean Dye
Dye's award winning artwork can be found in private and corporate collections and has been selected for numerous juried and invitational exhibitions. His work has also appeared in *The Artist's Magazine* and in *Pastel Artist International Magazine*. To see more artwork by Sean Dye, please visit his website at www.seandyestudio.com

Hugh Greer
Greer's paintings are exhibited in galleries throughout the United States. He teaches regularly at workshops and seminars and his work has appeared in several publications, including *Art of the West* magazine. He lives with his wife Terry in Wichita, Kansas.

Jane R. Hofstetter
Hofstetter teaches watercolor workshops throughout the United States and Europe. Her work has appeared in *Watercolor Magic* and *International Artist* magazines, *The Collected Best of Watercolor* (Rockport Publishers, 2002) and North Light's *Splash* series.

Margaret Kessler
Award-winning artist Margaret Kessler has been teaching painting for over 25 years. She is the author of *Painting Better Landscapes* and has written articles for and her art has appeared in *Southwest Art* and *The Artist's Magazine*. Kessler resides in Hilltop Lakes, Texas, with her husband, Jere.

Craig Nelson
Nelson has won over two-hundred awards of excellence in various national shows. His work can be found in several galleries throughout the United States. His paintings have appeared in the book, *Art From the Parks* (North Light Books, 2000). He is the author of *The Drawing Bible* (North Light Books, 2005).

Barbara Nuss
Nuss's landscapes have received national recognition, including National Arts for the Parks Top 100 and Oil Painters of America National Exhibitions. Her paintings have appeared in *Art From the Parks* (North Light Books, 2000). To see more of her artwork, go to her website at www.barbaranuss.com.

John Seerey-Lester
One of the world's most accomplished and renowned wildlife artists, Seerey-Lester is known for his unusual and compelling compositions. Seerey-Lester's work has appeared in the monograph *Face to Face* and in countless juried exhibitions.

Mark Willenbrink
Willenbrink draws from his many years of experience as an illustrator and fine artist to compliment his classes, workshops and writing. As a husband and wife team, Mark and Mary Willenbrink have authored *Watercolor for the Absolute Beginner* (2003) and *Drawing for the Absolute Beginner* (2006) both published by North Light Books. For more information, check out his website at www.shadowblaze.com

The following artwork originally appeared in previously published titles from North Light Books (the initial page numbers given refer to pages in the original book; page numbers in parentheses refer to pages in this book):

Painting With Water-Soluble Oils © 2001.
Dye, Sean. Pages 12–16 (8–9)

Acrylic Landscape Painting Techniques © 2002.
Greer, Hugh. Pages 30–31, 26, 38–39, 46–47, 58–59, 60–61, 64–65, 72–75, 76–77, 80–81, 82–85, 114–19 (10-11, 18–19, 40–41, 56–57, 66–67, 76–77, 88–89, 98–103, 106–07, 126–29, 140–43, 144–45, 152–53)

7 Keys to Great Paintings © 2005.
Hofstetter, Jane R. Pages 10–11, 29, 40, 45, 58–63, 66, 70–72, 75, 78–85, 120–22, 124 (8, 18–19, 37–41, 44, 56, 62–65, 68, 76–83, 93, 117–19, 148, 165)

Color Harmony in Your Paintings © 2004.
Kessler, Margaret. Pages 12, 36–38, 41–42, 46, 68–71, 74–76, 78–83, 89–99, 108–09, 112–15 (34–41, 44–49, 52–55, 60, 69, 75, 77, 83–85, 98–99, 106, 110–16, 120–21, 137)

60 Minutes to Better Painting: Sharpen Your Skills in Oil and Acrylic © 2002.
Nelson, Craig. Pages 10, 18, 24–26, 28, 30, 46–47, 64–65, 71, 73, 96–99, 100, 109–11, 113–15, 119 (2, 14–15, 26–27, 50–51, 61, 66, 74, 88–89, 138–41, 156–57, 182–83)

14 Formulas for Painting Fabulous Landscapes © 2004.
Nuss, Barbara. Pages 10–11, 16–17, 19–24, 34–41, 50–57, 59–63, 67–71, 73, 84–91, 118–27 (5, 22–23, 70–73, 86–87, 122–26, 132–36, 152–53, 158–63, 166–72, 184–89)

Painting Wildlife With John Seerey-Lester © 2003.
Seerey-Lester, John. Pages 36–37, 40–41, 44–45, 48–49, 56–57, 66–67, 72–73, 106–09, 115, 118–19 (24–25, 27–31, 92–97, 127, 150–51, 178–81)

Watercolor for the Absolute Beginner © 2003.
Willenbrink, Mark and Mary. Pages 9–12, 16–17, 43, 104–09 (16–17, 20–21, 57, 173–77)

TABLE OF
CONTENTS

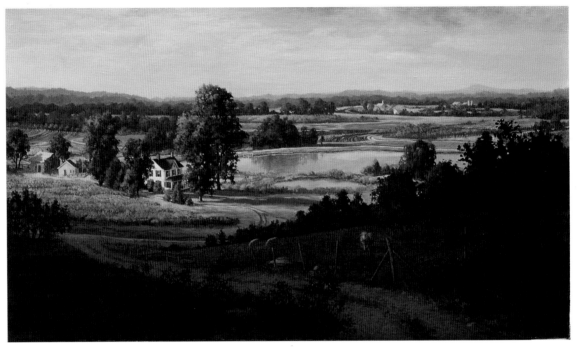

July Fields Oil on linen • 16" × 28" (41cm × 72cm) • Barbara Nuss • Private collection

Picnic View Transparent watercolor •
21" x 28" (53cm x 71cm) • Jane R.
Hofstetter • Private collection

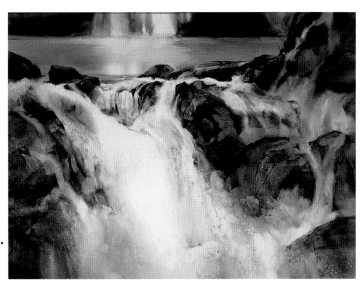

Below the Falls Transparent watercolor •
21" x 28" (53cm x 71cm) • Jane R. Hofstetter •
Private collection

Hanalei Valley Transparent watercolor • 21" × 28" (53cm × 71cm) • Jane R. Hofstetter • Collection of Karin Latham

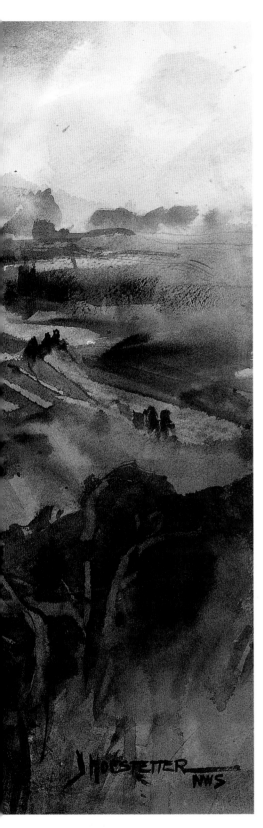

CHAPTER 1

Getting Started

There are many ways to go about painting the elements. Some artists prefer to work from sketches or photographs, while others prefer nature in front of them as they paint. Whether you're painting indoors or out, it's important to make sure you are properly equipped.

Oil and Water-Soluble Oil

Why Use Oil and Water-Soluble Oil?

Oil paint has been popular for centuries for a number of reasons:

- Oil in the paint allows the paint to spread easily.
- Oil can dry to a thin durable film for detailed work.
- Oil provides excellent adhesion for the pigment.
- Oil adds transparency to many pigments.
- Oil provides body to retain brush or knife strokes.
- Oil adds depth to the pigment not possible in its dry state.

Water-soluble oils are no exception to these benefits. The difference is that the oil vehicle has been modified to make it soluble in water, eliminating the need for harsh or dangerous solvents used to thin the paint and clean brushes and palettes.

Choosing Oil Paints

You will find that each brand of paint has its own consistency. After some experimentation you will be able to decide which brands work best for you. Remember that the mediums offered by one company are completely compatible with paints from another. It is also possible to mix the paint from two different brands to acquire the desired effect. You can add small amounts of traditional oil color to water-soluble oils to effect the color or the consistency.

All traditional oil paint brands have their own distinct odor, which is often pleasant for the painter compared to the smell of solvents. The water-soluble oils also have a different smell for each brand. All of the odors are subtle.

Layering Oils and Water-Soluble Oils

There are several rules for sound oil painting that should be followed for water-soluble oils as well as traditional oils. Apply thinner, fast-drying layers of paint first as a thin wash, usually called a stain in oil painting. Many experts believe you should be careful how much the oil paint is thinned. If it becomes as thin as a watercolor wash, it may not bind correctly, leading to adhesion problems. One way to avoid this problem is to add 3 to 5 percent damar varnish to the paint (traditional or water-soluble) before thinning. This will increase film strength. Subsequent layers may be thicker or could contain a higher oil content to provide transparency. It is always important to pay attention to the amount of oil in each layer. Oily layers should always be applied over leaner or less oily layers. If the reverse occurs, there is a strong likelihood of cracking, as the drying rates are different. Adding straight oil or mediums that contain oil will fatten the paint by raising the oil content. This will usually make it take longer to dry. Another concern for the oil painter is the fact that the amount of oil in each tube of paint varies with every pigment. Each pigment has a different absorption rate, which affects the oil content and drying time.

Drying Time

When painting in either traditional or water-soluble oils, you should wait until the early layers are dry before adding new layers. Royal Talens states that early layers of their H2Oil paint will be ready for overpainting in twenty-four hours. Paints from other manufacturers will most likely take longer to dry depending on the thickness of application and the pigment.

Mediums and Solvents

There are a number of mediums that have been developed specifically for water-soluble oil colors, including quick-dry mediums, linseed oils, stand oils, painting mediums, alkyd mediums and impasto mediums. The oil paint will remain water-soluble even after these mediums are introduced. Because traditional oil painting is quite oily, there are hundreds of mediums and recipes

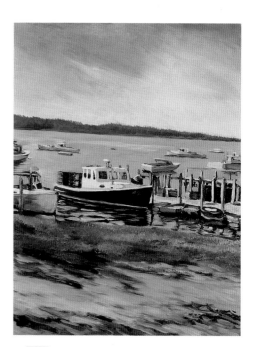

Medium Increases Transparency and Shortens Drying Time
Add a product like Winsor & Newton's Artisan Fast Drying Medium for water-mixable oils (alkyd based) to increase transparency and shorten drying time.

Early Catch Water-soluble oil on gesso board • 24" × 18" (61cm × 46cm) • Sean Dye

available to artists for a variety of effects. While it is possible to add some of these traditional mediums to water-soluble oils, the water solubility will diminish very quickly. Solvents may also be used with water-soluble oils, but that eliminates the most important advantage the colors have over standard oil paint. If you cannot find the perfect color in the new paints, small amounts (up to 20 or 30 percent) of traditional oil can be added to the paint and it will remain water soluble.

Although water-soluble oils thin with water like other water mediums, they are truly oil colors. The difference in drying is that after the water has evaporated out of the paint, the oil is still wet and must dry through oxidation. Watercolor, acrylic polymer emulsion colors (acrylic paints) and gouache dry quickly and completely after the water has evaporated. The slower drying time is perhaps water-soluble oil paint's greatest advantage over other water-based mediums. The extended drying time allows the artist time to manipulate the paint before it dries. The plein air painter can keep paint on the palette for long periods of time without the paint drying out.

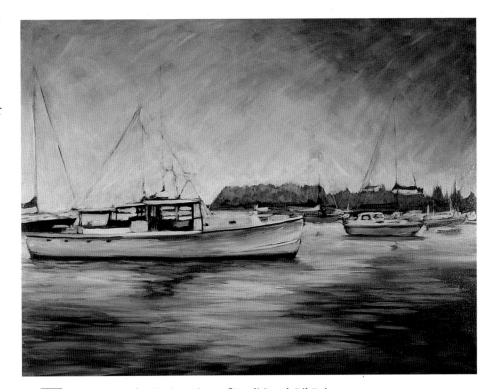

Decrease the Drying Time of Traditional Oil Paint
Add Holbein's Jellied Painting Medium (alkyd based) to the paint to speed drying and increase transparency for a traditional layered effect.

Owl's Head Boats Oil on canvas • 30" × 40" (76cm × 102cm) • Sean Dye

Acrylics

Acrylic paint has been on the market since the 1940s. It has become a popular medium in part because of its ease of use and durability. Like watercolor, acrylics are water based, so you can thin your paint with water and clean up with soap and water. But that's not all—acrylics can also be used like oil paint to create impasto effects.

Sometimes temperature and humidity can cause a support to bend or move slightly, but that usually isn't a problem for acrylic paint, which is able to stretch on a properly prepared support. It is for this reason that in some tests, acrylics have withstood the test of time better than oil paint.

Because of their remarkable durability, acrylic paintings do not need to be covered with glass, like watercolor paintings. According to paint manufacturer Golden Artist Colors, Inc., their acrylics are "lightfast, permanent and flexible."

There are many different brands and manufacturers of acrylic paints—you should experiment and find the brand that works best for you. Just make sure you use professional-grade paints.

You can pick any red, any yellow and any blue to create your own signature base palette. If you want to take some shortcuts, however, there are dozens of colors available in heavy-body and fluid viscosity.

Variety
Acrylic paints come in a wide variety of colors and can be mixed with various mediums to create different textures and effects.

	QUICK PAINT COMPARISONS		
Task	**Oil**	**Acrylic**	**Watercolor**
clean up	turpentine	water	water
durability	moderate	high	low
soft edges	when wet	when wet	when wet
dry time	slow	fast	fast
impasto effects	yes	yes	no

Heavy-Body Acrylics

When artist acrylics first hit the market, they were available only in a heavy-body formulation. Heavy-body acrylics have a creamy quality that facilitates mixing, color blending and brushstroke retention. Heavy-body and fluid acrylics have the same amount of pigment per cubic inch, but fluid acrylics are formulated to a thinner viscosity.

Fluid Acrylics

Fluid acrylics were born when paint manufacturers saw that artists wanted a thinner viscosity acrylic paint that could be used to achieve watercolor effects while retaining the color richness they had come to count on in heavy-body acrylics. Fluid acrylics are perfect for dry-brush techniques, detail work and staining, particularly on 100 percent rag watercolor boards.

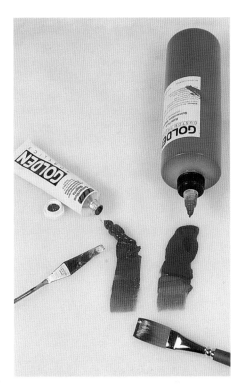

Viscosity

Notice how the heavy-body paint holds its shape until brushed out; the rich, creamy texture makes impasto effects possible. The Heavy-body acrylic retains brushstrokes, which is an important paint quality for textured artwork. The fluid acrylic paint allows for fine detail work, dry-brush techniques and staining of the surface.

■ FLUID ACRYLICS VS. WATERCOLOR

According to Golden Artist Colors, Inc., fluid acrylics have the following advantages over watercolor:

- more intense in color
- multiple washes will not mix together and get muddy
- more options of surfaces on which to paint
- can apply varnishes with UV protection
- watercolor effects without resolubility

■ FINISHING YOUR ART

Try a simple solution for finishing and preserving your acrylic paintings. This can be done with two Golden products: Soft Gel Gloss and Polymer Varnish With UVLS.

After your painting is complete, apply two coats of Golden Soft Gel Gloss that has been mixed 1:1 with water. This can be done on your palette. Brush your finished art and allow it to dry completely. Repeat and let dry. These two coats form your isolation coat.

The isolation coat allows for a more even application of varnish. It separates the painting from the varnish by sealing absorbent areas and adding a protective acrylic layer. It also protects color from lifting if you decide to remove the final varnish coat.

The last protective coat will be Golden Polymer Varnish With UVLS available in either gloss, matte or satin finish, depending on which coating you want to use. This is a hard, dust-resistant finish that protects your work. If dust and grime collect on the surface, the varnish can be removed with a mixture of household ammonia and water, and safely recoated with a fresh coat of varnish (follow manufacturer's directions for removal).

Oil and Acrylic
What You Need

Paints

You will find as many opinions about paints, brands and colors as there are painters. Make sure you purchase professional-quality, not student-grade, paints. A strong palette is vital for any painter. You can use the same palette for both oils and acrylics.

Brushes

Purchasing good brushes will prevent a lot of problems. It is impossible to paint a successful painting with poor brushes. Take good care of them, keep them clean and wash them out with brush soap after each use.

Mediums

OILS Mediums are open to varied opinions, so try different kinds to see what you like. Start with odorless, nontoxic turpentine as a solvent and Liquin as a medium. For your finish coat, try one-third damar varnish, one-third linseed oil and one-third turpentine.

ACRYLICS Thin with ordinary water when working with acrylics.

Palette

There are many types of palettes for you to choose from. Be sure the palette you select is compatible with the type of paint you use.

OILS Use a piece of glass approximately 14" × 18" (36cm × 46cm), duct taped around the edges over a medium-gray painted piece of Masonite for your palette.

ACRYLICS Use an enamel butcher tray approximately 14" × 18" (36cm × 46cm).

TRAVEL PALETTES French easels and Pochade boxes come with their own wooden palettes.

Containers

You will need the right container for the right job.

OILS An inexpensive jar with a lid made from silicon works well. There are many more expensive turpentine containers available if you want to spend the money.

ACRYLICS A good-size plastic water bucket works great.

Rags

Sometimes, paper towels are just too messy. Old cotton T-shirts, old towels or shop rags work best.

Timer

For the sake of pacing, a timer is essential.

Easels/Pochade Boxes

The workhorse for many artists is the French easel or field easel (full or half). This can be transported easily or used in your studio. It holds the easel, paints, palette and a canvas. Various Pochade boxes are available, all of which work fine. However, most Pochade boxes come without legs, so buy one with an attachment for a tripod.

Grounds and Surfaces

Try various grounds and surfaces. You may discover one that suits you better than another. Canvas on stretcher strips and canvas panels are obvious choices. Gessoed Masonite, gessoed hardboard and gessoed illustration board are other good options. Each ground/surface combination responds differently to the brush, so experiment until you find one that suits you. Try working on a toned surface, as this often relieves the anxiety of covering the white of the canvas.

■ SUGGESTED OIL AND ACRYLIC COLORS & BRUSHES

PAINT COLORS

Alizarin Crimson • Burnt Umber • Cadmium Red Light • Cadmium Yellow Light • Cerulean Blue or Winsor Blue • Sap Green (Hooker's Green for acrylics) • Terra Rosa (Red Oxide for acrylics) • Titanium White (a soft formula for oils, gesso for acrylics) • Ultramarine Blue • Viridian • Yellow Ochre

BRUSHES

Nos. 1, 2, 4, 6, 8, 10 and 12 hog-bristle filberts • Nos. 4, 6, 8, 10 and 12 hog-bristle flats • Sable flat for oils • 2- to 3-inch (51mm to 76mm) flat for acrylics

Healdsburg Haystacks Oil • 8" × 10" (20cm × 25cm) • Craig Nelson

Oil and Acrylic Palette

Artists lay out their palettes in many configurations. The most popular ways to lay out the palette are the spectrum, chroma-earth tone and warm-cool layouts. Whichever way you choose, the important thing is to be consistent. Your palette layout is like a piano keyboard. It should be the same each time you use it.

When laying out an acrylic palette, squeeze your paints on a folded strip of wet paper towel. This will help keep your paints moist and prevent them from drying out.

Titanium White, Cadmium Yellow Light, Cadmium Red Light, Alizarin Crimson, Burnt Umber, Terra Rosa

Yellow Ochre
Ultramarine Blue
Cerulean Blue
Viridian
Sap Green

2 Warm-Cool
You may opt to arrange your colors according to temperature.
The cool colors are placed on the left side of the palette. The warm colors are placed along the top.

Titanium White, Yellow Ochre, Cadmium Yellow Light, Cadmium Red Light, Alizarin Crimson, Ultramarine Blue, Cerulean Blue, Viridian, Sap Green, Burnt Umber, Terra Rosa

1 Spectrum
The colors in this palette are laid out to replicate the spectrum, or rainbow.

Titanium White, Cadmium Yellow Light, Cadmium Red Light, Alizarin Crimson, Ultramarine Blue, Cerulean Blue, Viridian, Sap Green

Yellow Ochre
Burnt Umber
Terra Rosa

3 Chroma-Earth Tone
You may choose to organize your colors into two groups: chroma, which would be yellows, reds and blues, and earth tones, which are browns.

Watercolor
What You Need

Paint

Use a variety of paint brands and choose paints mostly for their color, solubility and price. Pigments of the same name can vary from one manufacturer to another. Understanding the following variables will help you determine which paints are best for you.

GRADE Watercolor paints are available in two grades, student and professional. Student-grade paints are less expensive, but professional-grade paints may provide more intense color and better solubility.

INTENSITY The brightness of a color describes the difference between brilliant and less vibrant colors.

SOLUBILITY This is the ability of the paints to blend with water and mix with each other. High-quality watercolors will easily dissolve and mix evenly.

LIGHTFASTNESS This is a rating the manufacturer gives the paint on its ability to resist fading over time.

PACKAGING Use tubes of paint instead of dry cakes or half pans. The already soluble paint from a tube is easier to work with. If you'll be painting only occasionally, Use 8ml or 10ml tubes. Larger volumes may be more economical, but the paint might dry out before you finish them.

Paper

Your painting experience and the end result will differ based on the kind of paper you use. Some papers are harder to work with than others. Many artists use their best paper for final paintings and other paper for sketches and practice. Consider the following variables when deciding which paper works for your style.

QUALITY Student-grade paper generally absorbs paint faster and dries quicker, which makes it harder to work with than higher-grade paper. Professional-grade paper, for the most part, is better for layering and lifting paint and exhibiting the true color and brightness of paints.

SURFACE TEXTURE Watercolor paper's texture can be hot press, cold press or rough. Hot-pressed paper is smooth and produces hard edges and interesting watermarks when you apply paint but doesn't work well for gradations of color (a smooth transition from one color to another). Cold-pressed paper has a moderate texture and allows smooth color gradations. Some manufacturers refer to cold-pressed paper as in "not hot-pressed." Rough paper is an even coarser, more textured paper. Like cold-pressed paper, it allows smooth color gradations, but it offers more extreme textural effects. The rough, pitted surface allows lots of the white of the paper to show through when you paint on dry paper with little water. The texture also adds interest to certain subjects, such as ocean waves.

CONTENT The content of the paper affects how paint responds to the paper. Most papers are made of natural substances, but some are completely synthetic or made from a combination of natural and synthetic ingredients. As paper ages, acid can cause it to yellow. To be safe, use 100 percent cotton, acid-free, pH neutral paper. Don't assume that pH neutral paper is acid free; the manufacturer may simply have neutralized the acid. Look for "acid-free." Use this paper even for practice paintings because you're never sure when you'll want to keep one.

Palette

Use a palette to hold and mix your paint. Your palette should have a flat, white surface with low sides. Small palettes are easier to carry, but big ones are better for mixing lots of paint. You'll also need a cover to keep dust and dirt off the palette and paints, especially when traveling. If you have an airtight cover, let your paints dry out before covering them to avoid mildew. If your cover isn't airtight, remember to carry your palette flat so wet paint won't spill. When you finish a painting, don't clean the palette and throw away good paint. Because watercolors are water soluble, you can add water and reuse them.

Palette Setups

Each setup shown here progresses in complexity. Most of the colors are available in both student and professional grades. Try to avoid using white or black paint. Instead, use the white of your paper as the white in your paintings, and mix rich darks from other colors.

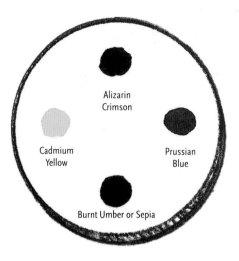

Four-Color Setup

A basic setup uses the three primary colors (red, yellow and blue) and one brown. These colors are available in student and professional grades.

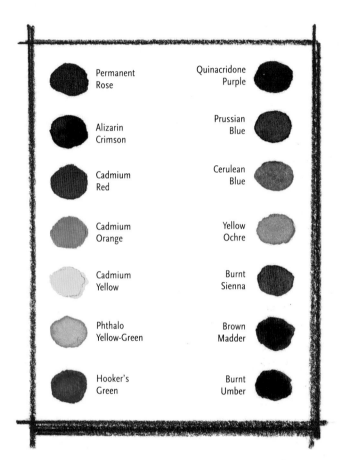

Fourteen-Color Setup

The additional colors of this setup are mostly available only in professional grade. Try this palette after you've gained some experience. It's fairly crowded, so an additional palette or the palette lid could be used for mixing.

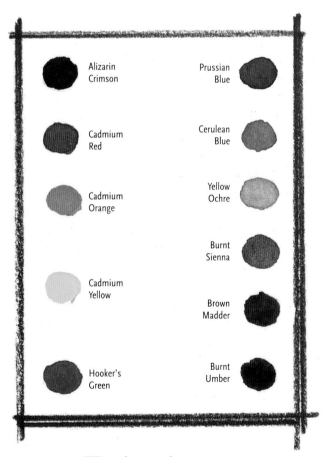

Eleven-Color Setup

This setup for the beginner provides a variety of possible combinations without using too many colors. All of these colors are available in both grades except for Brown Madder, which usually is available only in professional grade. You may also want to use professional-grade Cadmium Yellow.

Watercolor
What You Need

These are must-haves for painting in watercolor. You'll develop preferences for certain brands over time and after trial and error with many different brands. Experiment to discover your own favorites.

Paints

No one brand seems to have a complete set of watercolors that meets all your requirements, so use colors from a number of different brands. Certain colors in some brands tend to fade or contain opaque materials, which tend to make mud in the early stages of a painting. You should test different pigments to see for yourself. Here are some colors you may want to try, grouped by brand:

- Daniel Smith: Carbazole Violet, Cobalt Teal Blue, Green Gold, Indanthrone Blue, Permanent Brown, Quinacridone Burnt Orange, Quinacridone Coral, Quinacridone Gold, Quinacridone Sienna, Sap Green, Transparent Brown Oxide
- Da Vinci: Rose Dore
- Holbein: Cobalt Blue Tint, Indian Yellow
- MaimeriBlu: Orange Lake
- Rembrandt: Blue Green
- Winsor & Newton: Cobalt Blue, Cobalt Violet, Permanent Magenta, Permanent Rose, Raw Sienna, Scarlet Lake, Transparent Yellow
- Any brand: Cadmium Orange, Cadmium Yellow Light, Manganese Blue

Palettes

Use two folding palettes: a metal palette and a large, plastic palette that measures 5½" × 12" (14cm × 30cm) when closed. Fill each well completely and spray the paint with water to keep it moist during the painting process.

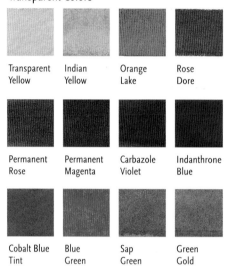

Transparent Colors

Transparent Yellow	Indian Yellow	Orange Lake	Rose Dore
Permanent Rose	Permanent Magenta	Carbazole Violet	Indanthrone Blue
Cobalt Blue Tint	Blue Green	Sap Green	Green Gold

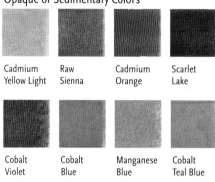

Opaque or Sedimentary Colors

Cadmium Yellow Light	Raw Sienna	Cadmium Orange	Scarlet Lake
Cobalt Violet	Cobalt Blue	Manganese Blue	Cobalt Teal Blue

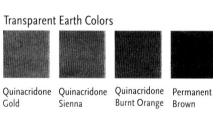

Transparent Earth Colors

Quinacridone Gold	Quinacridone Sienna	Quinacridone Burnt Orange	Permanent Brown

Brushes

Synthetic blends are best because they seem to hold enough paint and are sturdy enough to push the paint into wet washes and make it stay in place. Sable is okay; it is useful for a gentle wash over other colors.

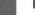 **Brushes**
From left to right, this page: ¼-inch (6mm), ½-inch (12mm) and 1-inch (25mm) flats; and 1½-inch (38mm) and 2-inch (51mm) wash brushes.

The angled synthetic brushes are great for wet-into-wet painting as well as detail work. For round brushes, the size you need depends on the size of paper or area you are working on. As a rule, use a slightly bigger brush than you think you will need. You can achieve a looser, more painterly look instead of a tight rendering.

Paper

Use 300-lb. (640gsm) Winsor & Newton Artists' Watercolor Paper, either rough or cold press. This brand has enough sizing to withstand stencil lifting later in the painting process. With this weight of paper you won't have to stretch it before painting and it takes sprayed water techniques without buckling.

Sponges

Damp sponges serve many purposes; and often save a painting. Keep at least three soft, natural elephant-ear

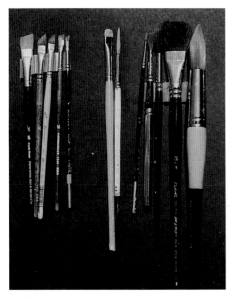

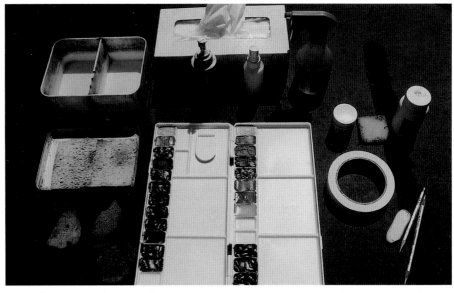

More Brushes

From left to right, this page: Five angled synthetic flats up to ½-inch (12mm) in size; a no. 4 bristle oil brush; a no. 5 rigger; nos. 1, 5 and 8 sable rounds; a 1-inch (25mm) flat sable; a jumbo round wash brush. The bristle oil brush is used to soften areas after removing masking, and the rigger is used for line details. Additional rounds can be useful.

Watercolor Supplies

Clockwise from left to right: natural elephant-ear sponges; synthetic sponge (with water container); water container; facial tissues; spray bottles (finger action, fine mist and trigger); graphic white; crepe lifter; masking fluid; artist's tape; white plastic eraser; a silver pencil. This palette shows another way you could lay out your colors: transparents on the left, opaque and sedimentary colors on the upper right and earth tone transparents on the lower right. Leave some wells empty for adding more colors or for color mixing. Also fill an extra well on the bottom left with more Quinacridone Gold to use for mixing with your greens.

sponges on hand to help wet the paper for painting wet-into-wet, to blend painted areas when needed, to create a soft edge on a shape or to clean up extra paint or errors without leaving hard edges. You can use a few other small, soft, natural sponges for these purposes as well as for lifting paint with stencils. A damp tissue could rough up the paper, but a damp sponge will not. Keep a small kitchen sponge near your water container to blot your brush so it won't carry too much water to the paper.

Water Spray Bottles

Keep three small spray bottles by your side when painting: a trigger bottle to keep palette colors moist, to quickly wash down the paper and to "erase" mistakes before they dry; a fine-mist bottle to keep the paper wet and provide gentle paint movement; and a finger-action bottle to give an irregular texture on somewhat dry paint. You may want to use a finger-action bottle instead of salt for interesting texture.

Other Materials

Additional supplies include:
- stiff backing board and artist's white acid-free tape for taping paper edges
- silver pencil (This pencil is lighter than graphite, and the wax in it keeps it from smearing once paint is applied.)
- white plastic eraser
- two water containers
- facial tissues and a soft rag
- hair dryer
- masking fluid
- crepe lifter
- small bar of soap
- old brushes
- plastic stencil sheets (for controlled lifting of paint) and small, sharp scissors to cut them
- graphic white (Try Pro White for the best results when mixing homemade gouache. It is water-soluble and nonpermanent, giving you a second chance to lift back to the white of the paper, unlike some white inks and acrylics.)

Painting Inside
What You Need

If you are just beginning to paint you do not need an elaborate setup to get started. Any kind of table will do. Try to find a table with a top that adjusts to any angle from vertical to flat. Use a chair with an adjustable seat and back and a built-in air cushion.

The side table, or taboret, is the heart of the operation and is on wheels. You can store all your supplies inside this table. If you pull out one of the drawers you can place your palette on it.

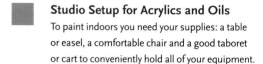

Studio Setup for Acrylics and Oils
To paint indoors you need your supplies: a table or easel, a comfortable chair and a good taboret or cart to conveniently hold all of your equipment.

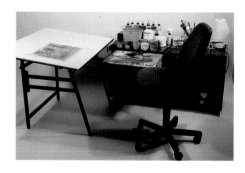

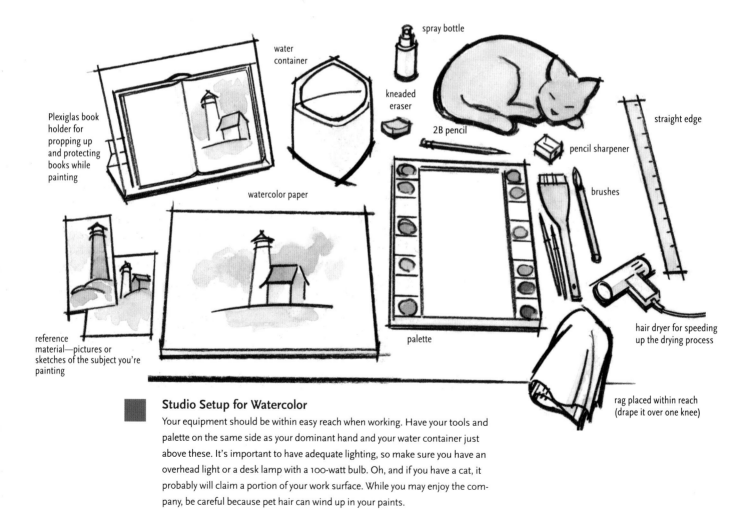

spray bottle

water container

kneaded eraser

Plexiglas book holder for propping up and protecting books while painting

2B pencil

pencil sharpener

straight edge

brushes

watercolor paper

palette

hair dryer for speeding up the drying process

reference material—pictures or sketches of the subject you're painting

rag placed within reach (drape it over one knee)

Studio Setup for Watercolor
Your equipment should be within easy reach when working. Have your tools and palette on the same side as your dominant hand and your water container just above these. It's important to have adequate lighting, so make sure you have an overhead light or a desk lamp with a 100-watt bulb. Oh, and if you have a cat, it probably will claim a portion of your work surface. While you may enjoy the company, be careful because pet hair can wind up in your paints.

Painting Outside
What You Need

You don't need an elaborate setup to paint plein air, or outdoors, so pack light. You'll need paints, brushes, a palette, paper, a water container, a 2B pencil, a rag and an eraser, plus the items discussed on this page.

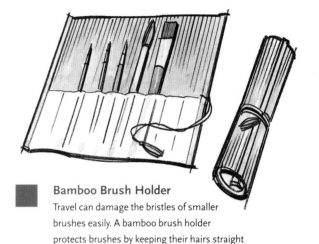

Bamboo Brush Holder
Travel can damage the bristles of smaller brushes easily. A bamboo brush holder protects brushes by keeping their hairs straight and allowing wet brushes to dry on the go.

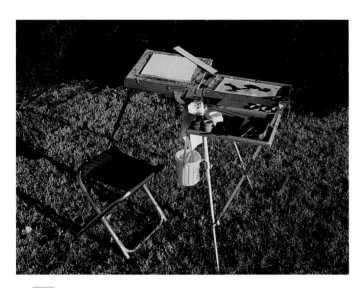

Painting in Nature
When painting outdoors you need to be organized and travel light. You will need a portable easel and collapsible chair as well as your basic tools. Everything should fit easily into your easel box.

Plein Air Painting Supplies
You may want to bring a painting surface, such as an easel. A French easel has a drawer for storage and extra work space. Bring something to sit on, preferably something that folds. Make sure it doesn't have arms; they get in the way when you're painting. Buy a brush holder for your smaller brushes and find a way to secure your bigger brushes to protect them. Carry a pair of binoculars to get a better look at things in the distance. Many artists carry cameras and sketchbooks so they can take pictures and do quick pencil studies to use as reference later.

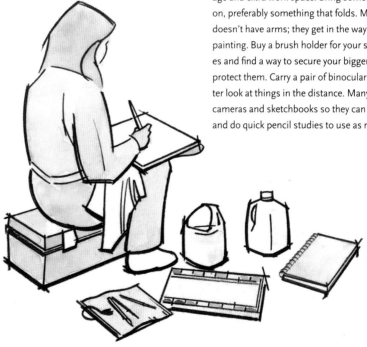

Getting Started

Before you set off to make a landscape painting, start with a plan. The following are some specifics to keep in mind as you determine your subject matter and the approach you want to take to paint it.

Gather Information on the Spot

As a landscape painter setting out to paint field sketches, your intent is to gather particular information about a scene as efficiently as you can: light, shadow, shapes, color, atmosphere and perspective. Think of the landscape elements as a starting point for a successful composition.

Because of the changing light, you may have two hours in the morning and two hours in the afternoon when the sun remains fairly constant and the shadows are interesting. When the sun is at its daily apex, the light is cool and flat and the shadows are barely existent—not good lighting for an interesting composition.

If you want real drama and excitement (and stress!), paint sunrises and sunsets when you have limited time to capture the quickly changing light. Some artists prefer the sunrise so they can still see and continue to paint from memory after the dramatic moment is over. To paint at a less frenzied pace, choose an overcast day when all the light is reflected from the clouds and the lighting stays consistent all day.

What Inspires You About the Scene?

Depending on your destination, you have already decided what you want to paint—a vista, a street scene, maybe a mountain overlook. Once you arrive there, you need to determine exactly what inspires you about that scene. Lighting is critical. Just the way a streak of sunlight strikes the leaves of a tree or highlights a flower garden can turn you on.

Isolate possible scenes with your viewfinder and keep an open mind. You never know what you might find. Be prepared to change your mind and be flexible. Discover what inspires you about the scene so you can in turn inspire the viewer.

Be aware of what you want to say. Know your feelings and your emotional reaction to a place or situation. Do you like expansive scenes or cozy, secluded spots? What do you respond to? Keep your options open. Explore and have fun!

What you paint is your statement. It's all about you and how you react to visual stimuli. For instance, some landscape painters are staunch environmentalists and paint the disappearing landscape. This is their way of conveying the importance of conservation and protecting it from suburban sprawl. Winslow Homer and George Inness were among these conservationists.

Arrange (and Rearrange) for a Pleasing Composition

Imagine yourself controlling all the elements in front of you. Once you have found a source of inspiration, you must decide how to best present it. Place the elements where they will best show off your source of inspiration. Introduce elements that aren't directly in the scene, like moving a tree from behind you and putting it into your sketch. Record this information with a thumbnail sketch in your sketchbook and then in color with a field sketch.

Often you have to be content to settle on a scene that needs to be modified or simplified in some way. Perhaps there are too many rocks or boulders. If you painted each one,

■ PLEIN AIR PAINTING TIPS

- Begin your compositional sketch at a point at least fifty feet (15m) from where you are standing. Pace off the distance if necessary. Starting any closer will often cause distortion and place too much emphasis on uninteresting areas.

- If you don't have the requisite artist's umbrella, situate yourself under a foliage-friendly tree or in the shadow of a building. It is important to paint in the shade; direct sunlight on your painting will wash out the colors. You may even have to face the opposite direction from your painting subject.

- Oil painters should wear nonreflective shirts to avoid glare. Gray and denim blue are good. White, hot pink, orange, yellow and lime green are bothersome.

you'd quickly lose your way and the painting would lose its impact. Figure on eliminating at least a third of what you see in front of you.

You will make some composition changes on location but will save others for revisions in the studio. Keep in mind that what you see should serve as a source of inspiration. You need not take the actual scene literally. As a friend once said, "Don't let the truth get in the way of a good painting."

Make Thumbnail Sketches

Use a viewfinder to help you determine initial composition ideas on location. Once you have found a potential composition, use a sketch template to outline a sketching area with grid marks in your sketchbook. Keeping the viewfinder at a constant distance from your eye, use its grid as a guide to quickly capture the essence of the composition in your sketchbook.

Transfer these initial impressions and ideas quickly into value sketches. Make changes or start new ones easily. Use a 2B or 4B pencil that can effectively produce dark values. A thumbnail sketch should take no more than two minutes. It is not a drawing; it is a concept in values. The details are unimportant.

Be creative! This is the time to arrange and rearrange the landscape elements in front of you. Use your sketchbook to make color notations as well. Once you have a thumbnail that pleases you, grid your canvas panel in thirds and transfer your sketch onto it.

Make a Field Sketch

Following the gridded sketch in your sketchbook, enlarge it rectangle by rectangle to your gridded painting surface. Once you have roughed in the scene on your canvas with charcoal or on watercolor paper with light pencil, fine-tune your drawing before you start to paint.

Once you are happy with your drawing, proceed with the field sketch in oil, watercolor or another medium of choice. There are advantages and disadvantages no matter what medium you use for your field sketch. For variety try:

1. the field sketch in oil and the final painting in oil
2. the field sketch in oil and the final painting in watercolor
3. the field sketch in watercolor and the final painting in watercolor
4. the field sketch in watercolor and the final painting in oil

It's all based on your preference and what works best for you.

Keep these field sketches for studio reference. On the back of each sketch, note the location, date and other particular details, such as the direction of the sun, the temperature and unusual weather notes. You will find elements or particular colors in these sketches that you can refer to over and over. You can use a sky from one sketch and put it with another sketch for a final painting. See pages 26 through 31 for further guidance on making a field sketch in either acrylic, oil or watercolor.

Take Photographs

Take photos before, during and after painting the field sketch. Shoot close-ups and regular shots. Take photos of any other interesting elements that you might use someday.

The 35mm SLR (single lens reflex) manual camera using slide film is the most versatile arrangement. Not only does it allow you to shoot a variety of exposures on location for future reference, but it is the best for shooting slides of your finished work.

■ MAKE A VIEWFINDER AND SKETCH TEMPLATE

A viewfinder isolates a section of a scene and allows you to easily see composition options. You can easily make a viewfinder that will help you visualize your composition in thirds, horizontally and vertically. Cut a piece of mat board about 8" (20cm) square. Cut out a 3" × 4" (8 cm × 11 cm) hole in the middle of it, and tape a piece of acetate over the hole. Divide the space into thirds and ink the grid onto it. Label the viewfinder with the different proportionate dimensions: 3" × 4" (8 cm × 10cm), 9" × 12" (23 cm × 30cm) and 12" × 16" (30 cm × 41cm).

Use the leftover cutout square to make a sketch template that will make it easy to draw your on-location value sketches in pregridded shapes. On the square, mark a grid that corresponds with the one on your viewfinder acetate. Use this template to first draw a rectangle in your sketchbook. Then make tick marks for the grid and draw that grid on the rectangle. These grid lines that match the ones on your viewfinder will help you pencil the scene accurately and quickly.

Choose the Medium

You can do field studies in any medium and on any surface. It all depends on what you want to achieve. Use graphite HB and 2B pencils, watercolors, watercolor pencils, acrylics and oils in the field and the same brushes you would use in your studio. Strathmore 3-ply kid-finish paper is a very versatile surface for field studies. It takes graphite, watercolor, watercolor pencil and acrylic. Most importantly it holds oil paint without oil rings. Carry a separator box to carry oil and acrylic paintings back to the studio. You can make one yourself or buy one from your local art supply store.

Take It All In

Oils and a Pochade box were used to paint this waterfall in Maui, Hawaii. The rich colors and thick texture of oil paint captured the scene.

Hide Out

You can sit in the shade and still paint a sunny scene. Look for a nice shady place that will allow you to view the scene; if you're using an easel, attach an umbrella.

Consider the Weather

You'll be fighting the elements as you work in the field, so make sure you select the right medium for the conditions. When working with watercolor or acrylic in cold conditions, add alcohol to your water to prevent it from freezing. It's no fun chipping ice off your water jar! Acrylics also dry very quickly and oil paint crystallizes and becomes less pliable in cold, dry conditions, so you have to work quickly. In humid conditions, on the other hand, it takes a long time for water-based paints to dry, so you have to be more patient than usual; laying in washes can be difficult.

Field Sketching with the Right Medium for the Climate
Acrylics are easier to use in some environments, such as cold, Alaskan weather.

Water Turns to Ice
Add alcohol to your water jar to keep it from freezing.
Carry rubbing alcohol when you go to an extremely cold climate.

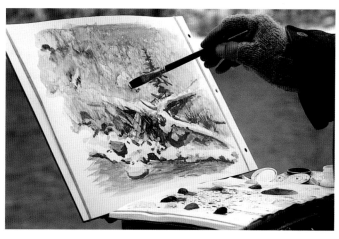

Cold Comfort
Items such as fingerless gloves can help you create suitable working conditions in cold places.

Sketching

A sketch generally depicts its subject in a linear fashion dealing primarily with the contour and basic linear breakdown of a given subject. At times a sketch may incorporate a bit of tone achieved by linear hatching, scribbling or smudging. Sketches may convey accuracy in perspective, proportion, gesture and compositional intent. It is often the groundwork on which a more finished piece is based.

Most painters begin their painting with a sketch of one form or another. It is with this premise that the sketch-and-paint approach to a quick study is often used.

When sketching for a quick study, the important information to get down is composition, subject placement, basic shapes, perspective (if necessary), proportions and gesture (if necessary).

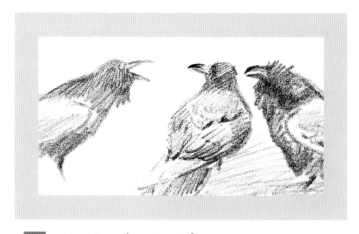

■ THE PURPOSE OF A SKETCH

It is important to understand that the purpose of the sketch is to create a shorthand or rough skeleton for you to build on. However, too finished of a sketch may inhibit you from painting boldly and directly. About two to five minutes should be long enough for any sketch before painting a quick study.

Use More Than One Reference

These are several quick graphite field sketches. They were used as references for the painting below.

Make the Most of Dark and Light

This painting was designed around the stark black image of the ravens against a white background. Composition is also very important in this piece. Notice the dark rock next to the ravens creates an abstract shape, which you can see if you squint your eyes to look at it.

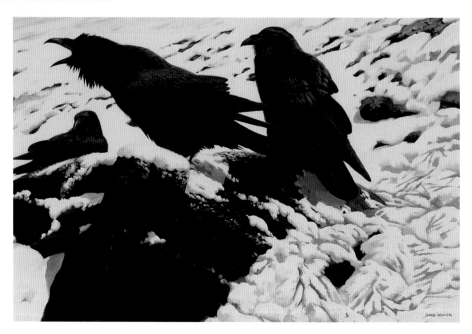

Command Post—Ravens Oil on canvas • 24" × 36" (61cm × 91cm) • 1994 • John Seerey-Lester

Translating From Field to Studio

Doing field sketches and paintings is very important, but it's equally important to know what to do with them back in the studio. Pure plein air painting is an art form itself, but your aim is to use these paintings and sketches as reference material. Field sketches often won't mean anything until a later time. Sketching the scene rather than just taking pictures forces you to spend time studying the scene, and it will always be in your memory. A field sketch not only provides facts about an animal, bird or habitat but also triggers memories about your experience and the feel of the moment.

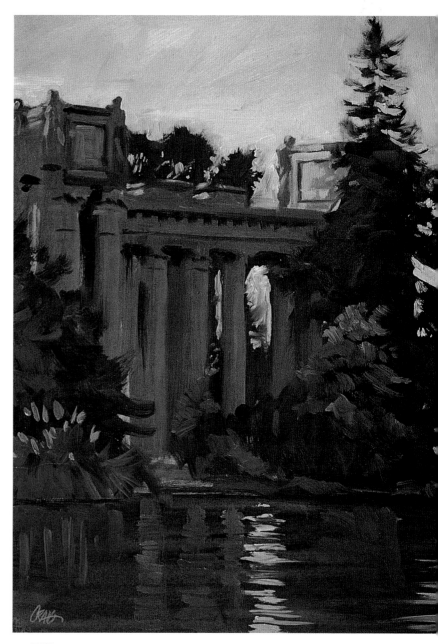

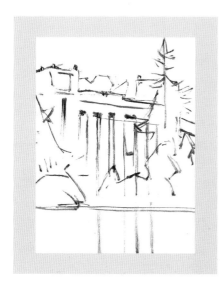

Sketch of Palace in Shadow

Some complex architecture can be overwhelming. It is important to break it down to its basic shapes. This subject has a strong vertical thrust. The columns and the trees have a repetitious upward movement. It is, therefore, important to get the approximate placement of the columns and the slight angle of the roofline to give the subtle perspective. As for the trees, it is the larger masses and the basic rhythm of the branches that need a quick indication. This sketch should take no longer than three or four minutes.

Quick Study of Palace in Shadow

Before painting this study, notice the differences in edge qualities between the architecture that has firm, crisp edges and the tree forms with wispy, soft edges. Lay in a very light blue-gray sky for the background using a no. 10 brush, then move on to the background trees. The architecture is a basic grayed brown (in shadow) that should be simplified using a no. 8 bristle flat. All elements should be painted in their basic shapes, with attention to the edges. This transforms the basic linear sketch into masses, which is how we see. Form can then be developed with value and color variation.

Palace in Shadow Oil • 12" × 9" (30cm × 23cm) • Craig Nelson

FIELD STUDIES
Acrylic

When using acrylics in the field, use Strathmore paper, canvas panels or mid-gray primed Masonite. Paper obviously is easier to carry, particularly on an extended field trip. Try cutting the paper to 11" × 17" (28cm × 43cm) and carrying it between two pieces of Masonite to keep it flat. Then attach the paper to a piece of Masonite with rubber bands for a hard surface to work on. When you return to the studio, put the completed studies in a binder. For shorter excursions, just carry several Masonite panels. Take a jar of mid-gray gesso primer into the field with you so you can redo an area that isn't working easily and quickly.

Adapt the Scene
Here the moose field sketch was adapted by darkening the setting and adding the phantom wolves.

Start With a Field Sketch
This field painting of a cow moose in Alaska was later adapted for a different animal. In this sketch the moose was added for scale. Use acrylic paint almost like watercolor, very softly and subtly and working from light to dark. Acrylic painting is like painting in a mist. As you paint darker washes, the mist lifts to reveal a clear image.

Phantoms of the Tundra Oil on Masonite • 36" × 24" (91cm × 61cm) • 1993 • John Seerey-Lester

FIELD STUDIES
Oil

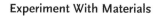

Oil can be an enjoyable medium to use in the field, although it takes far more preparation than acrylics or watercolors. If you're flying to a remote location, research the area to see if you can buy turpentine or mineral spirits there. It's illegal to fly with these.

When you paint in the field with oil, you have to paint positively. Try putting a thin wash of Burnt Sienna over the whole canvas and then paint the lights and darks over that value rather than using the white of your canvas. First check out the light source. What is in shadow and what is illuminated? Establish the lighting pattern by painting a thin oil wash in the shadow areas only with a mixture of Payne's Gray and Raw Sienna. Your light source will change as the sun moves. Don't chase the sun; the painting will turn out flat. Once you've established the light, don't change it. Then paint more opaquely, moving as quickly as you can with positive brushstrokes.

Experiment With Materials
Oil paint dries more quickly on Strathmore 3-ply kid-finish paper than on canvas or Masonite. The paper absorbs the paint without causing oil rings. The oil dries overnight, making this surface convenient for transporting. Unfortunately, oil paint isn't as pliable on paper as it would be on canvas or Masonite. Compensate by working faster.

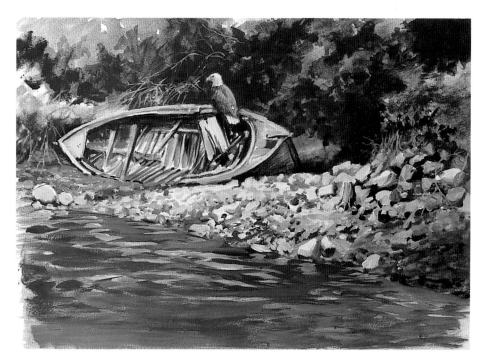

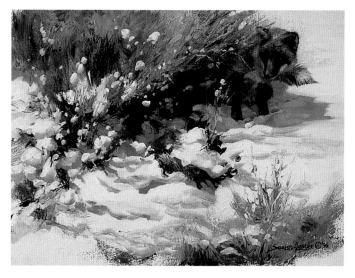

Be Ready When Opportunity Presents Itself
This painting of snow-covered sage was almost finished when a red fox peeked around the corner. When surprises like this occur, block them in quickly before they move. This kind of remarkable surprise is one of the joys of painting in the field.

FIELD STUDIES
Watercolor

Watercolor dries quickly and you can layer water-colors while they're still wet, making it an ideal medium to use in the field. First do a light pencil drawing; heavy lines show through transparent watercolor. Lay in a light wash for the main subject and another for the background. Then build up the detail areas, leaving the white of the paper for any areas that will be light. Add as much detail as you want for the foreground. Although watercolor is a very unforgiving medium, you can repair mistakes by lifting some paint from the area; add water, then dab it dry with a paper towel. You also can create highlights this way.

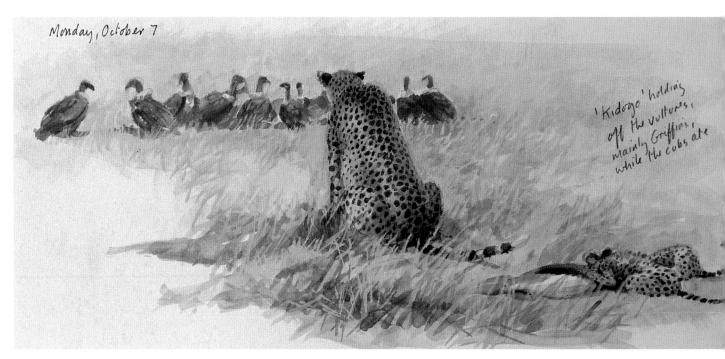

Monday, October 7

'Kidogo' holding off the vultures, mainly Griffins, while the cubs ate

Work Quickly
Draw a quick, light pencil sketch before applying the watercolor. Work very fast because the cheetah didn't sit in this position very long. She was protecting her cubs and their dinner, a gazelle she had killed, from the vultures.

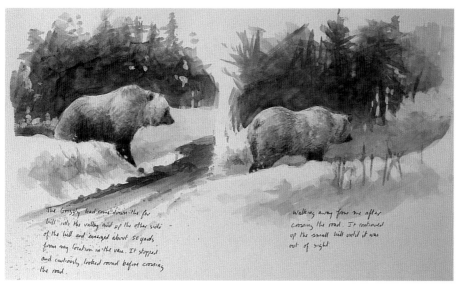

The Grizzly had come down the far hill into the valley and up the other side of the hill and emerged about 50 yards from my location in the van. It stopped and cautiously looked round before crossing the road.

Walking away from me after crossing the road. It continued up the small hill until it was out of sight.

Plod Along

Here are two watercolor studies of a single grizzly in Alaska. You get a real sense of the bear's strength and slow but steady movement with this progression of sketches. Make sure you maintain a safe distance (if there is such a thing) from potentially dangerous subjects. Starting with the bear, quickly apply washes of Raw Sienna and then Burnt Sienna. Use Burnt Umber for its shadows, then move on to the details.

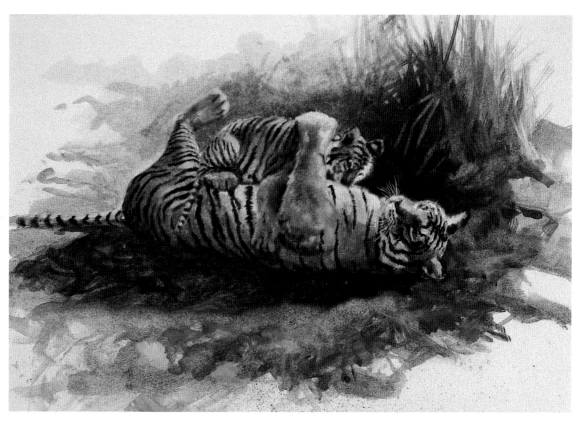

Sketch Quickly

This is a field sketch of a mother tiger and her cub in Ranthambhore, India. The tigers were quickly sketched in pencil, then the color was worked in as the tigers moved away.

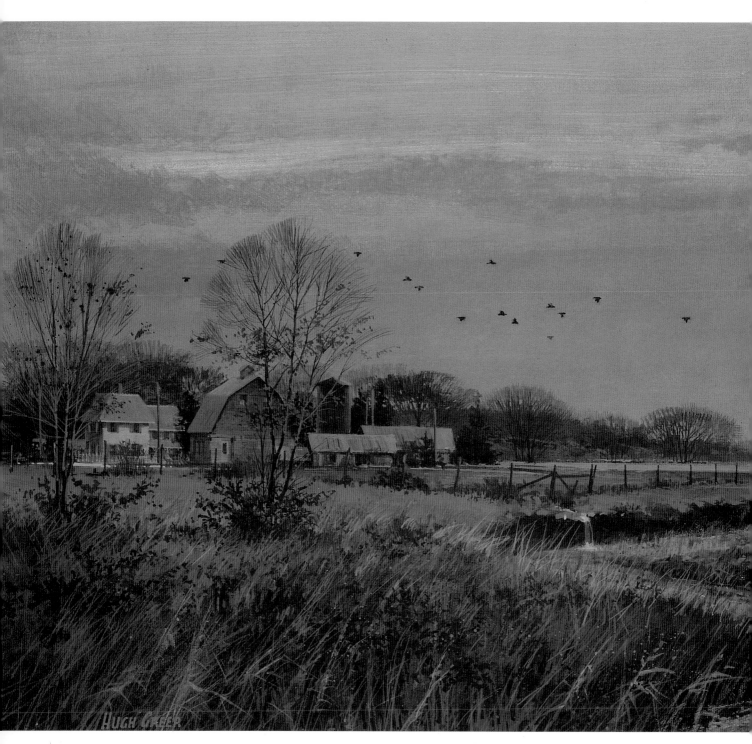

Volcanic Sunset Acrylic on Crescent illustration board no. 1 • 12" × 18" (30cm × 46cm) • Hugh Greer

CHAPTER 2
Color & Contrast

The correct use of color will help you express your subject more fully.
Learn how to use color to portray the many effects of weather and
discover how weather impacts the way color appears.

Consider the Conditions

Weather conditions such as sun, fog and rain affect how you see local colors, as do seasonal changes. Bright sunlight, cloudy days or fog challenge you to paint all types of atmospheric conditions. Select a color scheme to fit your scene, name your dominant color and go for it. It's just a matter of using the right values, color temperatures and degrees of color intensity in the right places.

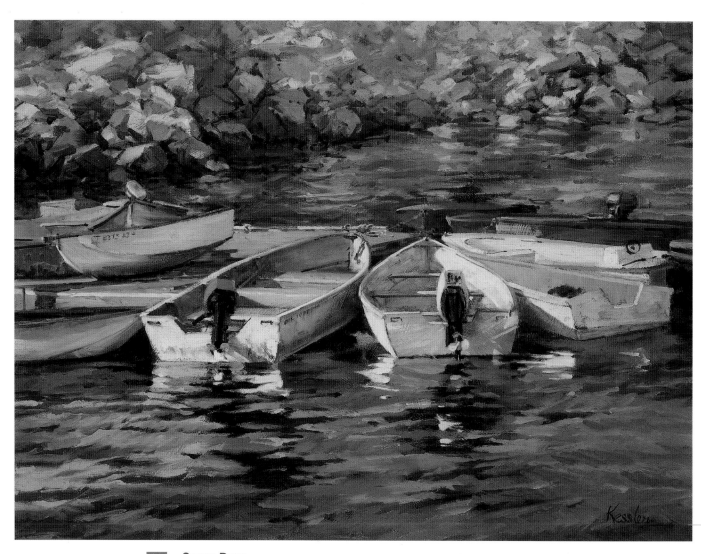

Sunny Days

For an intensely sunny day, select a complementary color scheme with blue as the dominant color and orange as the complement. The warm midmorning light comes from the upper left, so wash the canvas with Yellow Ochre and Cadmium Yellow Medium. Use complementary colors to mix a variety of hues: light and dark, warm and cool, bright and dull. Then block in the boats quickly, since the light continually changes. Block in the distant rocks using more variations of those same colors, keeping lines loose and forms undeveloped. The viewer's imagination will fill in the missing information.

Dinghy Dock Oil on linen • 18" × 24" (46cm × 61cm) • Margaret Kessler

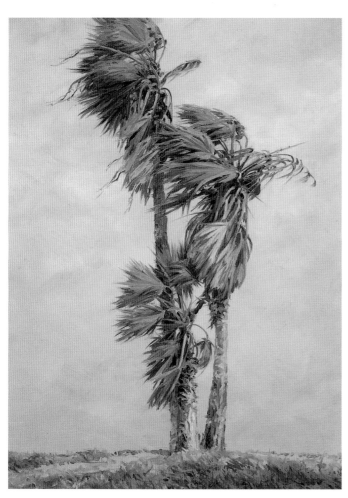

Morning Fog

A strong light source that is coming from one side normally reveals the form of objects with clearly defined, sharp details. Unmistakable shadows and highlights result, easily indicating volume. However, in this scene, the light is muted by a hazy atmosphere. To capture this foggy mood, first tone your canvas with Yellow Ochre. Keep the edges soft and the contrasts to a minimum except for the areas near your focal point—in this painting, the palm foliage on the tallest tree. For accents on the palm fronds, use warm darks in the sunlight and cool darks in the shadows.

Coastal Breezes Oil on linen • 24" × 18" (61cm × 46cm) • Margaret Kessler

Cloudy Days

This painting reflects one of those cloudy-day situations. Following a brief afternoon shower, an opening in the clouds created a spotlight on the front of this house as well as the scarecrow, which became the center of interest. Select an analogous color scheme on the Munsell wheel with a nice variety of beautiful neutrals. Use Yellow Ochre as the dominant color, with Ultramarine Blue as the complement.

Paint the sky with mixtures of Yellow Ochre, Ultramarine Blue and a few touches of Quinacridone Red. This is one time where you can throw out the rule book and add a foreign color, Cadmium Red Light, for the scarecrow's jacket. If you do introduce a new color, repeat it a few times throughout your painting.

Fall Gardening Oil on linen • 20" × 24" (51cm × 61cm) • Margaret Kessler

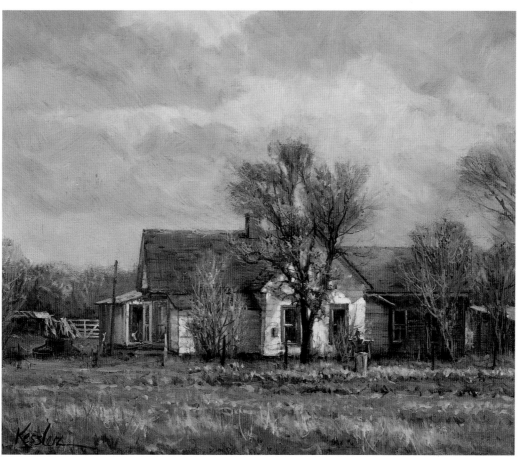

The Color Wheel

To understand both the color-mixing capabilities of your paints and the general color schemes available, you must be familiar with the color wheel. Wheels can vary, but the most commonly used one is the traditional, triadic color wheel. Its twelve colors are strategically placed in a circle so that equilateral triangles can be drawn to connect three types of colors: primary, secondary and tertiary.

The primary colors—yellow, red and blue—are the basic colors from which all others are derived. Every color your eye sees can be broken down into these three colors. They are unique because you can combine primaries to create other colors (yellows and blues to create greens, for example), but you can't mix any combination of colors to get these three pure colors.

The secondary colors—orange, violet and green—result from mixing together two primaries (red and blue combine to make violet, for example). Tertiaries are the colors that fall between the primaries and secondaries on the color wheel. They result from mixing a primary with one of its neighboring secondary colors. For example, yellow and green combine to create yellow-green.

Colors beside each other on the color wheel are called analogous, while colors directly opposite each other on the wheel are complementary. Complements can be placed next to each other in a painting for exciting color contrasts, or they can be mixed together to create lively neutrals.

Memorize the color wheel or have a copy of it handy as you paint. It is the most useful visual tool you have for creating color harmony. With a glance at this wheel, you will be able to select color combinations that are compatible and expressive of whatever emotion or mood you wish to convey. Try to lay out your palette in approximately the same order. Proper placement of your own favorite tube colors in this arrangement will help you easily see logical color relationships. Select pure, intense colors whose brightness can be adjusted as needed when you paint.

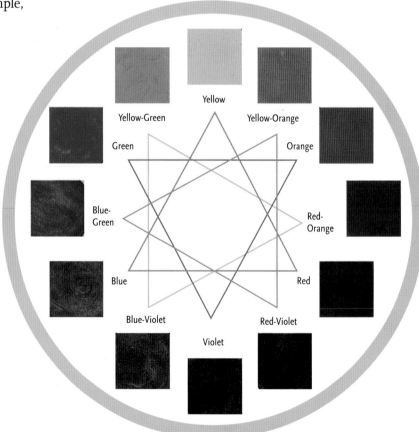

Traditional Triadic Color Wheel

Key
- primary triad
- secondary triad
- tertiary triad

Yellow
Yellow-Green
Yellow-Orange
Green
Orange
Blue-Green
Red-Orange
Blue
Red
Blue-Violet
Red-Violet
Violet

Eight Essential Color Schemes

This small color wheel and its various color schemes, can be cut out after the page is photocopied and laminated. As you paint, these are handy to refer to for the various options.

Every work of fine art needs warms and cools. Don't forget that warm schemes should use cool grays and cool schemes should use warm grays. This will help balance the colors in your painting.

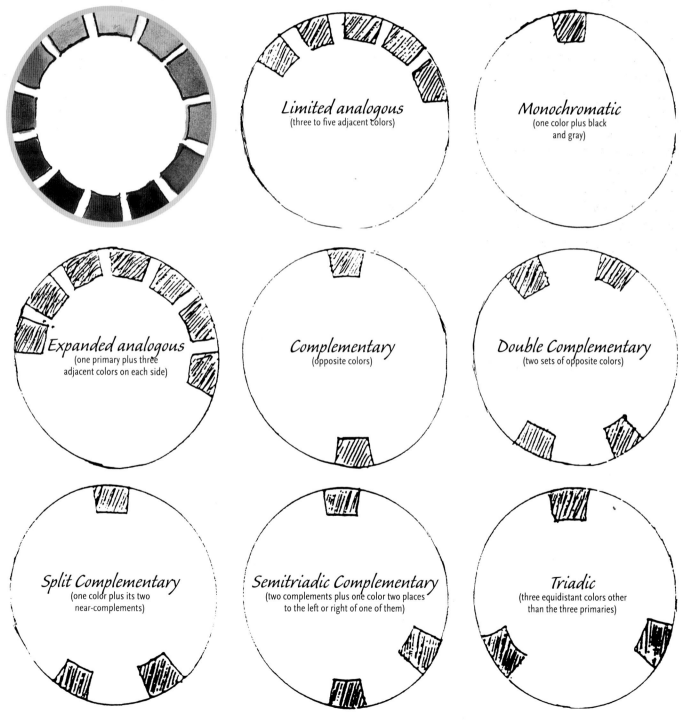

Limited analogous
(three to five adjacent colors)

Monochromatic
(one color plus black and gray)

Expanded analogous
(one primary plus three adjacent colors on each side)

Complementary
(opposite colors)

Double Complementary
(two sets of opposite colors)

Split Complementary
(one color plus its two near-complements)

Semitriadic Complementary
(two complements plus one color two places to the left or right of one of them)

Triadic
(three equidistant colors other than the three primaries)

Choosing a Color Scheme

Color should come from an artist's feelings and intuition about a subject, not simply the subject's local or photographic color. Using only the colors seen on a subject can be the kiss of death to a creative painting. To arrive at a good color scheme, ask yourself some questions. What kind of a mood does the subject present to you?

Determine the special qualities of your subject, its history. For instance, if you were to paint the ancient castle ruins in Les Baux, France, you may choose a palette illustrative of the castle's history. It has been said that long ago, the lord of the castle gave his wife some of her lover's heart to eat for dinner. When the lord's wife learned of his cruel action, she leapt off the battlements to join her lover in death! Knowing this may lend itself well to painting the piece predominantly red with a quieter green for the complement in this scheme. Such a color scheme also creates dramatic value contrast.

Not all subjects have such tragic or emotional histories, but they should evoke feelings. Translate those feelings into color choices and value patterns whenever possible.

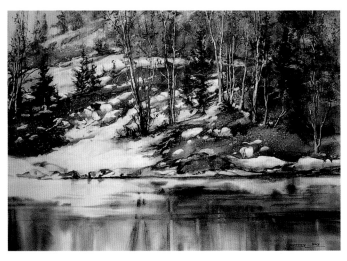

Monochromatic Color Scheme
This somber winter scene seemed to suggest a limited, quiet palette. Use Quinacridone Sienna with cool gray for the monochromatic scheme. Light to dark versions of these colors provide the value ranges, with the greatest amount of contrast being in the upper-left focal area.

Early Thaw Transparent watercolor • 21" × 29" (53cm × 74cm) • Jane R. Hofstetter

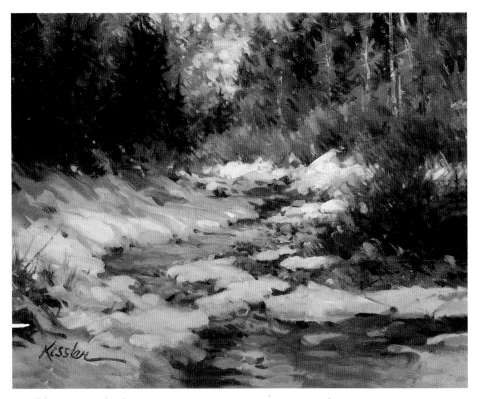

Top of the Morning Oil on linen • 14" × 18" (36cm × 46cm) • Margaret Kessler

Complementary Color Scheme
Repeat other complementary pairs here and there throughout your painting to bring more interest to your dominant complements. For example, the light yellow sunlight on the snow in the foreground (Lemon Yellow mixed with white) is dramatized by its complement, lavender (Ultramarine Blue, Quinacridone Red and white). In the distance, pale orange bushes complement blue snow shadows. Combine the reds and greens on your palette for the brown tree trunks. The color harmony might be lost if foreign browns like siennas and umbers are not introduced into the scene.

Split Complements

Split complements are a natural choice for this painting of red flowers against yellow-green and blue-green leaves. The reds can swing toward red-orange and bluish red, which give wonderful split complements.

Dancing Ladies Transparent watercolor • 21" × 28" (53cm × 71cm) • Jane R. Hofstetter • Collection of Bill and Mickie Robinson

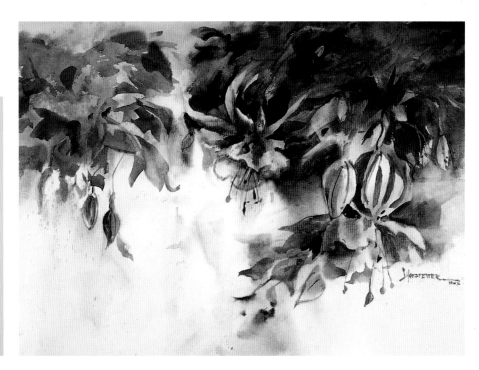

■ THE RULE TO REMEMBER

The key to good color relationships in any color scheme is dominance.

- Let one quiet color dominate the large masses.
- Let one intense color dominate the smaller bits.
- Let one value dominate (dark or light).
- Let one temperature dominate. (Warm colors usually have more yellow added; cool colors typically contain more blue.)

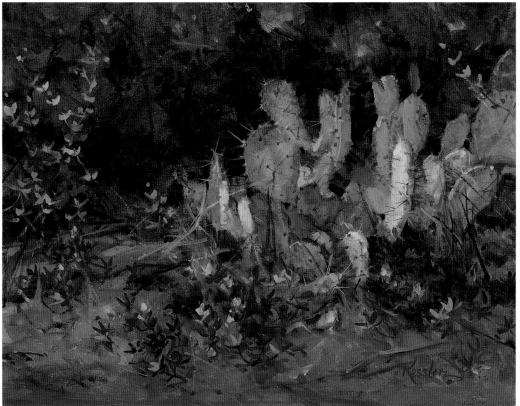

Double Complements

In this painting, blue-violet and yellow-orange are the dominant pair of complements, with blue-violet functioning as the dominant color. Touches of orange and blue, close neighbors of the dominant complements, are added in the form of wild grass and blue flowers (called bluebonnets). A thin oil underpainting of Yellow Ochre, Cadmium Yellow Medium, Cadmium Red and a touch of Phthalo Blue helps to set the tone for the color scheme. Partially blend these colors on the canvas, not on the palette.

Southwest Light Oil on linen • 18" × 24" (46cm × 61cm) • Margaret Kessler

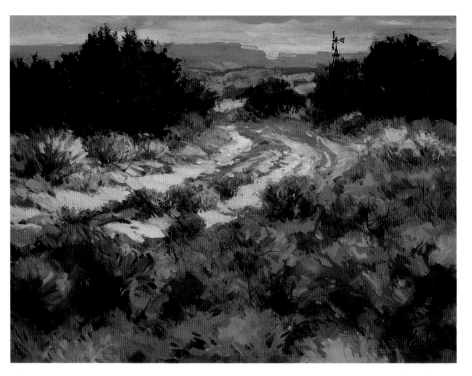

Triadic Colors

To convey a moody, gray day, alter the original warm desert hues by choosing to make this a predominantly cool painting with blue-green as the dominant color. Red-violets tinted with white quietly provide relief from the greens. Yellow-oranges add exciting, warm accents for contrast.

The windmill adds a strong focal point, as it creates a point of contrast (angular among the organic) that rewards the viewer for the trip down this lonely lane. An undertone of a medium-dark value of grayed violet helps create the mood.

The Steel Harp Oil on linen • 18" × 24" (46cm × 61cm) • Margaret Kessler

Semitriadic Complements

This is an interesting color scheme for this painting. Use the warms first, rather lightly, and darken down to the cools. The complements blue-violet and yellow-orange are accompanied by red-orange as the extra color, which gives more interest to the yellow-orange.

Old Europe Watercolor and graphic white • 29" × 21" (74cm × 53cm) • Jane R. Hofstetter • Collection of the artist

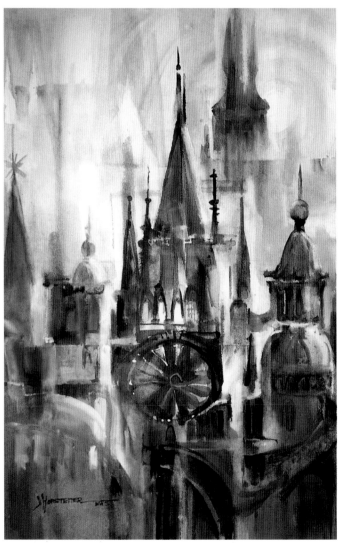

■ SWITCH IT UP

Allow someone else to choose the color scheme for a painting, even if it is opposite of what you think it should be. This forces you to try new approaches to a subject, stretching your creativity each time you paint.

Expanded Analogous Colors

In this abstract painting, the dominant primary color is, of course, red. Blue-violet, violet, red-violet, red, red-orange, orange and yellow-orange are a powerful combination. The blue-violet provides a little cool balance.

Wharfwood #2 Transparent watercolor • 21" × 28" (53cm × 71cm) • Jane R. Hofstetter • Purchase Award recipient at San Diego Watercolor Society Annual Exhibition

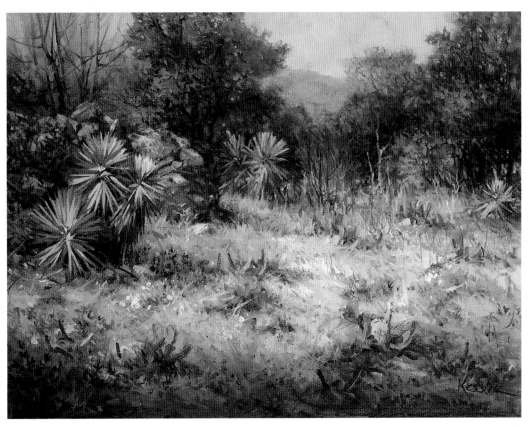

Limited Analogous Colors

In the field, spring greens are so similar that they can be overwhelming, so exaggerate what you see. Use an analogous color scheme to create a variety of green hues—yellow-greens, greens and blue-greens. You can even extend this family of colors to include yellows and blues. *Garden-field* emphasizes warm yellow-greens. Practicing repetition with variety to unite colors, repeat the blues within the foreground flowers and in the distant hills and sky.

Gardenfield Oil on linen • 18" × 24" (46cm × 61cm) • Margaret Kessler

Using the Base Palette

MINI-DEMONSTRATION: ACRYLIC

Using the base palette is fun and easy. Try this mini-demonstration to practice your color techniques.

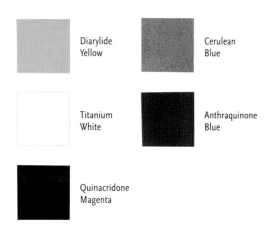

Diarylide
Yellow

Cerulean
Blue

Titanium
White

Anthraquinone
Blue

Quinacridone
Magenta

The Base Palette
The base palette has all the colors you
need to begin painting.

Materials List

ACRYLICS
Anthraquinone Blue,
Cerulean Blue, Diarylide
Yellow, Quinacridone Ma-
genta, Titanium White

BRUSHES
One-stroke brushes:
⅛-inch (3mm), ¼-inch (6mm),
½-inch (12mm), ¾-inch
(18mm), 1-inch (25mm) and
1½-inch (38mm)
Script brushes: nos. 1 and 2

OTHER
Crescent illustration board
no. 1, 18" × 24" (46cm ×
61cm), palette, palette knife,
paper towels, water

■ PRACTICE MIXING COLORS

There is no substitute for practice.
Color mixing will become second nature
as you hit upon colors that work and
repeat them in subsequent paintings.

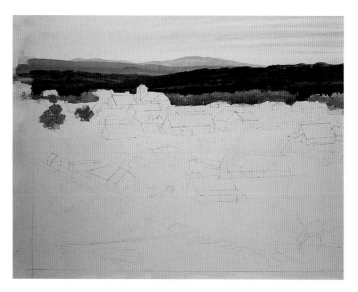

• 1 APPLY A WASH AND PAINT THE MOUNTAINS
Use Crescent illustration board no. 1 for your support.
Paint a thin wash of Quinacridone Magenta and Diarylide Yellow
to coat the board. Lay in the mountains using Cerulean Blue,
Anthraquinone Blue and Titanium White with just a touch of
Quinacridone Magenta. Use the same blue for all the mountains,
but add more white as they recede.

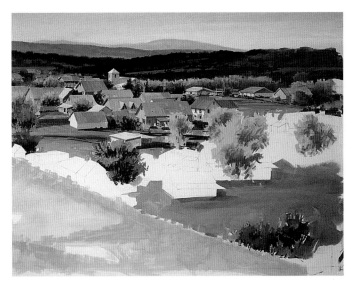

• 2 DEVELOP THE PAINTING

For the sky, use Cerulean Blue and Titanium White with a touch of Diarylide Yellow. For the autumn trees, use Diarylide Yellow with a touch of purple created from Quinacridone Magenta, Anthraquinone Blue and Titanium White. Paint the field with a tan made with Quinacridone Magenta, Diarylide Yellow, Cerulean Blue and Titanium White.

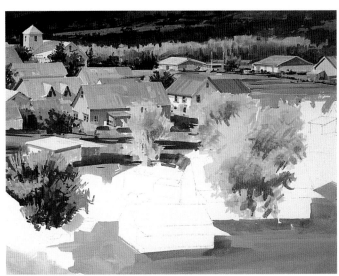

• 3 ADD DETAILS

The roof color was mixed by combining Quinacridone Magenta, Diarylide Yellow, Cerulean Blue and Titanium White. Use approximately 50 percent red, 10 percent yellow and 40 percent white. For a shaded red you can add a touch of Anthraquinone Blue.

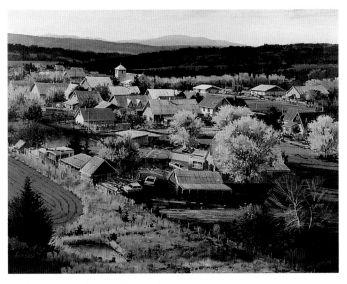

• 4 FINALIZE THE PAINTING

The strong reds and yellows mixed into the other colors throughout this painting give you a feel for the evening light. A blue-violet influences the shaded sides and shadows.

Northern New Mexico October Acrylic on Crescent illustration board no. 1 • 18" × 24" (46cm × 61cm) • Hugh Greer

"Color Search" Your Work as You Paint

Using color in painting doesn't have to be difficult. The main thing to keep in mind is to avoid using one color repeatedly in an area and to constantly "color search" while painting. In other words, do not go more than an inch or two (3 to 5cm) in your painting without changing the colors or values somewhat. The eye is very quick to find exact duplications of anything and loses interest quickly. Color searching will make your paintings look professional and pleasing.

As you practice color searching, try to avoid dipping into the exact same color twice and think warm to cool, light to dark, intense to less intense and complement to complement. It may take you a while to get the hang of color searching, but your work will grow enormously.

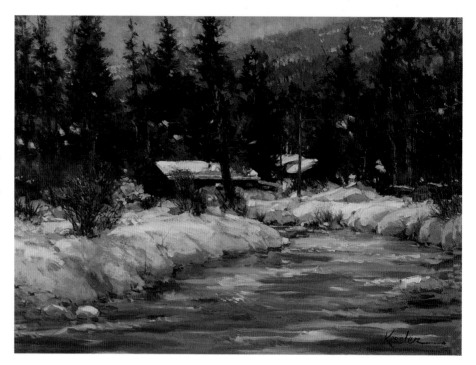

Injecting Life Into a Cold Scene

For this winter scene, emphasize cool blue-greens while adding complementary red-oranges and the appropriate discords to bring out the warmth and sparkle of the sunlight. Notice the pinkish lavender (a tint of red-violet) discords in the snow shadows near the big cabin, on some tree trunks and in the dormant midground bushes. The yellow-orange discord is most apparent in the foreground bush on the left, the pine foliage on the dominant tree near the center, the shoreline weeds and the storage shed on the far right.

Creekside Emeralds Oil on linen • 18" × 24" (46cm × 61cm) • Margaret Kessler

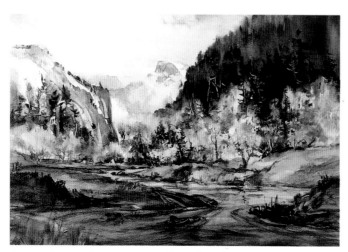

Yosemite Autumn Transparent watercolor • 21" × 28" (53cm × 71cm) • Jane R. Hofstetter • Private collection

Color Searching Brings Interest to Repetitive Subject Matter

Yellow-orange is the most intense color for these aspen trees. The analogous colors red-orange, orange, yellow and yellow-green border the yellow-orange. Blue-violet, violet and blue are the complements used. Notice how the dark hill is color searched and how the fall trees are intensified in the upper-left focal area. The Cobalt Blue Tint glaze over the foreground draws attention to the focal area.

Adjusting Greens for Different Times of Day

Green is often a hard color for students to use; many times they end up with garish, unnatural hues. For natural-looking hues, modify your greens with the color of the light that you see at a specific time of day. Look at how the changing colors of light influence the local color of these similar green trees.

Twilight

Just after sunset, earthy reds should be dominant. Dull the intensity of your bright greens with reds. It's easy to establish a quiet mood by using these muted colors. Keep your scene free of sharply defined details that are apparent only in bright sunlight.

Sunrise

For early morning scenes, start with a light, warm yellow wash on your canvas. This dominant color will unite all the colors in your painting. Add a touch of a less intense yellow to tone it down, if you wish. Be consistent: Keep your greens warm and sunny, too. This will enhance the emotional impact of your painting.

Evening Fog

Fog in morning light looks very different from fog in the evening. Yellowish grays are the dominant hues in the morning, whereas evening fog is dominated with red-grays and blue-grays. Because fog is dense humidity, bright colors are muted, details cannot be seen and treetops usually disappear.

Noon

Use a less intense yellow for most noontime scenes. The value of this color should be fairly light because the overhead light washes out your darks and reduces the intensity of bright colors. Indicate your light source by painting the foliage at the top of the tree both warmer and lighter than at the bottom.

Sunset

Orange, red and red-purple hues set the scene for sunset paintings. The closer it is to dusk, the cooler you want to make your wash. Continue the evening light theme by modifying your greens with those same sunset hues. Avoid sunny yellows. Paint it so it looks like a green tree at sunset, not an autumn tree in full color.

■ MODIFY YOUR GREENS WITH THESE OIL HUES

- **Sunrise:** Add Lemon Yellow
- **Morning light:** Add Cadmium Yellow Medium and/or Cadmium Yellow Deep
- **Noon and afternoon:** Add Yellow Ochre and oranges
- **Sunset:** Add red-oranges, Grumbacher Red and Quinacridone Red
- **Twilight:** Add reds and Cadmium Red Deep
- **Dusk:** Add Cadmium Red Deep, Dioxazine Purple and Ultramarine Blue

Emphasizing Warm Colors

A warm painting that contains no cool colors at all lacks the drama contrast creates. For this scene, use a predominantly warm color scheme with some cool accents.

Color Scheme

Yellow Ochre will be the dominant color, complemented by cool blue-violet. Some yellow-greens, yellows, oranges and the local neutrals (Yellow Ochre's neighbors) will adapt well to this predominantly warm theme. Note the discords: red-violet and blue-green.

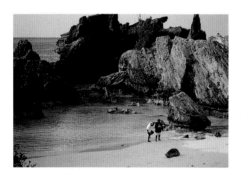

Reference Photo

Predominantly warm, light colors would work best for this scene. Sandy semineutral colors (ochres) will dominate. The inner energy of this awesome location (Bermuda) could be expressed with a full range of values.

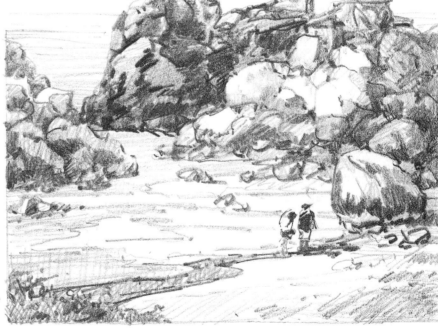

Light source →

Value Plan

A small sketch like this can help you decide how to divide the canvas. Will the painting focus on rocks and water, waves and the beach or the people? To give equal billing to all of these would create confusion, so emphasize the calm, protective nature of the massive rock barrier. A visual path starting from the lower-left corner leads the viewer's eye from left to right along the water line to the focal point: the two ladies. The large boulder points you back into the picture and eventually out to sea, forming an S-shaped composition. The people are placed appropriately off-center, but not too close to the edges or corners of the picture.

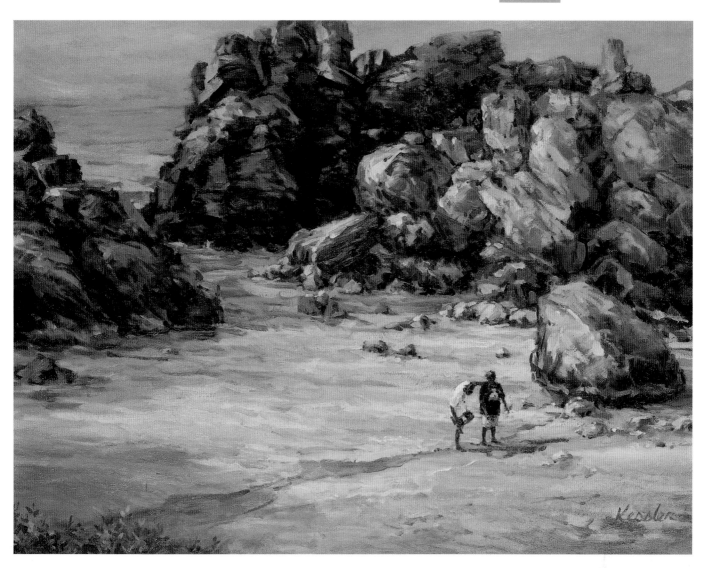

Finished Painting

An overall wash of Yellow Ochre oil paint thinned with turpentine immediately set the tone for the lighting conditions of the day: sunny and warm. Block in the color scheme with warm colors (a mix of Yellow Ochre and Cadmium Red Deep) that are slightly darker and cooler than the overall wash. For the lightest values, either leave the tonal wash exposed or lift out some of the tone with turpentine. Apply darker values with a mixture of Dioxazine Purple and Yellow Ochre. Then overlay this underpainting with colors from the analogous color scheme, reproducing the values in thick, colorful paint. To draw attention to the focal point, use the complement of ochre, blue-violet for the shirt on one of the figures.

Two cool discords, Viridian Green and Quinacridone Red mixed with Dioxazine Purple, add sparkle to the painting. These bright colors were dotted and dashed directly on the canvas near the focal point. You can see the lively effect of the more subdued discords used in the blue-greens of the foreground bushes, in the water and on the little tree in the rocks. Tints of red-violet can be found in the wet sand, the rocks in the shadows and on the horizon.

Coastal Cover Oil on linen • 18" × 24" (46cm × 61cm) • Margaret Kessler

■ DEALING WITH INACCURATE HUES

If some of your colors become the wrong hue, either too warm or too cool, scrape just that area off. After scraping, wash the remnants of the paint off with turpentine and blot dry, then repaint the area. If the whole painting is either too cool or too warm, wait until the paint dries. Use retouch varnish and lay warm (or cool) colors over some of the undesirably cool (or warm) areas. Reworking a dried painting ensures that the new layer of paint won't combine with the previous layer, and you'll avoid mud. Varnish secures the new layer of paint, helping it stick to the dry paint, and ensures that the new, wet colors and the dried colors match.

Emphasizing Cool Colors

When you want a predominantly cool painting, don't start with your coolest colors. Keep your early steps a little warmer than you want the finished painting, and cool things as you work. This approach prevents the premature graying of your colors.

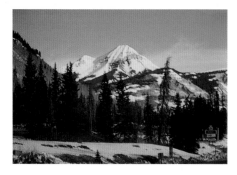

Reference Photo
Keep your camera loaded and ready to use at the drop of a hat. This slide was taken from the window of a moving bus headed for the ski slopes. Its quality is good enough for a quick study of this sunny yet cool winter scene.

Color Scheme
This analogous color scheme naturally sets up a cool color theme. Blue-violet is dominant and yellow-orange is the complement. Yellow-green and red are the optional discords.

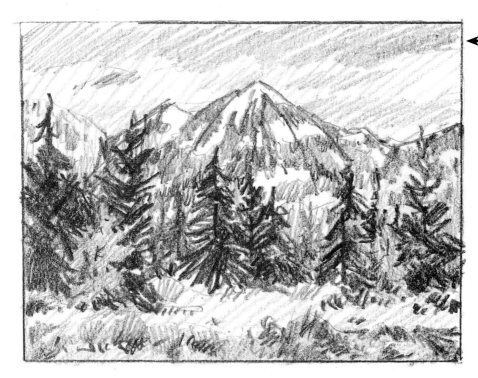

Light source →

Value Plan
Visualize your painting and lay it out in a limited number of shades of black and white. Make your sketch the same portions as the canvas you want to use. Determine the location of your light source and your focal point, the mountain peak. In this painting contrast horizontal bands of lights and darks in varying widths to develop the design.

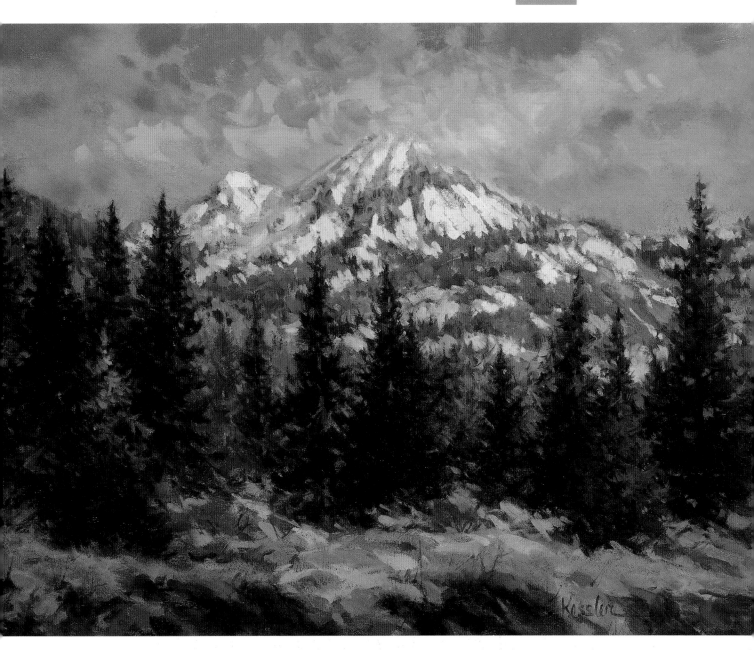

Finished Painting

First tone the canvas with a violet wash of Quinacridone Red and Cadmium Red oil paint cooled with a touch of Phthalo Blue. Be careful not to make it so dark and cool that you won't be able to easily cover areas of it with warm lights. Then begin developing the values by blocking in the darks using warm browns (various mixtures of Lemon Yellow, Cadmium Red Deep and a touch of Phthalo Blue) and lifting out the tonal wash in the light areas, such as the sunny snow on the mountain peaks.

Use a variety of greens in the foreground trees to emphasize the cools. For the snow, begin at the sunny mountain peak with a yellowish white and cool it as you work your way down to the valley floor. Shadows on the snow are tints of warm and cool blue-violets in the foreground that cool to blues and become lighter as they step into the distance. Complementary yellow-oranges for the autumn trees excite the eye. Allow the underpainting to show through in places to tie all the colors together. Paint major portions of the sky with the same color mixtures used for the snow.

A Peak in Time Oil on linen • 18" × 24" (46cm × 61cm) • Margaret Kessler

High-Key Color Schemes

Colors that fall in the lighter half of the value range are referred to as high-key colors. These may give an airy feeling to a picture. High-key paintings can contain a lot of beautiful color variation, since darks usually dull down intensity. Darks rarely are used beyond a 50 percent gray value.

High-key paintings are extremely challenging. They often have a tendency to get chalky or washed out. This is usually due to using too much white and not finding the color variations from light to shadow and reflected color. Temperature changes play an extremely important role in high-key situations.

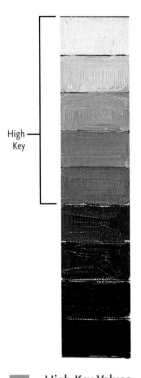

High —
Key

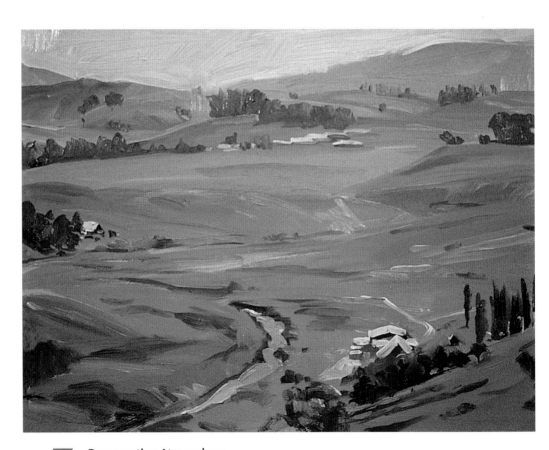

High-Key Values
This gray scale shows where the values for a high-key painting would fall on a full range of value. High-key paintings are represented by the light end of the gray scale.

Representing Atmosphere
Distant vistas offer an atmospheric high-key quality. The light greens and darker trees are softened through a veil of moisture in the air (often found near the coast). The airy, distant qualities are achieved by gradually adding more white and slight cools as things recede.

Spring Carpet Oil • 9" × 12" (23cm × 30cm) • Craig Nelson

Low-Key Color Schemes

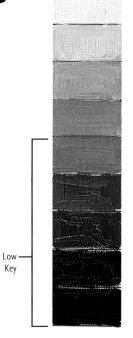

High-key color schemes represent the lighter end of the value scale; the darker 50 percent of the value range is considered low key. A dimly lit interior, a night scene or a figure in dark clothing or deep shadow can all contribute to a low-key painting. Extremely dramatic lighting may make for a mysterious mood in low-key paintings.

In low-key paintings, the light areas contain the most intense color. The shadows may often dissolve into the near blackness of a background. Analogous or limited palette schemes sometimes work best when attempting a low-key painting, but are not always necessary.

Low — Key

Low-Key Values
This gray scale shows where the values for a low-key painting would fall on a full range of value. Low-key paintings are represented by the dark end of the gray scale.

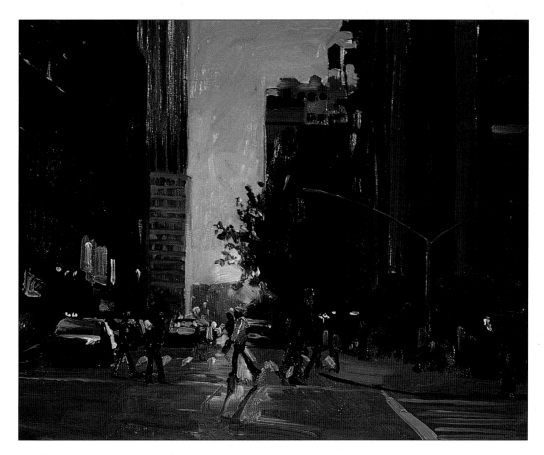

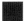 **Use Lighter Spots to Create Intensity**
The near-silhouetting of the New York cityscape in very dark tones is emphasized by the sky and sunset. The architecture is basically painted as a solid shape, with just a slight indication of detail. Any intensity occurs only in the lighter spots, where lights are being illuminated.

The East Side Oil • 11" × 14" (28cm × 36cm) • Craig Nelson

Contrasts: Putting It All Together

Consider all the contrasts available to you—not just the ones related to color—as you set out to do each painting. In addition to contrasts of light and dark, warm and cool and bright and dull, here are some other contrasts to think about:

Line
- vertical and horizontal
- thick and thin
- straight and curved
- continuous and broken

Shape
- large and small
- simple and complex
- geometric and organic
- hard and soft edges

Paint
- thick and thin
- opaque and transparent

Brushwork
- broad and delicate

When working with contrast in your painting, follow these guidelines to make sure it is used most effectively:

- Exaggerate contrasts nearest to your focal point. This area should draw the most attention.
- Subdue contrasting elements in areas that might distract the eye from your focal point. Contrast in other areas is OK, but don't let it steal the show.
- If your painting has a lot of contrast, make sure to repeat some familiar things for relief (a color, a shape, etc.). Exercise repetition with variety.

Contrasting this large tree and the mammoth mountains with a small human figure conveys the vulnerability of humankind.

The strong vertical lines of the ranger and the trees break the more restful horizontal lines naturally found in landscapes—the horizon line, the top of the mountain range and cast shadows.

To create excitement, juxtapose the violet background with its complement yellow (the ranger's hat). Light against dark, warm against cool, bright against dull and the placement of a human face in nature also call the viewer to this focal point.

This first-aid kit places a dash of complementary red against the ranger's green uniform. Red is also subtly throughout the painting.

Thick paint glistens in the sunny areas when contrasted with the thinly painted shadows. These lost-and-found edges also guide the viewer down the path toward the center of interest.

Ranger Bob Oil on linen • 20" × 24" (51cm × 61cm) • Margaret Kessler

This vertical bush stops the viewer's eye from leaving the painting. But restful horizontal lines dominate, continuing the moody theme.

Cool colors are kept to a minimum to avoid contrast that would interrupt the emotional theme. The warm glow of the painting enhances nostalgic feelings.

Contrasting large and small, the car and the oil drum, makes a good partnership.

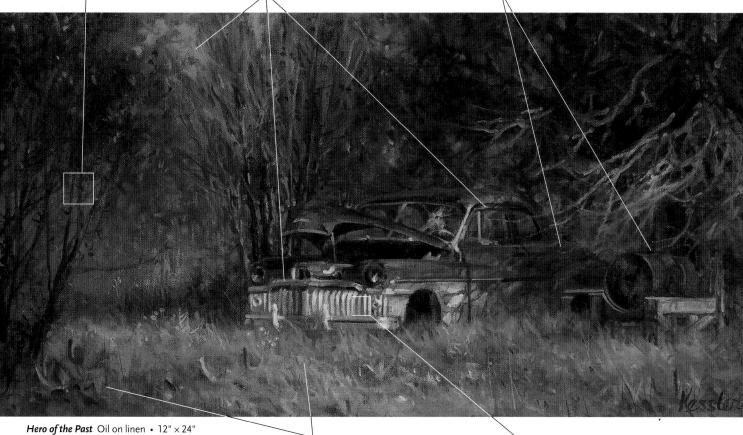

Hero of the Past Oil on linen • 12" × 24" (30cm × 61cm) • Margaret Kessler

Bright colors are limited to the center foreground and center of interest to keep the viewer from being distracted by the background. Note that even the lower corners of the canvas have been muted.

Sharply contrasting values are restricted to the focal point, the grill on the front end of the car. Ninety percent of the painting is done in a limited range of values to convey a quiet mood.

How Atmosphere Affects Color

There are two major ways to create the illusion of depth in a painting. One is linear perspective: the use of vanishing points. The other is atmospheric perspective: the progressive cooling of a color as it recedes into the distance. Some artists call this color recession.

Think of the atmosphere as a series of thin veils of airborne particles. The farther away you are from an object, the more veils there are between you and it. As you look through these veils into the distance, objects gradually become more indistinct as contrasting elements begin to weaken. Colors gradually become cooler and duller. The more dense the atmosphere is, the shorter the distance you can see before the colors mute into neutral grays.

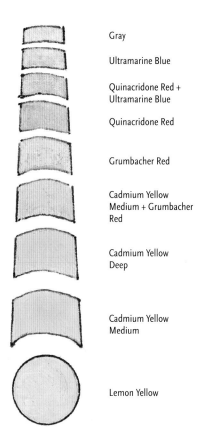

Gray

Ultramarine Blue

Quinacridone Red +
Ultramarine Blue

Quinacridone Red

Grumbacher Red

Cadmium Yellow
Medium + Grumbacher
Red

Cadmium Yellow
Deep

Cadmium Yellow
Medium

Lemon Yellow

Colors cool as the day moves from morning to evening, and they also cool as you move from foreground to background.

The Colors of Light, Adjusted for Depth
Just as the colors of light cool from yellow to red and on to blue as day progresses to night, so does the local color when you want to move from foreground to background. For example, green cools from yellow-green in the foreground to orange-green and red-green through the midground to blue-green and finally gray in the distance. For starters, modify your local color stepping through this chart to the degree of depth you want to portray. Also, progressively lighten the local color.

Colors also become less intense as they recede. For example, green changes from a warm yellow-green in the foreground to cooler orange-greens and red-greens in the midground, then to blue-greens and eventually cool grays in the background.

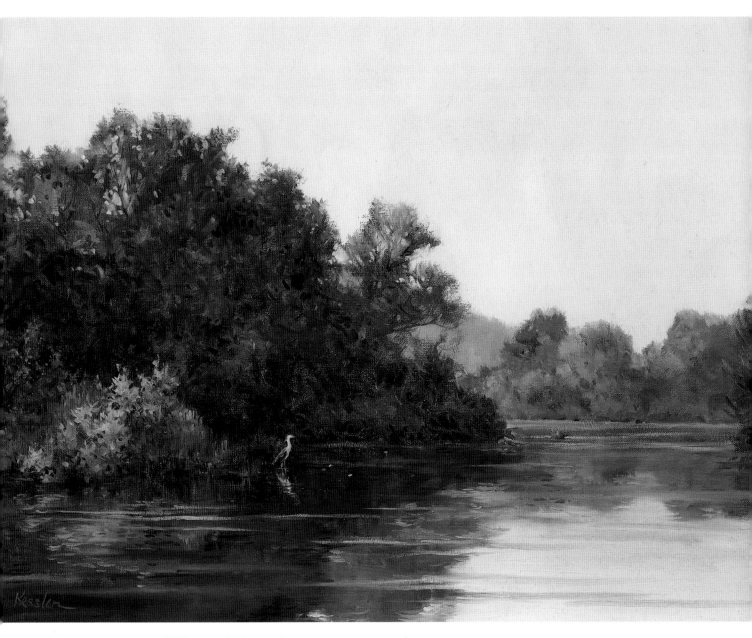

Combining Techniques to Create Depth

This painting conveys a sultry summer day on the river. The local greens in the large trees have been modified to reflect the time of day, the humid weather conditions and the onset of autumn. The trees in the distance are lighter, cooler and duller colors than the foreground trees. The local colors in the far distance are completely obscured by the blue-gray atmosphere. To add to this illusion of depth, overlap the trees, progressively reducing their sizes and simplifying details as you work toward the background.

Lazy River Oil on linen • 18" × 24" (46cm × 61cm) • Margaret Kessler

Get Exciting Results With Glazing

Glazing is most often associated with watercolor, but is also possible with acrylic and oil. It is accomplished by layering washes of thinned transparent color. The most important thing to remember when glazing is to be sure a wash is bone dry before going over it with another wash. Using a hair dryer dulls the color slightly, so try to allow the paper to dry naturally between washes.

Any transparent color can be layered for glazing, but it's customary to begin with the warmest color in your scheme and progress to the coolest color. Use a 1-inch (25mm) soft sable wash brush since it seems to disturb the underlying layers the least, but you can try a round or flat to see which you find easiest. (The type and size of the brush depends on the size of the area you are glazing as well.)

Here are some ways you can use glazing to enhance your painting:

- **Glaze dull, drab places in your painting to make them glow.**
 Even the most subtle glaze can change the color or temperature just enough to enliven an area.
- **Use glazes to connect areas of a painting.** Glaze spotty, busy or disconnected places with the overall dominant color to help tie them in with the rest of the painting.
- **Use glazes to emphasize or de-emphasize certain areas.** Draw attention to your focal area by building intense layers of color. Quiet supporting areas with an overall glaze of subdued color.
- **Enliven shadows with transparent glazes.** Cast shadows become more luminous when the local color of the shadow is applied first, then a darker shade of that color is glazed, then the color of the object casting the shadow is glazed on top.
- **Give a sky loads of atmosphere with warm-to-cool color glazes.** The more glazes, the more atmosphere and mood. Go from darker in value at the top to lighter at the bottom. Changing the value or temperature from side to side is exciting to the eye also. Try painting distant buildings at the back of a low-horizon field and letting the glazed sky dominate the painting for a powerful effect. Repeat the sky colors in the rest of the painting for a harmonious effect.

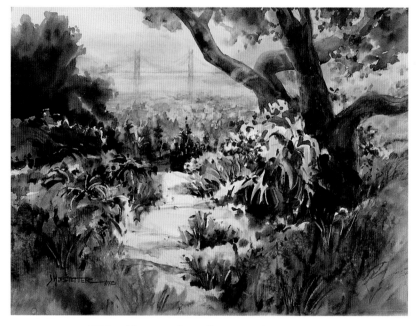

Glaze an Overall Area to Tone It Down
Glaze over the foreground of a painting with a wash of Cobalt Blue Tint, letting this area go into shadow to give the focal area in the midground more shine. Doing this for *Marjory's Garden* gives more strength to the focal area in the upper right.

Marjory's Garden Transparent watercolor • 53" × 71" (135cm × 180cm) • Jane R. Hofstetter • Collection of the artist

■ LIGHTFAST COLOR ENDURES OVER TIME

It is horrible to have a painting ruined because the color has faded. For this reason, make sure you use permanent, lightfast watercolors. Fortunately, there are books on the permanency of watercolor to help guide you in your choices. However, a nonfading color in one brand might fade in another, so be careful.

Incidentally, many museums store all watercolors in basement archives and show them for only a week or two during the year due to the watercolor paint's fading. Hopefully this will change over time if more watercolorists use only lightfast, permanent paint. Label the back of your artwork "lightfast color only."

Atmospheric Perspective

Using atmospheric perspective in addition to linear perspective adds a feeling of depth to scenes like this painting. Try using atmospheric perspective as you work en plein air. Painting en plein air forces you to work quickly while really observing the subject. Study the way the sky and shadows look when you start painting, and make a mental note to follow that guide. The light source, the sun, in plein air painting is constantly changing, so you have to keep it consistent in your painting even if it is changing in reality. When painting en plein air, you can work on a painting or a sketch that you'll use to paint a final painting later. Either way, the important thing is to relax and enjoy the experience. Whether you end up with a masterpiece or not, you'll improve your observation and technical skills, which are invaluable to future paintings.

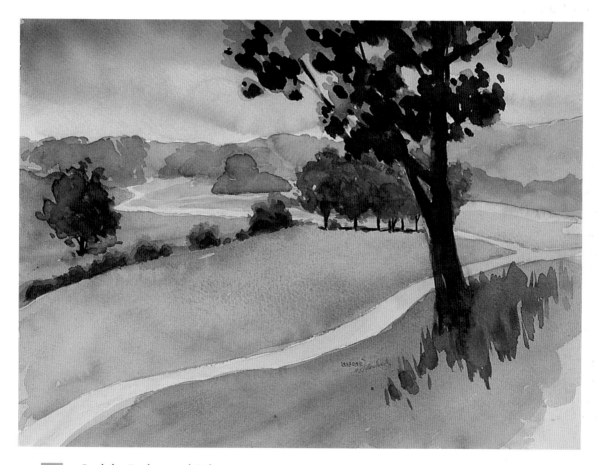

Cool the Background Colors

Notice that the colors in the foreground in this painting are richer and more intense with more contrast, while the background colors are cooler and more muted and neutral.

Meadow Trail Watercolor on 140-lb. (300gsm) cold-pressed watercolor paper • 12" × 16" (30cm × 41cm) • Mark Willenbrink

Creating Atmospheric Depth

MINI-DEMONSTRATION: ACRYLIC

Creating depth in a painting will give the viewer a sense of space and perspective. Atmospheric layering is one way to achieve depth in your landscapes.

Materials List

ACRYLIC S
Anthraquinone Blue, Cerulean Blue, Diarylide Yellow, Dioxazine Purple, Jenkins Green, Quinacridone Magenta, Titanium White

SURFACE
9" × 12" (23cm × 30cm) gessoed hardboard

BRUSHES
One-stroke brushes:
⅛-inch (3mm), ¼-inch (6mm), ½-inch (12mm), ¾-inch (18mm), 1-inch (25mm) and 1½-inch (38mm)
Script brushes: nos. 1 and 2

OTHER
ballpoint pen, lift-out tool, pencil, ruling pen, Saral paper or pastel stick, Soft Gel Gloss, tracing paper (inexpensive) palette, palette knife, paper, towels, water

•1 APPLY THE WASH AND TRANSFER THE DRAWING
Use an orange wash mixed with the base palette. Apply the wash to the support—darker at the bottom, lighter at the top. Let this dry. Sketch and transfer your drawing onto the support.

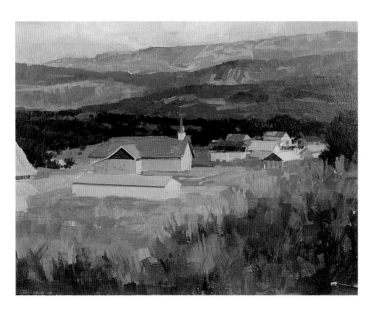

• 2 PAINT THE MOUNTAINS
Depth and atmosphere is going to be created in the mountains behind the chapel. You can see the layered effect of the mountains as they appear to recede (the colors become cooler and lighter). Leave some spots of the undercoat showing through in the mountains. Keep the background mountain colors grayed so they are not strong and vibrant. The foreground colors should be a higher chroma and have a more intense color.

• 3 DEVELOP THE PAINTING

Create a wash of Titanium White and Soft Gel Gloss with a tiny bit of Anthraquinone Blue. Apply a thin wash of this mixture over the mountains; this will soften them further, adding more atmosphere. The low hill behind the chapel is darker, providing a nice contrast to the red roof of the chapel and creating a center of interest. Paint the poplar trees with the edge of a ¼-inch (6mm) one-stroke loaded with a mixture of Jenkins Green and Dioxazine Purple. The poplar trees are the darkest part of this painting. Highlights on the poplar trees are from a mix of Jenkins Green, Diarylide Yellow, a touch of Quinacridone Magenta and Titanium White.

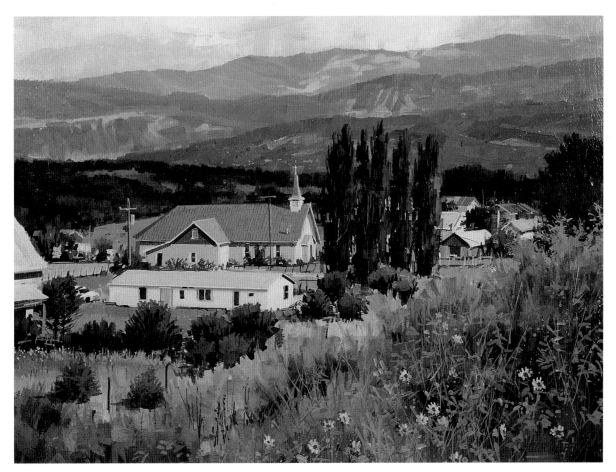

• 4 FINALIZE THE PAINTING

Embellish the foreground with sunflowers, telephone poles, grasses, weeds and shadowed areas. Brighten the sky if you like.

Church at Rowe Acrylic on gessoed hardboard • 9" × 12" (23cm × 30cm) • Hugh Greer

Atmospheric Depth on a Clear Day

onvey the bright light of a clear day early in the
painting process. For instance, rather than tone
the entire canvas with a wash of Yellow Ochre oil paint,
apply a wash of Yellow Ochre and Cadmium Yellow
Medium on the lower part of your canvas. Then tone the
upper portion of your canvas with Yellow Ochre and a
touch of Quinacridone Red, as the sky is cooler than the
foreground. You will find that this yellowish foreground
will advance in the finished painting.

Color Recession of Green

In this example, a warm-green local color is progressively cooled. Lighten the values with white to adjust for depth. Compare this strip of colors with the sunny greens that recede into the distance in *The Haymaker*.

Foreground

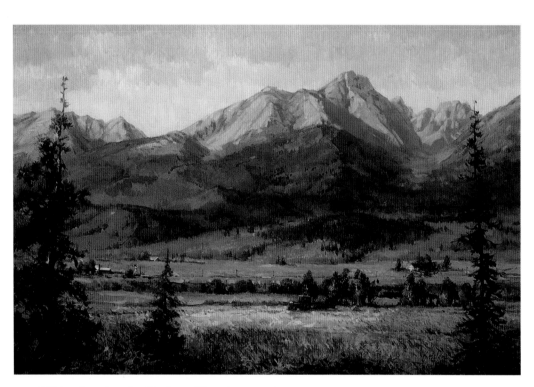

Creating the Illusion of Depth

To capture the crispness of the scene, modify your shadows with cool, neutral hues. For example, since the trees in the immediate foreground are in shadow, they will contain some cooler greens that have been neutralized with complementary reds and even violets. Start painting the sunlight by adding bright, slightly yellowish green colors below the tractor. Modify your greens in the distance by gradually moving from warm to cool hues.

The blue sky was created with a combination of the yellows and blues used to mix the greens in the trees and grass (Cadmium Yellow Medium, Lemon Yellow and Phthalo Blue), with adjustments made according to the colors of the light. Now you can see why it is wise to mix your own greens: They will be perfectly compatible with the yellows and blues in the rest of your painting. Color harmony results instantly.

The Haymaker Oil on linen • 24" × 36" (61cm × 91cm) • Margaret Kessler

Time of Day

Lighting can often convey the approximate time of day. The angle of the sun is the main indication of time of day. Morning light will tend to be cooler since the ground and atmosphere are not yet warmed up. Late afternoon light is warmer as it leads to sunset, which is often very warm and sometimes fiery in its color. Shadow length is another tell-tale feature dictated by the sun. Most plein air landscape painters prefer early morning or later afternoon for a more dramatic light effect.

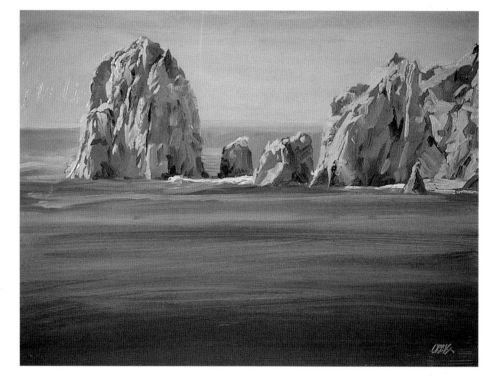

Morning Light

Morning light is cooler than evening light. The atmosphere is still cool and, although the light will be bright, it will not be as warm as light later in the day.

Cabo Morning Oil • 12" × 16" (30cm × 41cm) • Craig Nelson

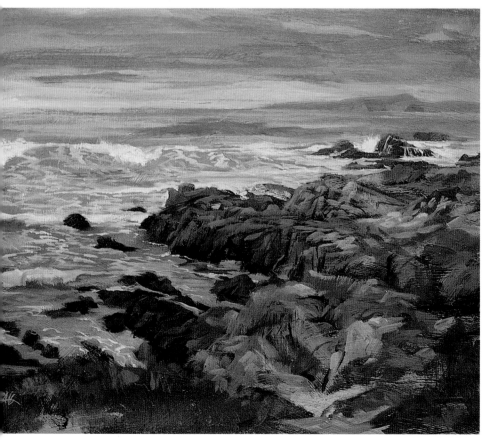

Afternoon Light

Pacific Grove Surf was painted in late afternoon looking west, on what was a gray day. Toward the horizon, a clear sky shows a yellow quality from the lowering sun. The rest of the subject is receiving an overall cool gray light. Light and shadow contrasted in rock forms are minimized. When painting surf, it is advantageous to watch the character of the breaking waves and their rhythm before indicating them as simply as possible. The light, colorful sky accent is added and accentuated at the very end.

Pacific Grove Surf Oil • 16" × 20" (41cm × 51cm) • Craig Nelson

61

Common Color Problems and Solutions

ere are some common color-related problems that many painters face. The next few pages show examples of these problems and suggestions for improvement.

Exact Color or Value Repetition Bores the Eye

The most common problem is the lack of color and value changes in large areas. Drastic changes are not always necessary or called for except within the focal area of a painting. Subtle shifts in value and color work for larger, quieter areas. Large areas containing many repetitive shapes require more extensive color searching.

Poor Sketch

This sketch shows no color or value searching in the sky, field and water. The buildings look fine within the focal area, but the large field stands up like a wall rather than stretching into the distance. Lead the viewer's eye into the focal area from the bottom of the painting, and don't decorate corners, which leads the eye out of a painting.

The sky is the color introduction to the rest of the painting, so its colors need to relate to everything else. If there is no blue in the lower half of the painting, an intense blue sky doesn't work. If there are flowers in the field, paint them first and then add darker colors around them. Avoid tangents, which are created when something ends as it meets the edge or end of something else (for example, when the tops of buildings end on the horizon). These visual tension points trap the eye.

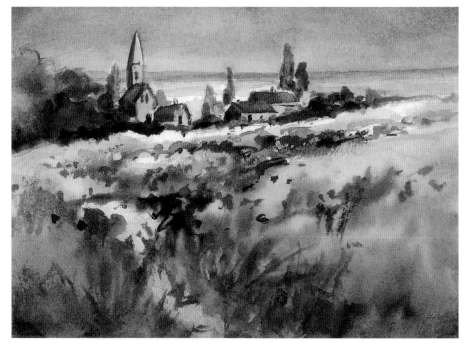

Improved Sketch

With added color and value change, the field now recedes into the distance. The greens in the foreground are quieter than the ones in the back of the field. They progress from cooler midtone values to warmer, lighter and brighter colors and contrasting values, with the most contrast appearing near the buildings in the focal area. Also, the off-center placement of the buildings creates a more exciting focal area.

Plan the big shapes of dark and light first to avoid equal color values throughout the painting. The water now changes from back to front. A higher horizon line, with the water, sky and field all of different-sized shapes, is most pleasing to the eye. The sky is no longer an overall intense blue, but more of a neutral tone that changes from top to bottom, cooler to warmer.

Color Assignments Can Lend an Amateurish Look

Some artists are so interested in drawing the subject correctly that they leave color to be painted from what the mind knows and not from what the eye sees. "Water is blue, tree foliage is light green and dark green and tree trunks are brown," the mind says. But experienced artists know that even if a photo shows general colors, they must be changed to some extent for a painting to become beautiful, and even more if the artist wishes to convey a sense of atmosphere and depth.

Rarely in nature is anything truly one pure color. The appearance of water, for example, changes depending on the light and reflections falling on it, as well as the surface underneath it. For true color harmony, some of each of the colors chosen for your color scheme should be found to a greater or lesser extent throughout your painting.

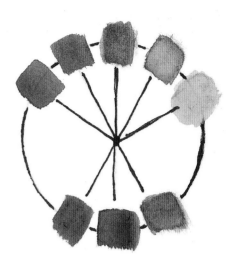

The Color Scheme
These sketches are based on a five-color analogous scheme with green as the dominant color and three subordinate complements.

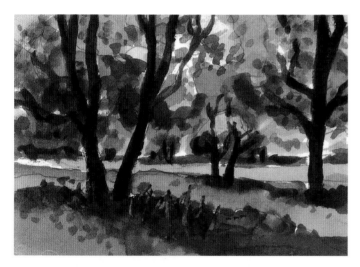

Poor Sketch
Most of the colors in the color scheme are not used. The trees, water, foliage and meadow don't work together to create good color passage, mood and unity. Without holding onto individualized color identity—integrity of plane—the separate planes get lost and become one. There is no focal area; one needs to be created. The trees are varied in size, but they lack grace and movement. Avoid making a tree line up with the edge of your paper and overlapping the branches in places with foliage. Both are distractions.

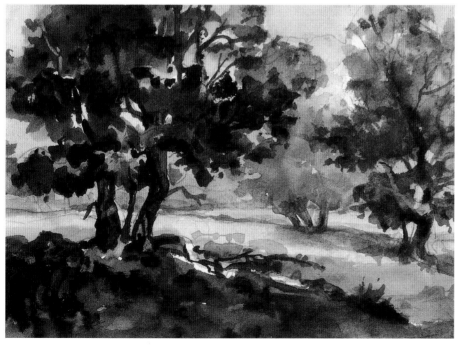

Improved Sketch
This sketch uses all the chosen colors in the scheme. Three separate color planes have been established; the added colors and changing values of the trees, foliage and meadow invite the eye to walk through the painting. To give the illusion of distance with color, each receding plane is slightly grayer, cooler and lighter. Since the water reflects whatever is around it, it too is changed. The focal area (the lower left) is clearly established with the strongest contrast and bright, warm complements. Play with strong dark colors in the foreground shadows if they are in the focal area.

Too Many Intense Colors Give Visual Indigestion

It can sometimes be difficult to use color restraint. However, if every flower in a painting is boldly colored and each tree is screaming for attention, the painting becomes repetitious and uninteresting. Throw some colors into shadow and be selective as you choose which ones will star in the show. Choose the focal area first, and save your boldest colors for that area. The colors in the rest of the painting must all be subordinate.

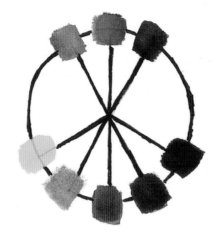

The Color Scheme

These sketches are based on a five-color analogous scheme with orange as the dominant color and three subordinate complements.

 Poor Sketch

If all the analogous colors are equally intense and used against intense complements, the eyes become overwhelmed and find it hard to continue looking at the painting.

Learn to plan quiet places in a painting. Only use the dominant color straight from the tube, and tone down the analogous colors on either side of this color. Always make the focal area the star of the show and avoid turning the spotlight on other areas at the same time. Let the water and sky change from front to back and top to bottom, and watch out for repeats and geometric shapes in the trees.

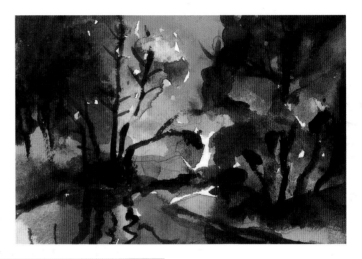

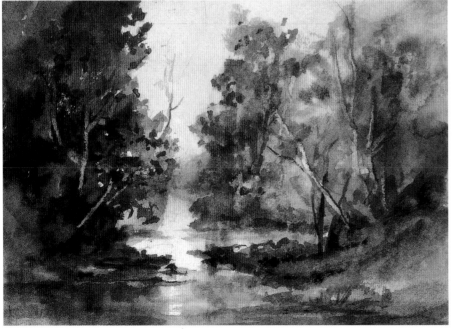

Improved Sketch

To showcase the autumn colors, mingle together several intense colors in a few focal area trees in the lower left instead of making every single tree intense. Leaving the white of the paper for the water nearest to the intense colors makes the focal area even brighter. The quieter complementary colors and cool shadows play against the brighter colors. Always play a variety of light, bright shapes against dark, neutral shapes, not an intense color against another intense color. Use similar but somewhat different colors in the various planes. The sky and water change color and value as they approach the horizon. Keep the water reflections quiet to help support the trees as the most detailed focal area. Scrape out lighter branches and let them change color instead of making them all one color and value.

Summing Up Color

Think about color before you start your painting. Some decisions you should make before you begin are:

- **What color will be dominant?** Sometimes when you squint while you view your subject, a color that seems to pervade everything can make its appearance.
- **Where will you use the dominant color?** Will it be a quieter background color in the larger shapes, or will it become the most intense color in and around the focal area?
- **What color scheme will you use?** If you use an analogous color scheme, how many analogous colors including and surrounding the dominant color will you use? Do you want to use the dominant color with its complement, with its split complement, or within a triadic color scheme? Review all the color schemes and then decide. Most importantly, check to see what colors you will not use intensely.
- **Will the painting be mostly warm or cool?** One temperature should dominate, though both temperatures can and should be used.

After you begin painting, consider these color questions:

- **Is there too much sameness of color in any shape, or is there a need for more color searching?** Do the colors "talk" to each other because of repeated or bounced bits of color between them? See if you have really color searched your dark areas as well as your light areas.
- **Are the colors more intense and contrasting in the focal area than**

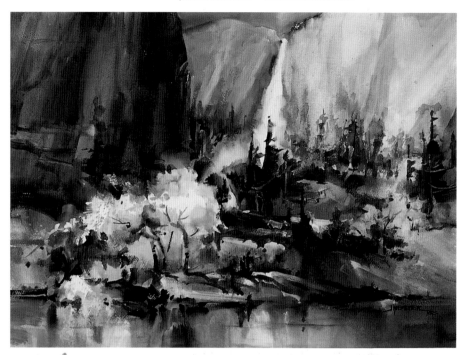

October Transparent watercolor • 21" × 28" (53cm × 71cm) • Jane R. Hofstetter • Collection of the artist

A Split-Complementary Scheme
The cool blue-violets and blue-greens in this scene are a perfect backdrop for the star of the show—the warm oranges of the newly turned autumn trees.

they are around the edges of the painting? Have you left the corners quiet in color and detail? Do any of the colors fight or compete with each other? If so, why?

As you near the end of the painting, ask yourself these questions:

- **Would a few warm or cool grays help play up the intense colors better than their complements?** Shadows are an easy place to add these colorful but not overpowering grays.
- **Are the final colors interesting and a little unusual in some way?** Think memorable color, not predictable or photographic color.
- **Aside from the colors, do the values work?** Use colored cellophane or squint to see if the values are what they should be. Can the eye move easily through the lights and darks of the painting?
- **Does the painting have integrity of plane?** Do the foreground, midground and background all have colors unique to them?
- **Have you successfully avoided "color-assignment syndrome"?** Be sure there are a variety of colors in each object. For instance, tree trunks reflect the other colors that exist around them, as do shadows.
- **Would some additional glazes help?** A glaze of color can connect disparate parts, intensify the focal area or subdue supporting areas.

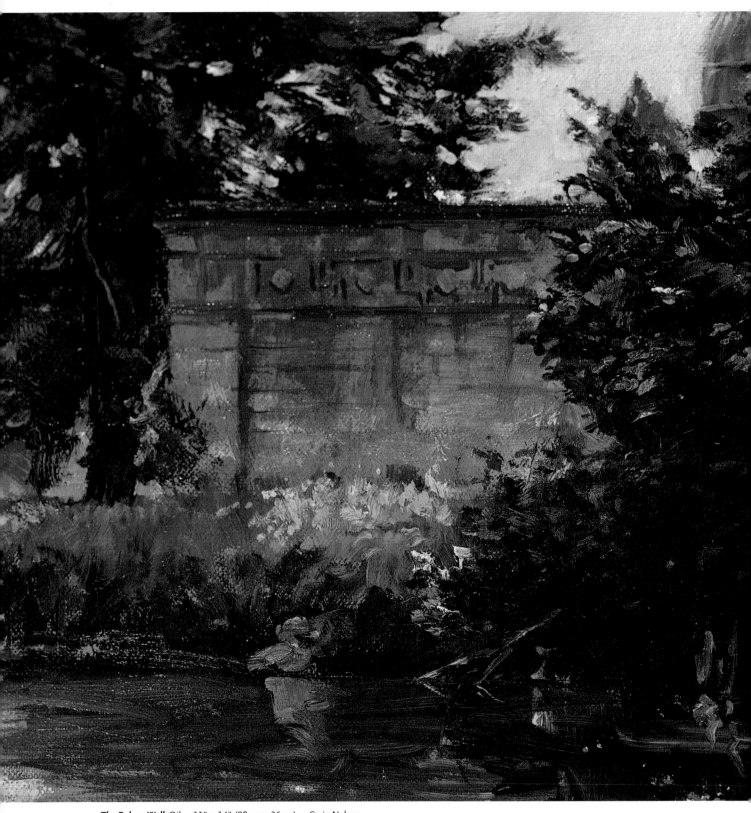

The Palace Wall Oil • 11" × 14" (28cm × 36cm) • Craig Nelson

CHAPTER 3

Composition
& Design

Good composition and design does not happen by chance; rather, they require planning before you paint and focus during the painting process. Learn how to make your paintings work by using the techniques in this chapter.

Center of Interest

The center of interest in every painting is where your eye stops to rest before traveling throughout the rest of the painting and back again to the first spot. There can be more than one center of interest, but we will concentrate on only one per painting. There are three basic ways of creating a center of interest: color, line or a combination of both.

Line as the Center of Interest

Sometimes it's fun to bend the rules and place the center of interest outside the center. The old stone fence points like a dagger to the barn in the upper right. From the barn, your eye travels along the fence row to the pond, back to the stone fence post and back again, always returning to investigate the details in the barn.

Denying Time, Spring Acrylic on gessoed hardboard • 12" × 9" (30cm × 23cm) • Hugh Greer

Color

Color is the dominant element in this sunset painting. This scene shows a different approach to emphasizing the focal area with color. Instead of the focal area containing the brightest colors, these colors surround the focal area. The brilliant, strong gradation of sky colors frames the focal area's quieter colors for a dramatic scene.

Mont-Saint-Michel, Sunset Transparent watercolor • 21" × 28" (53cm × 71cm) • Jane R. Hofstetter • Collection of Glen and Mila Hofstetter

Line and Color Combined

The strong dark colors against the white of the sky and snow help establish the center of interest. This painting is more about line work and composition than it is about subject matter. Without the strong lines, there would be no center of interest. Fence posts and fencing, electric lines and the horizon line all work together to draw your eye to the center of interest.

The Red Gate Acrylic on Crescent illustration board no. 1 • 10" × 16" (25cm × 41cm) • Hugh Greer

Contrasting Values and Complements for a Strong Focal Point

This painting of an overcast day begins with an overall warm gray wash of Cadmium Red Light mixed with Ultramarine Blue. The darkest darks are placed nearest the focal point on the right side of the mountain, and some sunny snow is placed in this area for contrast using white and Cadmium Yellow Medium. To draw more attention to this focal area, yellow-orange touches are juxtaposed against blue-violet ones.

Contrasting various hues of the two complementary colors in both the sky and the landscape provides repetition with variety. Some of the mountain colors are bounced into the foreground and sky, maintaining the blue-violet dominance. A couple of bright yellow-orange shapes against the blue-violet ridges where the sunlight changes to shadow make the painting sing.

Cathedral Lights Oil on linen • 18" × 24" (46cm × 61cm) • Margaret Kessler

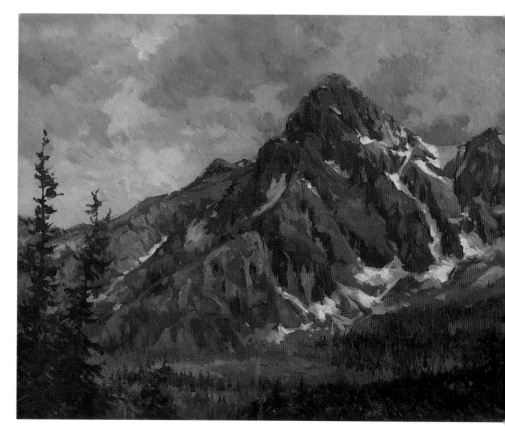

Reference Photos

This narrow Burford street epitomizes the character of the Cotswolds in England, but it was impossible to photograph it in one shot because of the intrusive stone wall. Photographing bits and pieces of it was the only choice. The painting was developed in the studio and was inspired by these photos, which captured the cozy feeling of a narrow Cotswold street.

Focus down the street.

Zoom in on the chimney details.

Capture a sidewalk petunia planter.

Peer around the obstructive stone wall.

Photograph the sunny side of the street, showing cast shadows from unseen trees and a reference for figures.

Focus on the Cotswold street-side landscaping.

Include the whole scene with mostly road.

Photograph the stonework at the end of the street.

First Sketches

Lay out the photos and conceptualize the scene. Make some changes that will improve the composition. Do a few initial sketches and a field sketch to work out compositional and design issues. Initial sketches like these are also a good place to work out difficult areas in your painting before you actually paint it.

■ PROBLEMS WITH THE SECOND VALUE SKETCH

In this case, no field sketch was done on location, so evaluate the second pencil sketch:

- A wide, boring street is a common problem in street scene paintings and is the obvious problem here. Creatively adjusting the street will solve this problem effectively.
- A minor adjustment will place the people in a pleasing position.

First Value Sketch

Replace the straight road with a curved one and include other elements from the various photos. The whole-scene photo shows a long stone wall and little of the houses. Scrunch the houses together by deleting yards of wall, and substitute a short stone wall for the intrusive one. Now the houses and street are visible, but the sunny spots on the stone wall, the area of greatest value contrast, are of little interest. The interesting areas are in the shadows.

Second Value Sketch

Reverse the sunshine to bathe the houses and stone wall in bright sunlight. Cast shadows from unseen trees create a sun-dappled street, adding visual interest to an otherwise boring area. The large sunlit shape grabs the viewer's eye and leads it down this narrow Cotswold street, allowing the viewer to enjoy its unique character and ultimately arrive at the walking figures.

Solve Design Problems and Finalize Your Composition

Once you're happy with your initial sketches, do a few additional sketches to hammer out any remaining design problems and establish your composition. Having the design and composition worked out before you begin painting will allow you to focus more on the acutal job of painting and you won't be tempted to compose during this part of the painting process. Flip to page 122 to complete the painting.

Eye-level line Lighter trees Darker house Directional shape

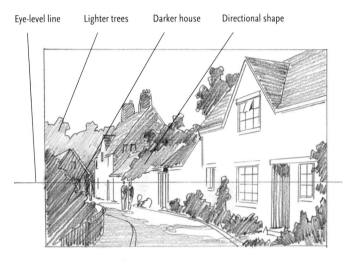

Design Solution: Three Is Not a Crowd
Reduce the number of figures to a pleasing group of three: a single person plus a pair with their heads on the eye-level line. The perspective lines direct the viewer's eye to the lone figure where the planter's foliage serves as a stop.

Vanishing point for the houses Vanishing point for the planter and curve in the road Perspective lines for the road Eye-level line

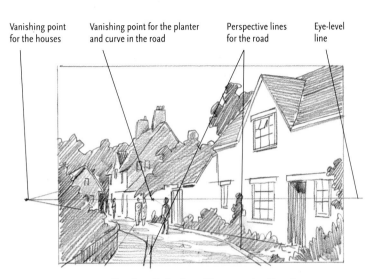

Design Solution: Narrow the Road
Elongate the sketch to fit a half-sheet of watercolor paper by adding on to the right side of the sketch. Redraw the houses in correct perspective using a left vanishing point. When you draw the chimneys and the windows in the distant houses, consider the right vanishing point, which is out of the picture at a considerable distance.

To accurately draw the angled road and the planter, establish a new vanishing point on the eye-level line. Where the road curves away from the house, fill in with shrubbery and flowers.

Final Pencil Drawing
Introduce overhead branches to add an intimate feeling and a logical reason for the cast shadows on the road. Add another tree behind the large house to soften the sharp roof angles.

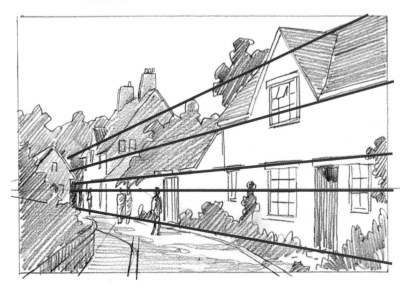

Getting the Perspective Right

Sometimes you will paint a building in one-point perspective, where only one side shows, but more often you will paint in two-point perspective, where two sides are visible. To create buildings that appear convincingly three-dimensional and recede into the distance, remember two easy rules. First, there is only one eye-level in any one picture. Second, all actual parallel lines converge at the same point on the eye-level line, called a vanishing point.

In two-point perspective, buildings are more appealing if their sides are shown unequally. In this situation, applying perspective to details can be tricky, but the details need to be as convincing as the overall perspective of the building they belong to. Use the following tips to make sure your windows, chimneys and other details look correct.

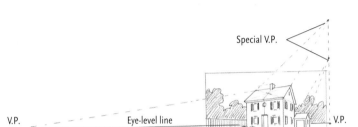

A House in Two-Point Perspective

Draw a house at an angle so both the front and one side are visible. Locate the two vanishing points on the eye-level line far enough apart to avoid distortion. (Distortion occurs when a true right angle is drawn as less than a right angle.) All the horizontal lines of the door, windows, steps, roof and chimney on the front of the house converge at the left vanishing point. The horizontal lines of the windows, chimney, garage and sidewalk on the right side of the house converge at the right vanishing point.

Make the roof by drawing an arbitrary pitch line upward until it reaches a point exactly above the right vanishing point. This new point is a special vanishing point to which the other roof pitch line extends. The pitch lines for the garage roof also have their own special vanishing point. To center the chimney on the roof, draw diagonals across the roof plane and draw a line through the center toward the special vanishing point. Place the chimney at this point.

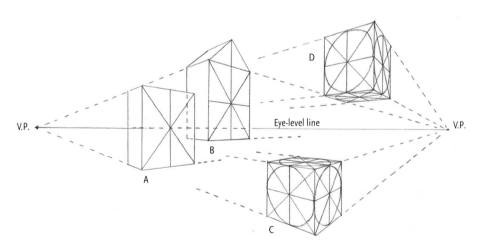

Drawing the Details

To find the centers of windows, doors or any other rectangular plane, first find the center of rectangle **A** by drawing diagonals from the corners. The center is where the diagonals cross; draw a vertical line through this point. To form a gable (**B**), extend the rectangle's centerline vertically to an arbitrary point, then join that point to the top two points of the rectangle.

For circular structures or details such as wheels, silos and pipes, make circles on the side of cubes **C** and **D** by first drawing the diagonals. Then draw vertical and horizontal lines through this intersection. On the cubes' top and bottom planes, draw through the center points to both vanishing points. These lines bisect the outside lines of the plane, creating four points. Connect these points by drawing an ellipse (a perfect oval touching only those four points). For arches in windows and bridges, construct the circle and then use only the top half of it.

Trial Before a Larger Finished Painting

Almost all painters have used studies as a quick indication of what they might want their larger finished pieces to look like. The study shows your first concept of the image on canvas. And it is in the study that you may realize you wish to change something to see if it works to your satisfaction before proceeding to the more time-consuming finished painting. You may wish to try a couple of viewpoints, subtract or move something or decide if it is worthy of doing a completed version.

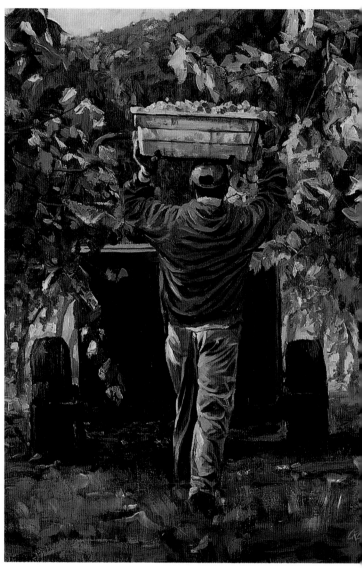

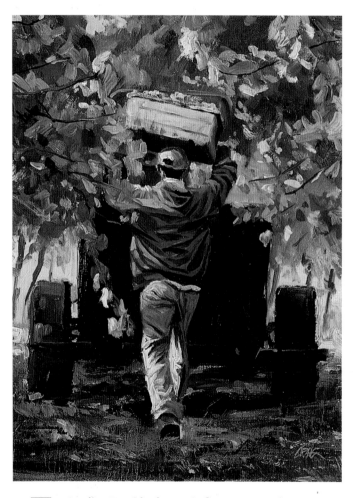

Studies Provide the Basis for Larger Work

This study was developed from many reference photos of the workers harvesting. These photographs have been the inspiration for many studies and larger finished paintings. The colorful abstraction of the grape leaves are a wonderful setting for a figure. Like a great dance performance, they move swiftly and with the utmost efficiency. It has been a joy to paint the many studies and extremely exciting to attempt to convey all of this in a larger work.

Top Load Study Oil • 14" × 11" (36cm × 28cm) • Craig Nelson

Refine Your Finished Paintings

Keep the basic color and attitude of the study but uncover the figure so both hands show gripping the large bin. Also notice that both feet show in the finished painting, giving him a more secure base. Other than this, it is a matter of developing a richer and more layered look in the grapevines and carrying the refinement further.

Top Load Oil • 24" × 18" (61cm × 46cm) • Craig Nelson

Recognizing Weak Design

It's easy to recognize a poor design because chaos prevails. Just like stepping into a cluttered house, you won't feel a sense of planned order—you'll just notice a lived-in look. You'll find haphazard lights and darks, warms and cools, and brights and dulls scattered about like toys, books and clothes.

A good design has a sense of visual order. It brings many different elements together and is able to organize them into a unified whole.

Consider *Seaside Excitement,* a painting that has potential but doesn't quite measure up because it has some design problems. Beautiful colors and fancy brushwork will not save a poor design.

A Closer Look at a Problematic Design

The basic composition—an off-center pyramid on a squarish canvas—forms a solid design structure, but it is not executed well. The design in the water—lights and darks linked together in the lower-left corner—gracefully leads your eye into the painting. The crashing wave on the right guides you up the side of the island, and your eye naturally slides back down the left side. It continues moving from left to right along the front edge of the island, but then the lack of a strong focal point leaves you wandering aimlessly.

A harmonious color scheme is not evident, and the painting lacks a dominant temperature (it looks half warm, half cool). A stronger complementary color scheme of Ultramarine Blue and Yellow Ochre, with one color obviously dominant, would be more interesting. Make the cool color dominate by reflecting the cool water and sky colors onto the island rocks.

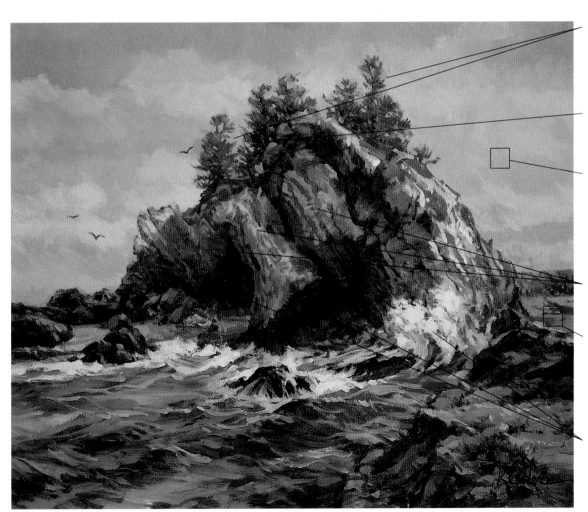

All trees are on the far side of the island. Lower the base of the far-left tree and eliminate the two trees on the right for more interest.

These three trees are too similar. Lighten and cool the center tree to move it back in space.

Value changes in the sky are too similar. For contrast, use broken colors and loose brushwork to darken the blue of the sky. Add a few highlights to the clouds.

Same-width shapes are boring. Redesign using repetition with variety.

Perspective problems make the distant water look as if it is below a dam. Redesign or replace the distant water and beach with foreground rock formations.

Three focal points compete for attention. Select one and use contrasting elements to emphasize it while de-emphasizing the others. Avoid contrast at dead center.

Seaside Excitement Oil on linen • 20" × 24" (51cm × 61cm) • Margaret Kessler

75

The Elements and Principles of Design

You are already familiar with many of the elements of design—shape, value, size, color, direction, line and texture. They are the building blocks of your painting. Your ability to organize the elements in an eye-pleasing way instead of a haphazard manner is governed by the principles of design—unity, conflict, dominance, repetition with variety, movement with gradation and balance. Without considering these principles, the attractive elements in your painting might not work well together to express your intended statement.

Let's review the elements of design and take a closer look at the six principles.

Corner of Charles and Cathedral Watercolor • 12½" × 17½" (32cm × 45cm) • Barbara Nuss

Turning Gray Into Sunshine
The "U" shape effectively frames the sunlit area on this autumn day. The streak of sunlight brings the viewer's eye into the painting, and the shadow shape on the sunlit fence forms an arrow thrusting the eye back toward the house where the flower box adds a bright color accent. Scattered fallen leaves contribute to the feeling of the day. The wet-in-wet sky illustrates the typical changing weather patterns. The birds add a vital spark of life to the painting.

The Elements
Consider the elements of design the ingredients of your painting:
- **Shape.** Make them irregular, and avoid boring, perfect geometric shapes.
- **Value.** Use the darkest and lightest values in the focal area and less contrast in the large areas.
- **Size.** Have a variety of big, medium and small shapes.
- **Color.** Don't go more than an inch or two (3cm to 5cm) without some change. Never exactly repeat the same colors.
- **Direction.** The emphasis can be horizontal, vertical, curved or diagonal.
- **Line.** Practice using a variety of lines and edges: thick to thin, broken to solid, lost to found.
- **Texture.** Use it sparingly and irregularly, and merely suggest texture instead of overdoing it.

The Principles
The principles of design are like the recipes you use to combine the ingredients, the elements of design.
- **Unity.** Make all parts of the painting speak the same language for a quality of oneness. Try to have one part introduce the next as the eye moves through the painting. Just remember that unity or sameness can be boring without some conflict or variety.
- **Conflict.** Create a little tension and excitement with opposites— strong contrasts of value, color, direction and so on. However, be careful not to overdo it!
- **Dominance.** Avoid fifty-fifty divisions. Know which element or elements should dominate, and push it! But remember, the stronger you push, the stronger the mood.
- **Repetition with variety.** The eye can instantly spot duplicates and become bored. However, repeats and rhythms are delightful in a painting if they are not exactly the same. All of the elements can be repeated endlessly with variety.
- **Movement with gradation.** Direct the eye comfortably through the painting with any of the seven elements, using gradation to enliven the passages and add depth. Know where the focal area is before you make decisions on how to move the eye.
- **Balance.** Imbalance is uncomfortable, so trust your feelings when evaluating the balance in a painting. Formal or symmetrical balance can be boring, but informal or asymmetrical balance is visually pleasing. View your painting upside down or in a mirror to check for good balance.

Applying the Elements

Let's see how each element of design can be applied for the best results. Notice that it's nearly impossible to talk about one element without mentioning another or to mention proper use of an element without a principle coming into play. This demonstrates how naturally these elements and principles can work together once we understand how to use them.

Shape

Shape is one of the first eye-catchers in a painting. It's important to have a variety of dark and light shapes and avoid boring geometric shapes. It is also important to let the shapes introduce each other and speak the same language. This shows up most often in the edges of a shape as well as the related colors and textures. Lastly, the negative or background shapes in a painting should be as exciting as the positive shapes. Variety is the key to handsome shapes.

Value

The dark and light values in a painting can attract or deter viewers. They might hurry from across a room to get a better look if the values are varied, well placed and dramatic. They can lose interest if the painting seems to use only one value.

First choose the dominant value: light or dark. Then arrange your light and dark shapes into connected overall shapes that lead the eye to the focal area, which should contain the greatest amount of value contrast. Use gradation within the various value shapes to keep them interesting.

Shape

Here the dark geometric shapes of the trees are contrasted effectively against a light background. The outer edges of the trees are painted with loose brushstrokes to indicate the shaggy bark texture, and touches of the colors you see in the snow are reflected onto the tree trunks. Now look at the cone-shaped, young pine tree on the far right in the foreground. You can create a sense of volume here, too, by simply modifying the principles used to create a cylinder.

Drama of Light Oil on linen • 18" × 24" (46cm × 61cm) • Margaret Kessler

Value

This painting's emphasis is on value and texture, while color plays a minimal role. The light values dominate the darks.

Frozen Cascade Watercolor and graphic white • 21" × 28" (53cm × 71cm) • Jane R. Hofstetter • Collection of the artist

Size

To look interesting, the parts of the painting must vary in size. The eye will quickly spot any exact duplicates. Size relates to all the elements in the painting. Texture, color, line and so on must vary in quantity and arrangement, so as to never repeat exactly. Usually the larger, simpler pieces join up with the outside edges; the smaller, more irregular ones are within the focal area.

The largest size or quantity of an element determines the dominance of a painting. Select in advance the element or elements you wish to fulfill this role. Elements that are not dominant should be played down.

Color

Color is very personal, as we all see and feel it differently. If you choose color to be the dominant element in a painting, predetermine the color scheme, then develop great amounts of color change and gradation as you paint. Be sure to get the values of the color correct. Practice mixing and matching colors. Think about using cools or grayed colors to play against the brightest ones. Make the most exciting color statement in the focal area.

Size

Size plays a large role in establishing the scale and depth within this painting. The tiny cars travelling across (and the small boats sailing underneath) the bridge lend a massive feel to it, though the structures of the bridge appropriately diminish in size in the distance. The variation of size within the foreground rocks and foliage keeps this area from being boring.

Golden Gate Transparent watercolor • 29" × 21" (74cm × 53cm) • Jane R. Hofstetter • Private collection

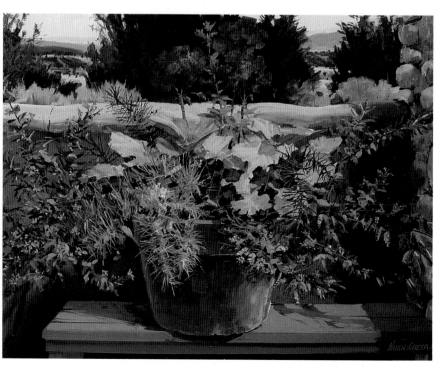

Color As the Center of Interest
Strong color attracts your eye and serves as a focal point. The bright red flower of the geranium draws your eye into the painting.

Southwest Geranium Acrylic on gessoed hardboard • 12" × 16" (30cm × 41cm) • Hugh Greer

Direction

There are four directional movements possible in a painting: horizontal, vertical, circular or curvilinear and diagonal or oblique. A well-designed painting is dominated by only one of these. The other directions can be used to a lesser extent, but it is best to select the dominant direction as you plan the dark and light shapes in the preliminary thumbnail and stay with it.

Line

This element is the oldest known form of art. The lines found in ancient cave art are among the most beautiful and expressive. Lines should follow the dominance of direction and constantly change so as not to become redundant. As you add lines to your painting, think broken to solid, uniform to irregular, thick to thin, dark to light, soft to hard and warm to cool; doing this will give you an eye-pleasing dominant group of lines.

Lines can border shapes or be beautiful calligraphic expressions of texture or writing in a painting. Be careful not to overdo your line work, however, as it can make a painting look cluttered and busy without some simple areas of rest.

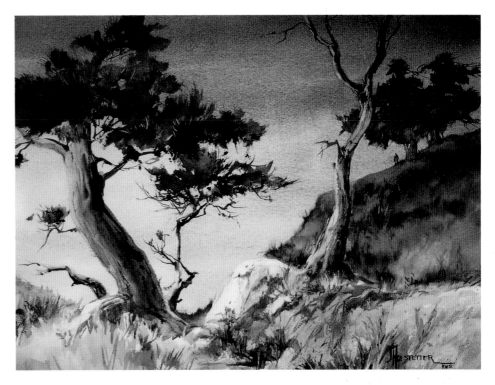

Direction
Strong diagonal lines and shapes are used to direct the eye to the focal area (lower left).

High Horizons Transparent watercolor • 21" × 28" (53cm × 71cm) • Jane R. Hofstetter • Private collection

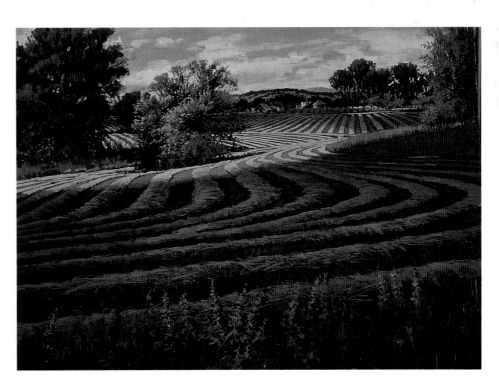

Line
This is a freshly mowed field, and the patterns of cut hay lead your eye to the center of interest that is highlighted by the sun on the golden tree. Even the flowers in the foreground point to the center of interest.

Patterns of Summer Acrylic on gessoed hardboard • 18" × 24" (46cm × 61cm) • Hugh Greer

Texture

Of the seven elements, texture is perhaps the least important. It is, however, useful in describing a surface as well as enriching and increasing its weight. Texture is used most often in the focal area to give further description and importance to that part of the painting.

Amateur artists often wish to paint every leaf on a tree because they see all the leaves. Advanced artists use the fewest leaves they can to describe the silhouette of the tree. Too much texture makes a painting superficially decorated instead of well designed.

Many good paintings have been ruined because of a painter's need to tickle the subject to death with small brushstrokes. Texture is best used in various-sized sections and irregularly, usually to enrich a large bland area. I have found that texture most successfully enriches a painting when the color is very muted. Andrew Wyeth is a master of this.

Texture

In this painting, the existing textures are kept to a minimum to allow the color and magic of a summer day to shine forth. Notice how the eye can move toward and away from the light figure without getting stuck in a bull's-eye situation. Texture keeps the focus within the painting and away from the edges and corners.

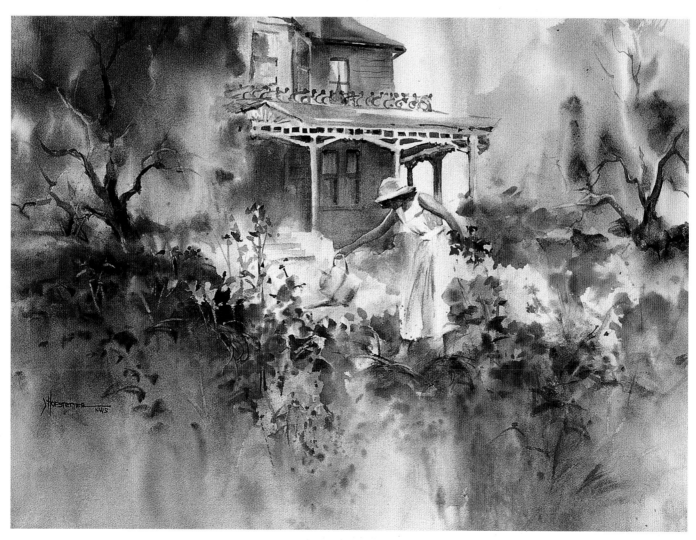

July Garden Transparent watercolor • 21" × 28" (53cm × 71cm) •
Jane R. Hofstetter • Private collection

Exercising the Principles

Exciting design shows only the best parts of a scene or subject with interesting variety, rhythm and stunning poetry woven throughout rather than showing the subject only as a camera could report it. Exciting design happens when artists learn and interpret the principles of design and apply them to the elements in their paintings. Let's study how this can occur.

Conflict

Two opposing versions of an element provide conflict: a soft, straight horizontal edge against a hard, jagged diagonal one; a strong orange against a blue-gray; a large light shape against a smaller dark one. Conflict prevents boredom. How much conflict is necessary? A field of poppies probably needs some conflict to hold the viewer's attention. Do you add an interesting tree, a few figures? To decide, ask yourself why you wish to paint the field. How can you make the mood stronger without destroying your main idea? Where do you want the focal area to be, and how can you increase the drama there?

Unity

Unity is the most important of all the design principles because it takes just a glance to see if everything in a painting is working together. All of the strongly emphasized elements must be echoed but always a little differently. For example, a painting that has tones of blue on only one side is not unified. While the artist's technique—such as a calligraphic style or a pointillist brushstroke—can bring everything together, unity usually is due to a certain feeling generated by the concept behind the painting that pervades each shape and detail. You may need to preselect whatever you will strengthen or emphasize in the painting and then stay with these ideas throughout the painting's development.

Conflict

To depict the "walking thunder," it's important to create great drama and contrast between the stormy sky and the land. Set up a cool sky against the warm land with soft, curved clouds playing against the hard, angular shapes of the buttes.

Walking Thunder Transparent watercolor • 21" × 29" (53cm × 74cm) • Jane R. Hofstetter • Private collection

Unity

Here the main goal was to make the house "gingerbread," the flowers and the foliage speak the same language. To help accomplish this, bounce similar warms and cools in the shadows.

Gingerbread and Hollyhocks Transparent watercolor • 21" × 28" (53cm × 71cm) • Jane R. Hofstetter • Private collection

Dominance

Dominance is key to the success of any painting. Total equality in a painting equals total visual frustration. The eye will not linger where there is no order or hierarchy, only chaos. Most paintings can succeed with two or three dominant elements. Decide first which elements you wish to emphasize and where. Then make them do one or more of the following:

- Show the greatest amount of contrast.
- Be the largest element or cover the most area.
- Repeat a lot with subtle changes each time.
- Be the strongest color or the brightest.

Repetition With Variety

Repetition is a way to connect the various parts of a painting, bringing a sense of unity to the composition. Each repeat must differ enough from the others so the repetition is not too predictable. Choose two to four elements to repeat throughout the painting. Then test your imagination and make these repeats only similar. Repetition without exact duplication gives beautiful rhythm to your work and can echo the motif of the painting in various ways.

Movement With Gradation

The eye usually enters a painting at the bottom or from a side. It moves along the lights if the painting contains mostly dark values and along the darks if light values dominate. The eye then moves around the painting until it comes to the focal area,

Dominance

The curved shapes in this painting dominate the horizontal and vertical shapes in the background. The cools dominate the warms, but notice how all the colors bounce into each other a little for variety. See how the warm ground color bounces off of the pigs' bellies?

Piggy Backs Transparent watercolor • 21" × 28" (53cm × 71cm) • Jane R. Hofstetter • Private collection

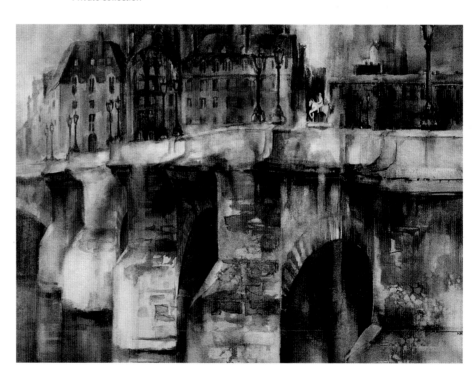

Repetition With Variety

In this painting the size, texture, color temperature and direction are repeated. Each of the repeated vertical bridge spans is a different width. Different eras of civilization added various-sized rocks to the bridge, which provided various repeated textures to choose from. The color consists of repeats of warm against cool. Lastly, the direction is a strong horizontal going back in space, with varied repeats in the verticals of the buildings bringing us to the focal area at the upper right.

Paris, Le Pont Neuf Transparent watercolor • 21" × 28" (53cm × 71cm) • Jane R. Hofstetter • Courtesy of Christopher Queen Galleries

where it stops to enjoy this most exciting part. It will return again and again to this area via the visual path the artist has provided.

Gradation is one way to guide the eye around a painting. Gradual change from large to small, dark to light, warm to cool, thick to thin, hard edges to soft edges will carry the eye through the painting on the path you set.

Balance

Balance happens when forces that oppose each other are equal. In painting, formal balance involves using equal divisions of space and equal amounts of shapes. This can be predictable and boring, so many artists prefer informal balance. Think of a seesaw: The heaviest weight on one side must be near the center to balance the lighter weight on the opposite end. One way to achieve informal balance is by placing a big, light shape opposite a small, dark shape.

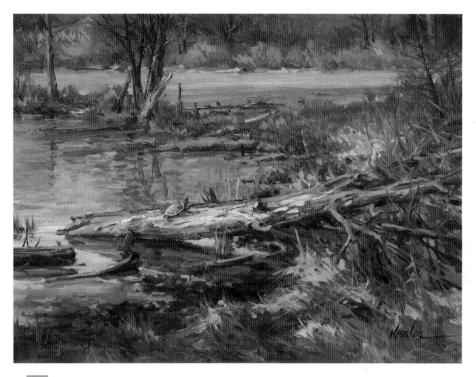

Movement
Contrast light and dark to create subtle linear movement in your painting. To enhance perspective, diagonal lines in the foreground give way to horizontal lines in the distance. Animals and people attract attention, so don't place them in the center or near the edges of your canvas.

Turtle Log Oil on linen • 18" × 24" (46cm × 61cm) • Margaret Kessler

Balance
The building's off-center location and the placement of the focal area in the upper right maintain the balance of the piece. Most paintings use this kind of informal balance.

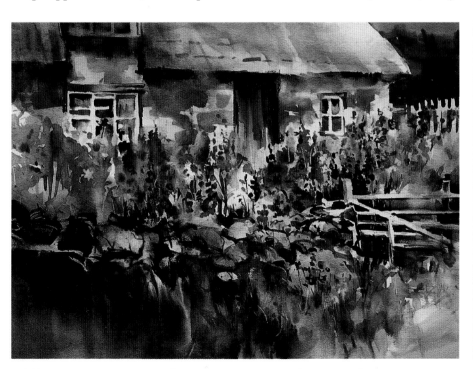

Yorkshire Cottage Transparent watercolor • 21" × 29" (53cm × 74cm) • Jane R. Hofstetter •
Collection of Lee and Diane Brandenburg

■ FIXING IMBALANCES

If you feel an imbalance in your painting but can't put your finger on it, look at it with a different perspective by viewing your work upside down or in a hand mirror. Add weight to an area by trying some of the following solutions:

- Darken the area.
- Create more value contrast within the area.
- Add more intense color to the area.
- Add irregular pattern or detail to the area.

Whatever you decide, be sure the weight you add does not overpower the painting or detract from the focal area (if the area you are adding the weight to is not within the focal area).

Planning Ahead

Planning your compositions can reduce the number of problems you face while painting. Basic design mistakes, such as balance problems created in the early stages of the painting process, can't always be solved later. It's well worth it, then, to do some preliminary planning.

■ LIST YOUR PAINTING GOALS

With so many decisions to make, you may want to write your goals down so you don't get off track during the painting process.

1. Identify the emotional theme: joyful, romantic or somber.

2. Locate your light: its source and intensity.

3. Pick your format: canvas shape and size.

4. Select a value theme: predominantly light or dark.

5. Plan the color temperature: predominantly warm or cold.

6. Plan the color intensity: predominantly bright or dull.

7. Choose a dominant color.

8. Select a color scheme: complementary, analogous, etc.

9. Sketch the composition: a small three-value sketch (black, white, gray) done to scale. Check the balance and aesthetic appeal of the design.

10. Divide the space: predominantly landscape or skyscape, or a closeup of an object.

11. Choose whether to emphasize the foreground, midground or background.

12. Locate the main focal point: off center, but not near the edges or corners.

13. Plan a path: the direction for eye movement through the painting to the focal point.

14. Dramatize important areas; de-emphasize or eliminate distractions.

Choose a Color Scheme

Dominance of one color is a key to unity, so select that dominant color wisely, balancing it with its complement and optional discords. Here the sunny Yellow Ochre of the rocks is the dominant color. A blue-violet (Ultramarine Blue) is the complement, a great color for the flowers.

Working With Reference Materials

If you're working from photos rather than on location, there is no hurry, as the light is not going to change. Study your source material and select a canvas shape and size that supports the mood you wish to convey. Consider the general implications of each format: Vertical suggests power, horizontal is more relaxing and square suggests stability.

Ensure Contrast

Simplify your full-value sketch into its most basic statement, a two-value study. This will help you prevent half-and-half problems: half light/half dark, half vegetation/half rocks, and so on. Group light (or dark) objects and link them together so your pattern rhythmically flows across your canvas.

Develop a Composition

Draw several small sketches, exploring different compositional possibilities. Look for opportunities to contrast values, colors, lines, sizes and shapes, emphasizing contrasting elements near your center of interest. Create patterns and directional movement. This boxy shape stabilizes the explosive nature of springtime.

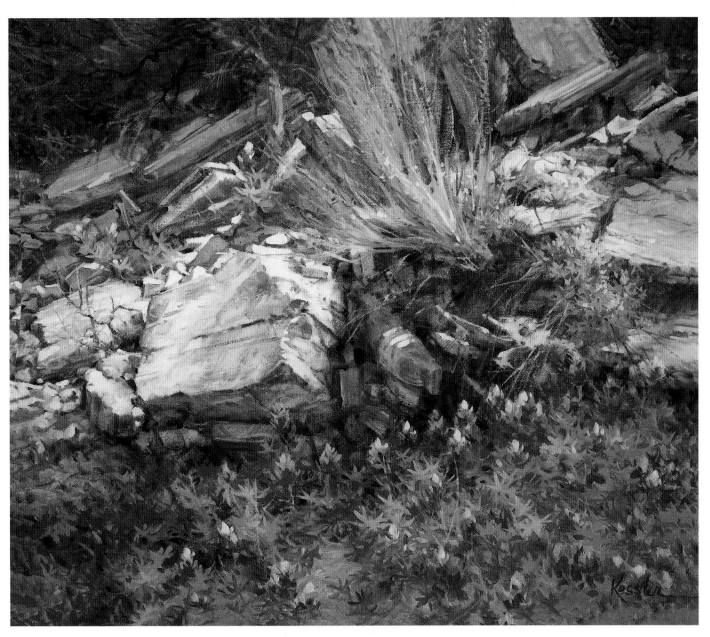

A Well-Executed Design

Annual Celebration is bright and explosive—a reward for planning ahead. Starting at the lower left, the spiraling movement in the composition leads you through the painting. The yellows in the outer ring of the spiral guide you to the complementary bluebonnets, which burst open in the area to the right of center.

Repetition with variety helps pull this painting together. The rock colors repeat in the foreground sand; sunny flowers are juxtaposed with shaded ones; and the fracture lines in the rocks are repeated elsewhere in the lines of the sticks, roots and blades of grass. These lines direct the viewer to the heart of the painting.

Annual Celebration Oil on linen • 20" × 24" (51cm × 61cm) • Margaret Kessler

Choosing a Compositional Formula

Have you ever gone out to paint a landscape and been overwhelmed by everything? You see a terrific tree but have no clue as to where to place it in your painting.

These classic fourteen composition formulas are guidelines for organizing and arranging the major and minor pieces of a landscape. Rather than being confounded by a complex scene, you can confidently move or add a tree, change the horizon or even move a mountain. Knowing and understanding these formulas will help you arrange elements for strong, effective, interesting and thereby successful paintings.

Decide which compositional formula best suits your purpose. See how close your inspiration is to one of the formulas and proceed from there. Rearrange and modify elements as necessary to make a formula work.

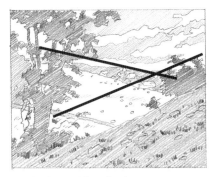

Use the **diagonal formula** when you want to emphasize strong slanting lines, such as a mountain or cliff balanced by an opposing diagonal shape.

Confirm Your Plan Before You Paint

A successful landscape painting develops in these two main stages: (1) the field sketch to capture the essence of the scene, and (2) the final painting that incorporates the changes made along the way.

You are now ready to begin your final painting. You have a color field sketch and your reference photos. Improve your field sketch and fine-tune troubling areas. Lay tracing paper over your field sketch and move things around until you are satisfied.

Design an entry into and an exit from your painting. For people whose languages read from left to right, it is more comfortable for the painting to "read" the same way: with the entry on the left and the exit on the right. For people whose languages read the other way, the opposite is true.

Plan each of the four corners to be different, even if it is only subtle. As necessary, add a "stop," a design element that stops the viewer's eye from continuing in one direction and points it in another direction.

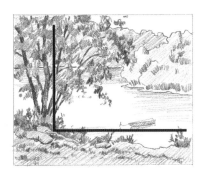

Use the **"L" formula** when you have a tree or building on the left with a shadow area in the foreground.

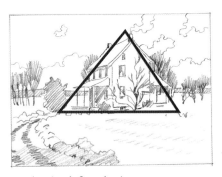

Use the **triangle formula** when you want to arrange elements into a classic, formal composition.

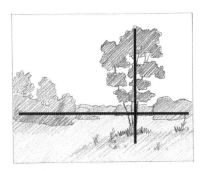

Use the **cross formula** when you have a strong narrow vertical across a strong horizontal landscape.

Use the **"S" formula** when you have a road or stream weaving through a scene.

Use the **pattern formula** when you have an expansive vista with no discernible focal point.

Use the **tic-tac-toe formula** when you need to find the most effective spot for a special center of interest.

Use the **three-spot formula** when you need to organize repeating shapes.

Use the **steelyard formula** when you have a large element and a second similar, smaller element.

Use the **"O" formula** when you have a center of interest encircled by dark elements, such as overhanging trees.

Use the **radiating lines formula** when you have numerous lines radiating from a common vanishing point.

Use the **overlapping shapes formula** to artistically arrange shapes in a short depth of field.

Use the **"U" formula** when you have buildings or trees that frame each side of the painting and connect at the bottom with a strong shadow pattern or other dark area.

Use the **balance scale formula** when you have a dominant center of interest with similar masses and shapes somewhat equally on both sides.

Involved Landscape Scenes

When combining fields, trees, hills and architecture, you must employ various effects as well as create a pleasing composition when setting up the design. It is very important to be aware of all of the various elements in a scenic composition and understand their differences and individual characteristics.

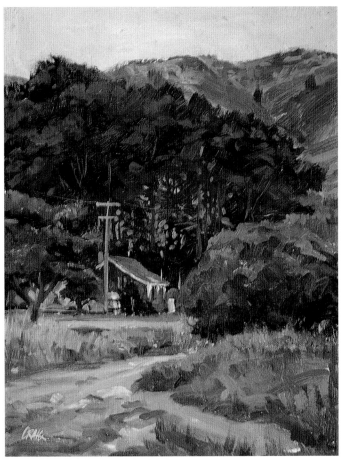

Keep Your Thinking Organized

It is crucial in a complex landscape painting to keep your thinking organized. Begin from the background working toward the foreground. In this painting the focal point is the house in the midground. The background hills should be painted with cool pale tones to keep them receding into the background. The foreground has the most color but is painted more loosely and abstractly. The road leads to the focal point, which is framed by the grove of trees behind and trees to the right and left. Finally, some small, firm controlling strokes finish up the house.

Leaving Muir Beach Oil • 14" × 11" (36cm × 28cm) • Craig Nelson

A Bold Landscape

Atmospheric conditions are often an integral part of landscape painting. Fog and mist are effects that may be crucial to depict a given scene. It is great practice to paint in various weather conditions, not only on beautiful sunny days. As the fog here begins to lift, it reveals much of the landscape in sunlight showing greater contrast and stronger color.

The Fog Leaves Tomales Oil • 12" × 18" (30cm × 46cm) • Craig Nelson

Evaluating Possibilities

In landscape painting the possibilities are endless. Lighting, subject matter and composition are the ingredients that each painter must evaluate and respond to. The following three locations are within a few miles of each other and were all possible studies for finished paintings.

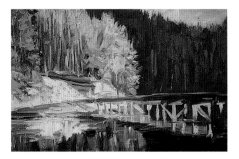

First Study

Dramatic afternoon light and shadow and a rustic bridge were inspirational for choosing this subject. A quick, bold study captured the feeling.

Bridge Across the Snake Oil • 7" × 11" (18cm × 28cm) • Craig Nelson

Second Study

Reflections, foreground shadow color and atmospheric detail in the midground and background were the motivation for this study. The small size allowed for this to be completed quickly.

Near Oxbow Bend Oil • 5" × 8" (13cm × 20cm) • Craig Nelson

Third Study

Mood and composition were the primary factors in this study. The early, even glow from the sun accented the simplicity of the mountains, while the shadowy foreground demands more detail.

Evening at Grand Teton Oil • 7" × 11" (18cm × 28cm) • Craig Nelson

Final

Any one of the previous studies would most likely make an interesting finished painting. The choice here was made based on a new challenge. The close value of the background trees and shadows, and the rich cool greens in the foreground foliage combines with the near abstract reflections to create a provocative harmony in the painting.

At some point, it is possible that the other two studies may be developed into larger finished works. This is one advantage of having several studies to choose from and continually evaluate.

Shadows and Reflections Oil • 18" × 24" (46cm × 61cm) • Craig Nelson

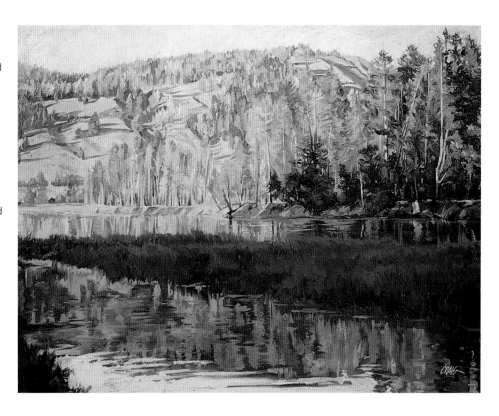

Painting Negative Space

Painting negative space allows you to paint your subject in a luminous fashion and cut out the shapes with opaque paint. Some magical things happen when you paint this way. You can discover this for yourself. Almost all paintings have negative space in them.

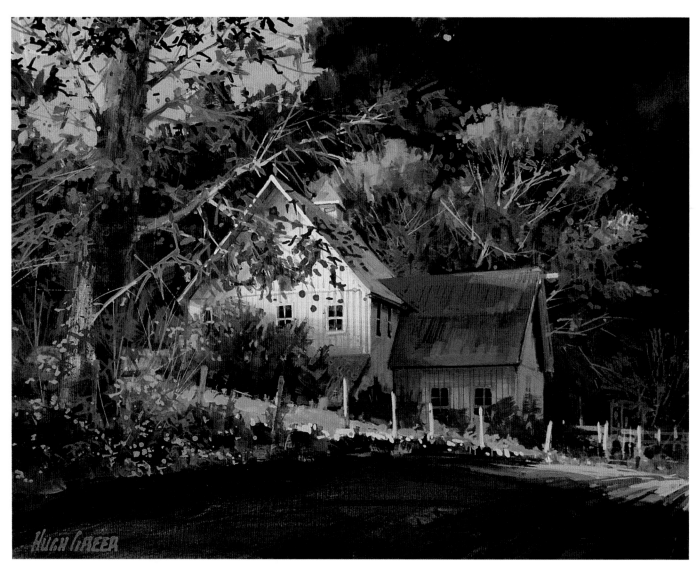

Painting the Negative "Back and Forth"
The tree behind the barn was painted with a transparent technique and then the hill behind it was painted, cutting in the shapes of the tree and barn. Forward for more detail to the tree, then back again to the hill and barn; thus, the back-and-forth or negative space technique.

Lilac Bush and Atchison Barn Acrylic on gessoed hardboard • 8" × 10" (20cm × 25cm) • Hugh Greer

Painting "Dark" Negative Space

The center of interest in this painting is the light green tree in the midground and flowers in the light underneath the green tree. The dark negative spaces are everywhere. Without them, the center of interest would not appear to be so bright.

Painting "Light" Negative Space

This is a high-contrast painting using both ends of the value scale: no. 5 in the foreground and no. 1 in the background. The viewer is standing in the shadows of the trees looking out to an open field filled with morning light. The light background is washed in first and the trees are painted over that, allowing the light to sneak past the breaks between the trees. The light punches in negative space "holes" in the mass of trees.

Shortcut Acrylic on Crescent illustration board no. 1 • 12" × 9" (30cm × 23cm) • Hugh Greer

Putting Principles Into Practice

Besides atmospheric perspective, you can use color and value to add impact to a painting's lighting, enhance the movement in a painting, add a secondary point of interest or lead the viewer's eye through a painting.

Establish the Range of Values First

Although the overall color of this painting is warm, the hues still range from warm to cool. Because of the low sunlight, the background shadows are cooler and lighter than the midground and foreground. After blocking in the cow moose, the cottontails are added in the foreground to establish the range of values.

Lady of the Mist Oil on canvas • 12" × 24" (30cm × 61cm) • John Seerey-Lester

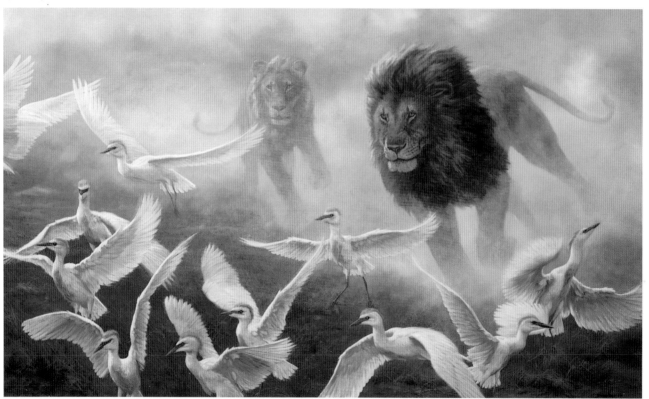

A Wider Range Indicates Greater Depth

Not only does this painting provide an extreme example of receding values and hues, you can exaggerate this effect by applying plenty of detail in the foreground and practically none in the background. This gives the impression of greater depth and distance, which adds to the lion's speed.

Sudden Rush—Cattle Egrets With African Lions Oil on canvas • 36" × 60" (91cm × 152cm) • John Seerey-Lester

Natural Passage

Passage is easily found in waterfalls or in white water rushing down creeks or over ocean rocks. Just go with the flow and create strong, various-sized, light water shapes to carry the eye over the dark, wet rock shapes.

Sierra Cascade Transparent watercolor • 29" × 20" (74cm × 51cm) • Jane R. Hofstetter • Private collection

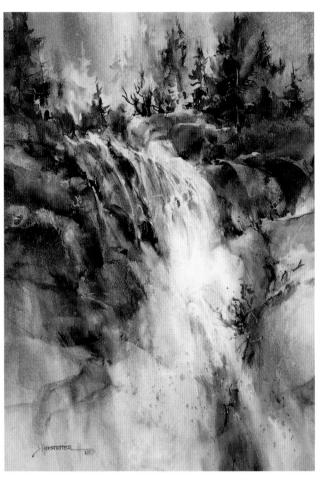

Add a Secondary Point of Interest

Although the wolf is the main subject, it is pushed back behind the snow-laden branches. Sometimes you'll need to introduce something new or unexpected to create more interest. An interesting light source or a color not used elsewhere in the painting often works well. This basically monochromatic painting needed an extra spark of interest. By adding the rising sunlight to just the one area, you can make it the focal point so the viewer will "discover" the wolf next. This way you'll give the viewer more interesting things to see without overcrowding the painting.

Dawn's Early Light Acrylic on canvas • 60" × 48" (152cm × 122cm) • John Seerey-Lester

Painting Weather

When you add elements of weather, such as rain and shadow, don't just add them as part of the environment; use them in the composition. You also can use weather elements to affect the mood of a painting.

Add to the Subject With Atmosphere

This painting is set in heavy rain, creating a mood and adding interest to a painting that would otherwise be mundane in concept. The tiger's expression as it stands in the rain also adds to the feeling of the piece.

Monsoon—White Tiger Acrylic on Masonite • 24" × 36" (61cm × 91cm) • John Seerey-Lester

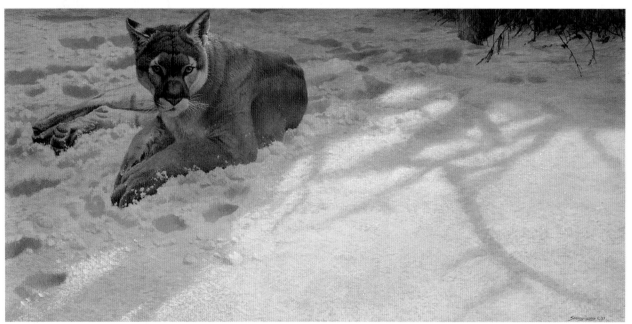

Use Light and Shadow Together

This piece is set in moonlight, letting the trees' shadows direct the eye. The cougar is placed in shadow so the illuminated snow would become more noticeable as a focal point. In this case the elements that come with the atmosphere contributed to the composition.

Moonshadow Acrylic on Masonite • 24" × 48" (61cm × 122cm) • John Seerey-Lester

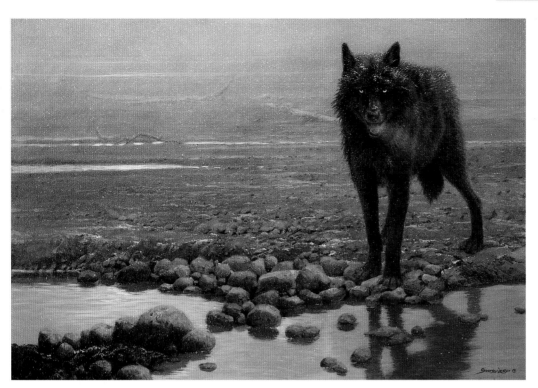

Even Dreary Can Be Interesting

A cold mist shrouds the riverbed on this cold, dank day. The black wolf adds to the dreariness of the environment. Its breath and reflection in the water provide secondary points of interest. Most of the impact, though, comes from the setting and the softly falling snow. Imagine the piece with none of these elements and how uninteresting it would be.

Eyes of Winter Acrylic on Masonite • 24" × 36" (61cm × 91cm) • John Seerey-Lester

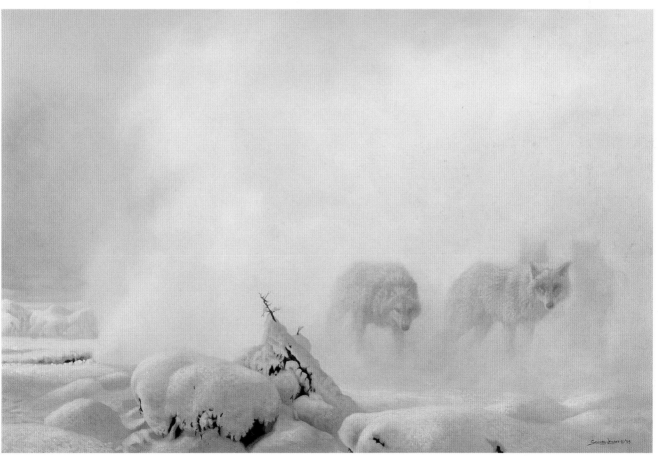

Come Out Into the Cold

In this painting wolves emerge from the steam of a geyser in Yellowstone National Park into freezing air and ice-encrusted snow. The wolves and the plume of steam are painted first. Then the mist is drybrushed over the wolves to push them back. Shadows are added in the snow and some dark areas in the foreground for contrast.

Return to Yellowstone Oil on canvas • 24" × 36" (61cm × 91cm) • John Seerey-Lester

Some Work, Some Don't

Artists often dislike particular paintings once they finish them. If we, as artists, achieved exactly what we wanted each time, we'd never progress. Don't be despondent. Always think positively: "My next one will be great."

Finish Two, Keep One
When the top painting was finished, it just didn't seem to work. The lighting was OK, but the setting needed something more and the pups were too hidden. It would be more interesting to silhouette the wolf pups than place them in the snow, so the setting was changed by painting dead leaves on the ground for the painting below. The viewer can see the dark wolf pups more easily in the second effort.

Yellowstone's Future Acrylic on Masonite • 12" × 36" (30cm × 91cm) • John Seerey-Lester

Keep It Simple
Every painting has a better chance of working if you keep it simple. Correctly placing the duckling that jumped from the nest is vital for this painting to work. The second duckling, about to leave the nest, is high up in the piece, subdue it and the background's values so they don't interfere with the downward movement of the falling duckling.

Leaving the Nest—Wood Ducks Acrylic on Masonite • 60" × 12" (152cm × 30cm) • John Seerey-Lester

Stay on Track

Try to stick to the general design and lighting arrangement you've planned as you paint. Otherwise it's easy to get in trouble. You can alter elements in a painting, but stay on track once you've developed the basic idea.

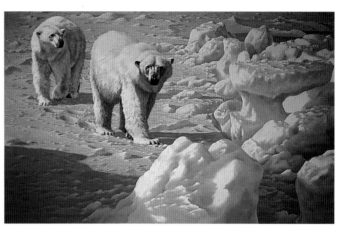

Stick to Your Design
The original idea was polar bears walking along broken ice with the simple contrast of dark against light powering the painting. Once the lighting changed and the ice floe was added, the painting became too complex.

Along the Ice Floe—Polar Bears Oil on canvas • 30" × 48" (76cm × 122cm) • John Seerey-Lester

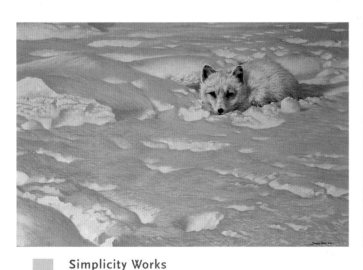

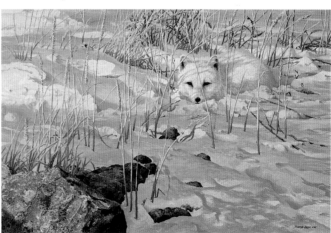

Simplicity Works
Again the idea was simple and should have worked well. The original use of lighting was fine, but at the time it felt as though the painting needed something more dramatic. In the finished painting at right, the light source was changed and rocks and grasses were added. In this case, the end result wasn't as successful as the original idea. Often, simplicity works.

Lying in Wait—Arctic Fox Oil on canvas • 24" × 36" (61cm × 91cm) John Seerey-Lester

How Far Should You Take the Details?

Details are the final brushstrokes in your painting. Like window curtains, they decorate. You can spend half an hour or days painting them. Remember, however, that extensive and beautiful details can't rescue a bad design. Conversely, poorly painted details can ruin a great design.

You must decide how far to take the details in your paintings. You could:

- Leave your painting just as it looks after you've blocked in values and colors, only overlaying your underpainting with thicker paint.
- Develop it to an impressionistic stage by refining the basic light and dark shapes and color masses using broken (or unblended) color.
- Develop it to an impressionistic stage and then add details to one of the planes—foreground, midground or background.
- Develop it to an impressionistic stage and then add details at the center of interest only.
- Continue developing other areas of details to create secondary focal points without allowing these areas to compete for attention with your primary center of interest.
- Refine your painting until it is photorealistic—fully developed with details.

There is no right or wrong place to stop painting: It's a personal decision. You may want to experiment with a number of these styles. The point is, if you construct your painting one step at a time, doing your best with each step as you go, the amount of detail you place on your attractive, stable design should not make or break the painting.

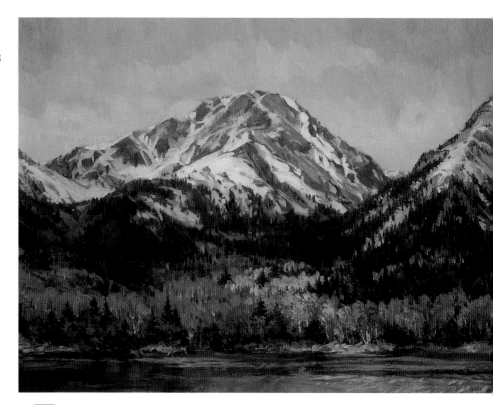

Be Brave With Your Paint

Most beginners don't use enough paint, typically for two reasons: (1) oils can be expensive, and (2) they lack experience in boldly handling thick paint. Work toward creating a juicy, luxurious look—and don't be timid. Using assertive brushstrokes, experiment with thick paint. Begin each painting with your darks, leaving them relatively thin, and use thicker paint to build up to the lights. Pile on the paint in the light areas near your center of interest (here, the sunny autumn trees) and wherever you want to create a sense of glare (sun reflecting off water or snow, for example).

Notice the snow patterns on the mountaintop in this painting. The thick, light color of the snow is scumbled (or dragged) over the thinly painted dark mountain. The contrast of thick and thin creates reflected light in these selected areas, greatly enhancing the scene.

Mountain Pride Oil on linen • 18" × 24" (46cm × 61cm) • Margaret Kessler

■ USE CONSISTENT BRUSHWORK

Brushwork and the texture created with thick or thin paint are an important part of painting details. Keep your brushwork consistent. In an oil or acrylic painting avoid having both palette knife marks and brushwork in the same painting, since mixing these techniques might draw the viewer's eye away from your theme.

Designing With Limited Details

The detail work in *Timberline Ridge* is very limited. Paintings like this succeed or fail depending on the success of your basic design. You have to tell your story through the elements of the design (value, line, color, pattern, movement, shape and size) rather than through the details.

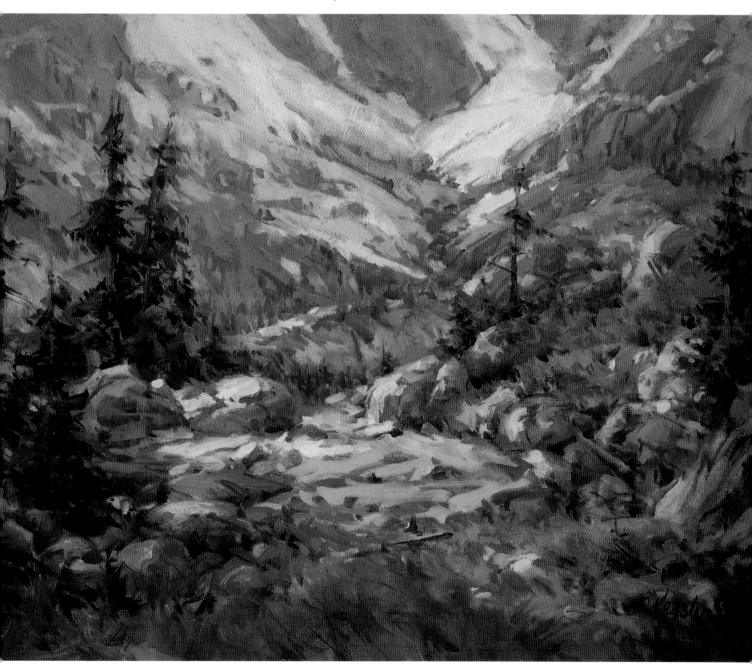

Timberline Ridge Oil on linen • 18" × 24" (46cm × 61cm) • Margaret Kessler

Saving a Bummer of a Painting

A bummer of a painting is a painting that nobody likes except you, the artist, and after a while when you find out nobody else likes it, you decide you don't either! At first your friends won't tell you that the painting has a problem, and even if they do, you don't want to hear it. That's why artists are called sensitive.

If you have a painting like this, set your piece in front of you while you're doing other work. You may be surprised at what you eventually see. As you're working on another piece, some technique, principle or even a new idea may suddenly dawn on you. It may work so well on that bummer, you'll want to give it a new name.

Painting Number One

This piece, originally titled *Kiamishi Hikers,* had been around for a year or two and hadn't sold. It faced the wall for another year. The sky, mist and background mountains were pleasing, so they were left alone. After a while, it was determined the problem was in the midground and foreground areas.

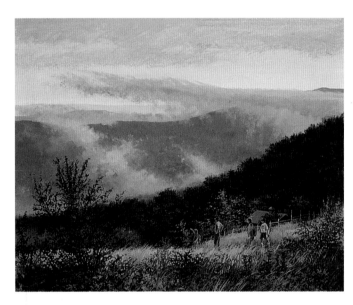

Use Composition to Move the Viewer's Eye Around the Painting

Here the background is left as is, and focuses on the smooth and uninterrupted line of the midground dark hill. So much of the line composition leads the eye to the left and out of the picture! Not even the dark foreground tree can stop this movement. The eye should be directed to see more and more of the painting, not the wall next to the painting.

So, change everything below the line created by the midground dark hill. The line of this hill is too smooth. The figures are poorly spaced. The barn roof adds nothing to the composition and is out of scale.

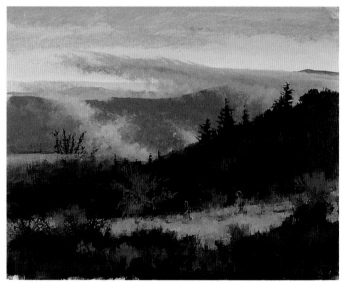

Soften the Hill Line and the Foreground

Since the area is rich in redbud trees and pines, break up the smooth line of the background hills with some irregular pines and some sporadically placed redbuds. The placement of the redbuds momentarily arrests eye movement and focuses the viewer's eye on the figures. Use a low chroma for the redbud color.

Paint over to the foreground to simplify it and eliminate the barn roof and two of the four figures.

Further Develop the Center of Interest

Use a lift-out tool in the wet paint of the hill-line trees for some texture on the hill and to allow some of the old painting to come through. Add the dog to make a threesome.

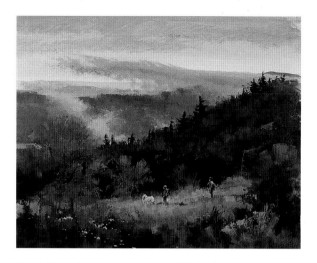

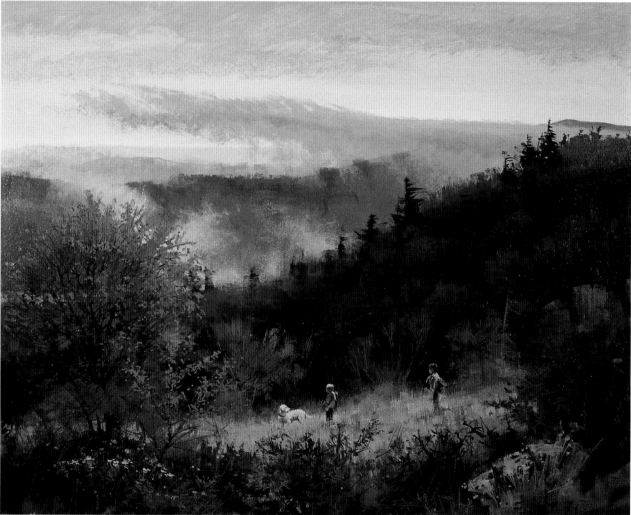

Finished Painting

Add detail to the redbud in the foreground by masking and then splattering to suggest individual buds. Use a ruling pen for some of the limbs and leaves. Give the right side of the redbud in the foreground more detail to keep the eye closer to the center of interest. The figures and the dog need to be more focused, so add highlights.

Buds Acrylic on Crescent illustration board no. 1 • 14" × 18" (36cm × 46cm) • Hugh Greer

Painting Number Two

When you are old enough to have grandchildren and they move away to Michigan, Michigan quickly becomes a favorite place to visit. An interesting thing about the state is the sight of tidy farms sporting much-needed snow fencing. It was this snow fencing that helped save another bummer of a painting.

 Determine the Problem

This painting, *The Fallen Guard*, did not go through the usual elimination process to qualify as a bummer—it hadn't even been to a gallery. The intention was to leave a lot of white foreground in the finished painting, but it wasn't working. It just didn't have the right balance. There was too much snowy foreground to make a strong, interesting composition.

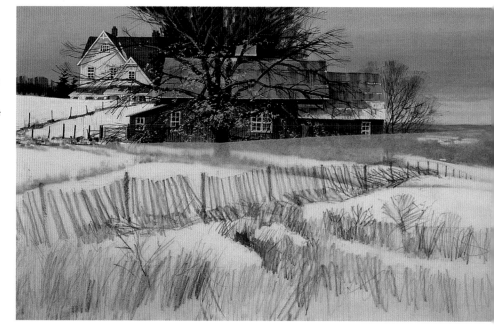

Add Interest to the Foreground

By placing a piece of tracing paper over the foreground, you can sketch a possible solution to the problem and make any adjustments to your composition very easily at this point. The tracing paper is transparent enough for you to see the entire painting and how your new sketch works.

Try Out the New Composition

Place a clean sheet of thin, clear plastic film over the sketch and tape it to your painting. Begin to paint directly on the acetate. There will be two layers over the painting: the sketch on tracing paper, and over that, the acetate to paint on. This process helps establish shapes and color composition before painting directly on the original. Remove the pencil sketch and leave the painted plastic film for a clearer understanding of what you will have on your original. If you like what you see, trace the sketch onto the original, and you're ready to begin painting.

■ TIPS FOR PAINTING GRASSES

- Make several sketches on tracing paper to see which one you like best.
- Use photos to refresh your memory of the grasses and fences in that location.
- To create negative space, scrape away excess color on the plastic film with a toothpick or a small, sharpened wooden stick. Keep in mind that the longer you wait to remove acrylic on clear plastic film, the harder it will be. If the acrylic dries too much to make scraping feasible, dampen the acrylic paint surface.

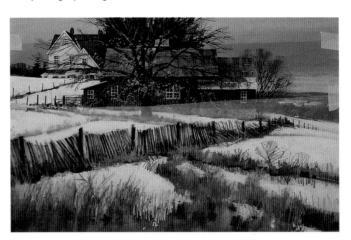

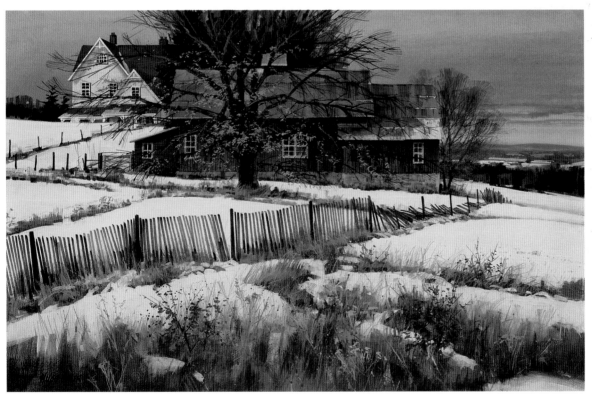

Finished Painting

The overcast day calls for a little more gray in the grass color than was on the plastic film overlay. You may find it necessary to adjust your colors slightly to fit the overall color scheme of your painting. Paint in the snowy ground around the dead grass. Use splatters and a lift-out tool to create the dead grass textures.

The Fallen Guard Acrylic on gessoed Masonite • 14" × 22" (36cm × 56cm) • Hugh Greer

103

Painting Number Three

There is nothing like a blast of color from early daffodils after a cold February to get your attention! *Trumpeting Spring* celebrates the promise of more color and warmer weather in the coming months. There are many good qualities about the original painting, but something is missing.

White Out a Space on the Tree

The surface of the painting needs to be white where the new daffodil will be in order to achieve the desired luminosity. Use several coats of Titanium White acrylic paint to get a bright white.

Determine the Problem

All the flowers are painted using transparent luminous glazes on gessoed hardboard. The dark negative space painted behind the flowers defines their shapes, making them a brilliant center of interest. It seems a single lonely daffodil against the dark tree trunk will provide the additional interest needed to capture the viewer's attention.

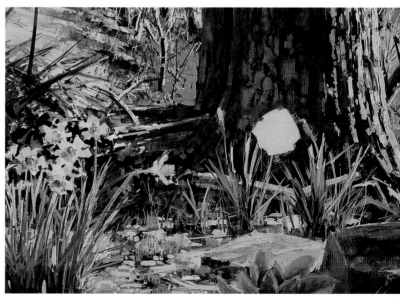

Add Luminescent Color

Paint over the bright white with Diarylide Yellow acrylic paint and a small amount of Soft Gel Gloss for a luminous bright yellow.

Paint the Negative Space

Determine the shape of the daffodil by painting the negative space around the flower. Because the tree trunk makes up the negative space, paint an opaque mixture of the base palette for the bark. To suggest moss on the bark, mix a warm blue using the base palette with a little extra Titanium White and Anthraquinone Blue acrylic paint.

■ TIPS FOR EDITING PAINTINGS

- Paint a daffodil on a sheet of clear plastic film and move it around your painting to see where it belongs. If you like, you can experiment with several different postures for your daffodil as well.
- It is possible to save a whole painting by whiting out the undesirable parts of the original with Titanium White or gesso. Usually, if more than half the original painting has to be painted white, it's probably best to just start over.

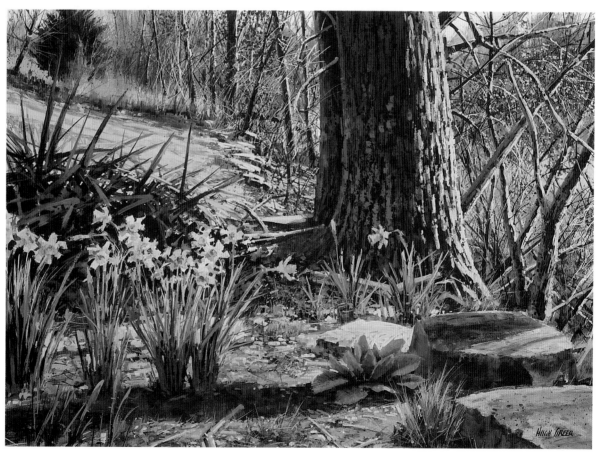

Finished Painting

Add splatters and limbs with a ruling pen and a no. 1 script brush to give the painting some finishing touches. The new flower's shape and suggested motion point back to the rest of the group, keeping the eye within the center of interest.

Trumpeting Spring Acrylic on gessoed hardboard • 18" × 24" (46cm × 61cm) • Hugh Greer

105

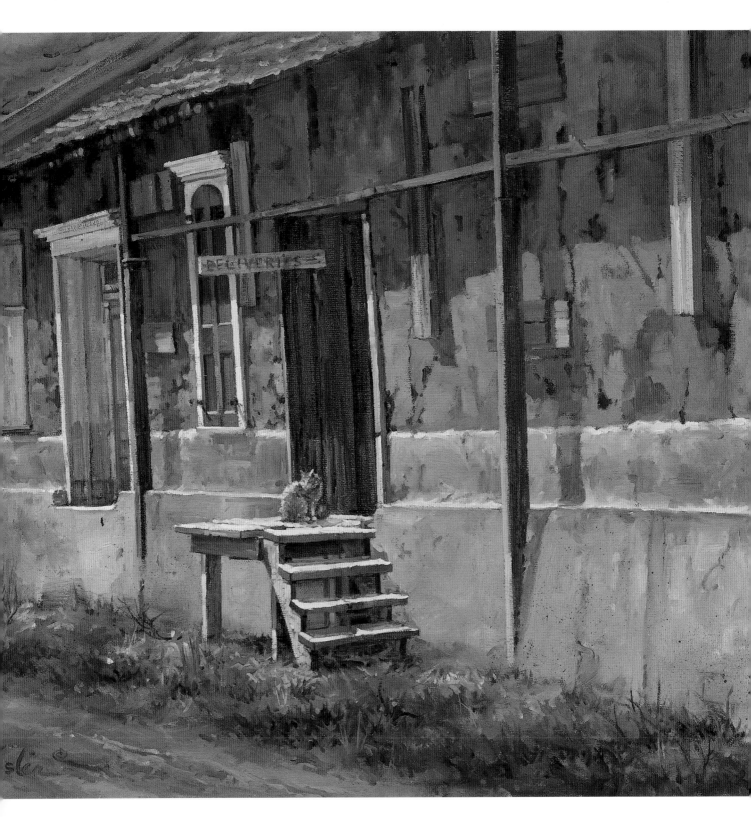

Waiting Oil on linen • 20" × 30" (51cm × 76cm) • Margaret Kessler

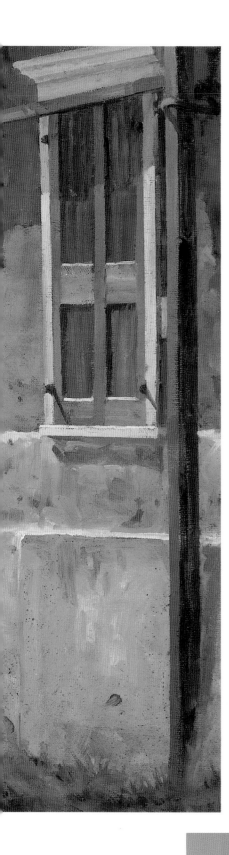

Sunlight & Shadows

Light and shadow are not only affected by the weather, but also by the time of day and the season of the year. This chapter will show you how to take these different factors into consideration and create sunlight and shadow effectively in your paintings.

Understanding Light Sources

It's important to identify the light source for consistency in highlighting and shadowing. The following examples of light falling on houses and trees illustrate how different light sources cast shadows. Compare these paintings to one another to gain a greater understanding of light, shade and shadows.

Shade Shadow Reflected light into shade Light Light source

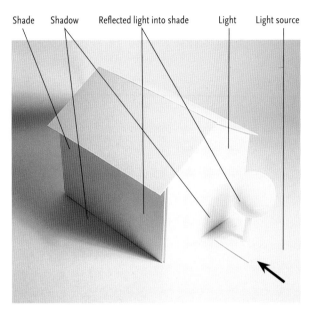

Reflected light into shade Shadow Strong light Shade

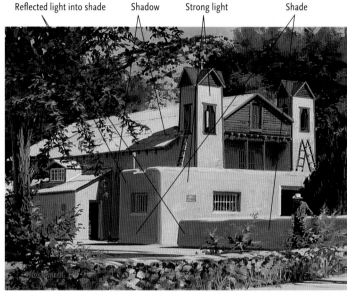

Light Perpendicular to the Viewer
The light source is perpendicular to the viewer, thereby illuminating one surface. Bright sunshine lights up the front facade of this building. Notice the strong shadows and reflected light.

Shadow Light source Reflected light Shade

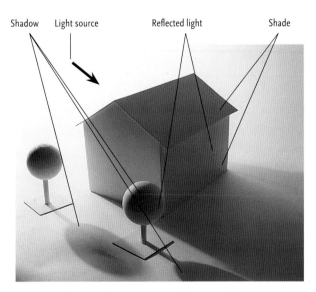

Dark background Translucent leaves and flowers Dark shadows

Light Coming at the Viewer
When the subject is between the viewer and the light source, you have backlighting. This can be the most dramatic lighting of all. One of the reasons for its drama is that the subject (center of interest) is illuminated against a contrasting background. Some artists specialize in this type of lighting in their paintings.

Light source Secondary light Secondary light Strong light Shadow
 Strongest light Both surfaces are illuminated Shadow

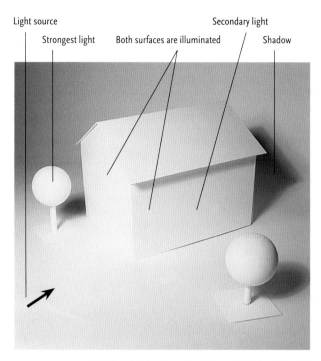

Light Coming From Behind the Viewer
The light source is behind the viewer looking toward the subject, resulting in illuminated multiple surfaces.
The long shadows are typical of late evening.

No direct light source Soft shadows Softer shadows Mid-value colors—not a lot of strong contrasts

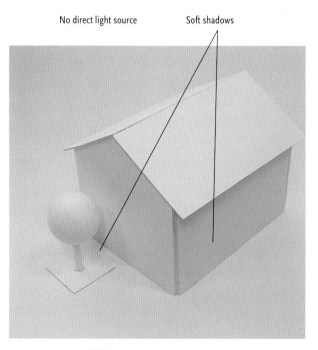
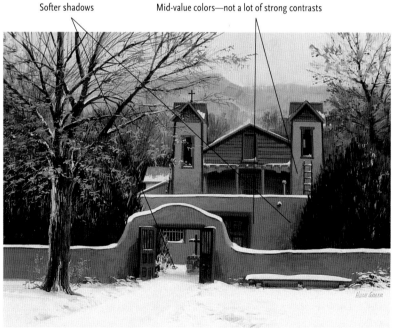

Diffused Light
Overcast days produce the diffused lighting in which artists often prefer to work. The soft shadows and over-head lighting create a more subtle effect than backlighting. Diffused lighting means a soft light source from above; this creates light shadows and values toward the midrange. Notice how close in value everything is. There are no hard-edged shadows.

How Light Affects Local Color

The amount and type of light that falls on an object always affects its true color, or local color. The local color of an object is simply a starting point. The colors of light are constantly changing, and depending on the time of day, affect the local colors of everything we see.

Once you are familiar with how light changes color throughout the day, you can modify the local colors in your painting, conveying any time of day that you desire. For example, if you wanted to paint a green tree in early morning light, you would modify the green with tones of yellow—the color of morning light. In many situations, you can paint the color of light and use just enough local color—in this case, green—to indicate the true color of the subject.

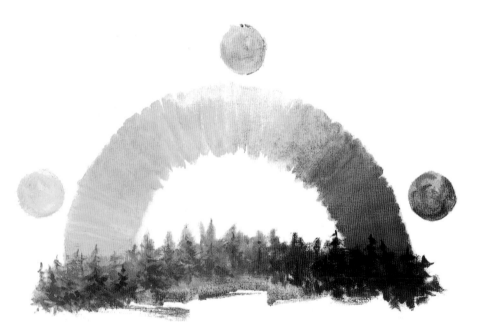

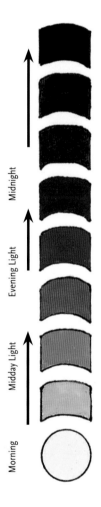

How Natural Light Affects Color on a Sunny Day
Time of day tells us the direction of the light and often its intensity. There is a noticeable difference between light at noon and at just past five o'clock. On sunny days, the color of the light changes many times. Early morning light is quite yellow and looks clear and refreshing. As the clock moves toward noon, the light takes on a Yellow Ochre tone—light in value because colors are bleached out by the intense sun overhead. As afternoon light develops, the Yellow Ochre darkens and then progressively changes to orange, orange-red and then red as sunset approaches. You can see the effect of the changing light on the green pine trees painted in this illustration.

The Colors of Light
On a clear day, natural light washes the landscape with a variety of colors ranging from warms in the morning to cools in the evening, modifying the local colors of everything you see. To indicate time of day, use these colors of the light to adjust your local colors.

Building Harmony in Morning Light

DEMONSTRATION: OIL

For the following demonstration, you'll paint an autumn day, dawning and full of promise.

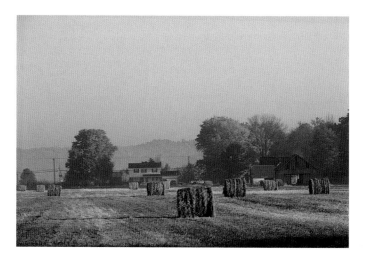

Reference Photo
The white house, barns and hay bales are in strong sunlight with the heat of day burning off the morning fog. To express the time of day rather than feature the buildings, simplify the composition by eliminating the house. Don't fall into the trap of squeezing too many items into a limited amount of space.

■ MIX IT UP

The materials list includes a warm and a cool hue for each of the three primary colors. Try mixing your own secondaries from these colors.
A quick refresher:
- Orange: Cadmium Yellow Medium + Grumbacher Red
- Violet: Ultramarine Blue + Quinacridone Red
- Warm green: Cadmium Yellow Medium + Phthalo Blue
- Cool green: Lemon Yellow + Phthalo Blue

If you don't want to mix your violets, you can substitute Cobalt Violet and Dioxazine Purple as your warm and cool versions, respectively. Likewise, you can substitute Permanent Green Light and Viridian Green for your warm and cool greens. Also, you can add Yellow Ochre and Cadmium Red Deep to your palette instead of mixing these semineutrals from scratch.

As you mix, remember that when comparing two hues of one color, the one with the most yellow in it is the warmest. (Phthalo Blue is warmer than Ultramarine Blue, for example.) Warm up cool tube white with a touch of Lemon Yellow.

Select Your Color Scheme
You could use the complements orange and blue on the triadic color wheel for this painting, but that would be very limiting. Instead, use the analogous color scheme on the Munsell wheel, shown here. With several hues of orange for your dominant colors, Phthalo Blue is your complement; Dioxazine Purple and Viridian Green are your discords. Look toward the center of the wheel from your oranges to see all the delightful neutrals you can mix.

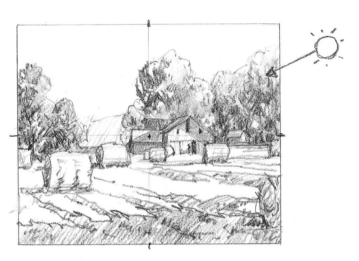

Value Plan

Divide a rectangular format into three horizontal sections, making unequal bands for the sky, the barns and trees and the field. Avoid placing objects in the exact center of your composition. Plan your values, making the sky the lightest value and the barns and trees the darkest values. Establish the doorway of the main barn as your focal point. Arrange cast shadows so they are moving away from your light source, moving the viewer's eye from left to right. The two partial bales on the right edge of the canvas act as eye-stoppers, leading your viewer back into the painting.

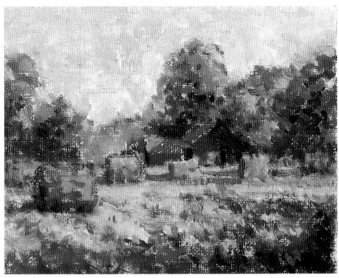

Color Study

Make a small color study [this one is 3" × 4" (8cm × 10cm)] to finalize the colors you will use in your painting. This is a chance to try out various color choices and develop your ideas further. Experiment with your options and select the best one for your painting.

Use a variety of oranges mixed from Cadmium Yellow Medium and Grumbacher Red. Modify them with Cadmium Yellow Deep, Yellow Ochre and a touch of white. Then, mix your own greens with Cadmium Yellow Medium and a touch of Phthalo Blue for warm yellow-greens, and Lemon Yellow mixed with Phthalo Blue for cool blue-greens. Mute these greens with your various orange mixtures.

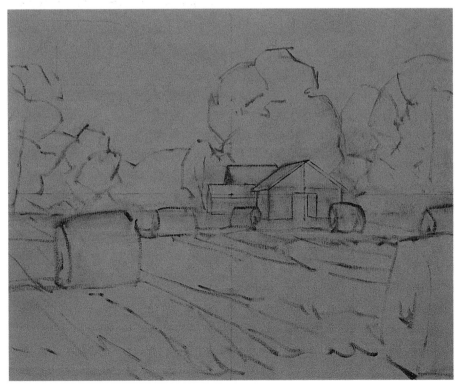

• 1 TONE AND DRAW

With a paper towel dipped in turpentine, mix together Yellow Ochre and Lemon Yellow directly on your canvas. Divide the canvas into thirds. Load a no. 1 round bristle with Yellow Ochre and rough in the landscape. Wipe out any unwanted lines with a dry facial tissue. Practice repetition with variety by varying the height and shape of the trees and bales of hay. Design with different numbers: three barns, six bales.

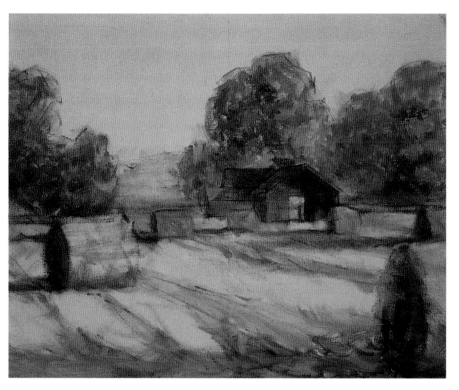

• 2 START BLOCKING IN YOUR COLORS

With your no. 5 filbert bristle, block in the buildings and shadows using variations of Ultramarine Blue and Dioxazine Purple. If an area gets too dark, simply lighten it by blotting with a facial tissue. Continue blocking in your color values. On your palette, mix warm darks with various combinations of Yellow Ochre, Cadmium Red Deep and some warm yellow-greens. Clean your no. 5 filbert bristle and use these reddish browns on the sunny areas of the barn. Repeat this color in the sunny, dark areas of your trees. Clean your brush and place orange complements for contrast near your center of interest using mixtures of Cadmium Yellow Medium and Grumbacher Red. Keep your brushwork loose.

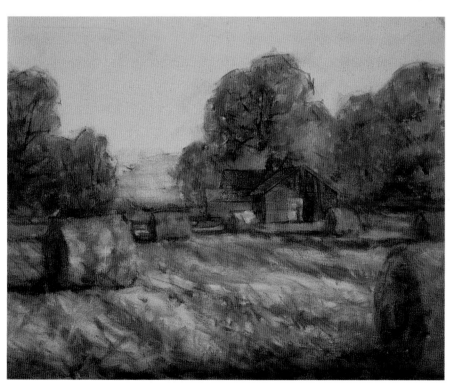

• 3 FINISH YOUR VALUE PLAN

Before starting the sky, finish laying in your value plan. With the side of your no. 2 filbert bristle, suggest tree trunks and branches. Smudge to lose edges here and there. Paint the smaller branches lighter in value than the larger ones. Working outward from your center of interest, continue painting the field. Repeat the same color mixtures you used in step two or the barns and trees, but emphasize yellows rather than oranges and reds. (Remember, yellow advances as it is the first color to catch the eye.)

At this point, your thin underpainting should be dry in about fifteen minutes.

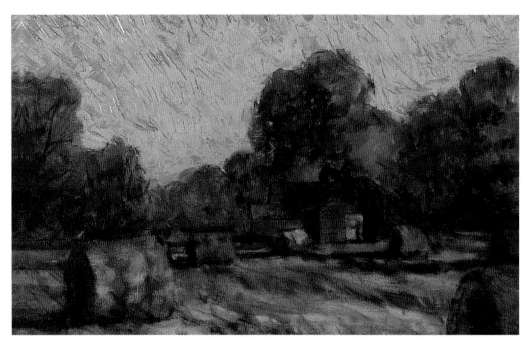

• 4 BEGIN THE SKY WITH A PALETTE KNIFE

Mix tints of the red, yellow and blue separately on your palette. With your palette knife, overlay your underpainting with dots and dashes of these tints. Because of the morning light here, the right side of your canvas will be predominantly yellows (tints of Lemon Yellow and Cadmium Yellow Medium). Use your cooler tints of mixed oranges, reds (Quinacridone Red) and violets (Dioxazine Purple) as you move away from the sun to the left.

Now add your cool colors. Nearest the sun, add a tint of warm Phthalo Blue; farthest away, add a tint of cool Ultramarine Blue. Also apply tints of Ultramarine Blue and Cadmium Red Deep near the horizon to indicate distance. When painting a clear-day sky like this one, it is important to keep the values of your sky colors similar.

• 5 FINISH THE SKY

Step back a little from your painting, then start blending this thick paint with a dry no. 8 filbert bristle. Crosshatch at random, but leave the colors somewhat broken as overworking will dull your sky to a gray hue. Start with the warmest color, yellow, working into the oranges and reds. Without cleaning your brush, continue into the warm Phthalo Blue, and lastly, into the cool Ultramarine Blue.

If you need to rework some areas, lift off or add more paint with your palette knife. Then, with a clean, dry brush, start blending in the new color splotches, starting with the warms and working into the cools. Caution: Don't make any modifications like this after the paint has begun to set. Sticky paint doesn't blend.

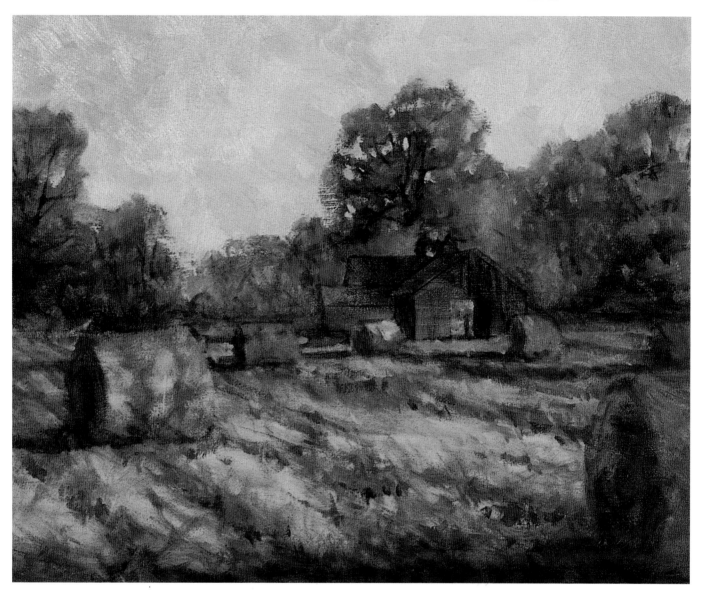

• 6 ADD SKY HOLES AND DEVELOP THE DISTANT TREES

Use some paint left over from the sky—a neutralized mixture of reds, yellows and blues—to paint the sky holes in the major trees. Modify the color as needed. (The smaller the hole, the darker, duller and cooler the color should be.) Make these negative spaces interesting by varying their size, shape and placement. Save some of this leftover sky color for later to reflect light on the field, the tops of trees and the hay bales.

Start developing the distant trees with tints of Cadmium Red Deep, Ultramarine Blue and cool greens.

■ **PAINTING POINTERS**

As you head into the final stage of the painting, remember to:

• Build up thick paint in the sunlit areas and keep darks thin.

• Use creative brush marks: slashes, dashes, dots, verticals, horizontals and diagonals.

• Save defined edges for your center of interest and leave others lost.

• Use warm darks in the sunlight and cool darks in the shadows.

• Make cast shadows dark and sharply defined at their source, then gradually lighter, softer and cooler (reflecting sky colors) toward the distant end.

• Reflect touches of your sky color on the ground, adjusting the values as needed.

• Modify areas of your painting that you are dissatisfied with using touches of color that stay within your color scheme.

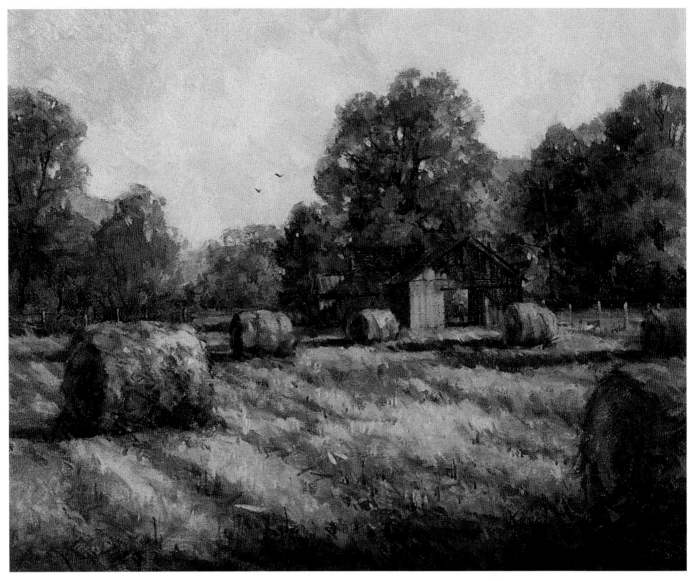

• **7 FINISH THE DETAILS**

Paint your colors thickly in this step, using mostly no. 4 to no. 6 filbert bristles. Refine your center of interest and work out from it, repeating all the colors you have used so far. Suggest individual planks and imperfections in the barns for character. Warm and lighten the main barn's outlines. With your no. 1 round bristle, add fence posts to knit your buildings into the scene. With your signature brush, add some birds to the sky. With your no. 2 filbert, add darks to the tree foliage using tints of Cadmium Red Deep, Ultramarine Blue and Viridian Green. Add a few more sky holes and limbs. Don't let the minor trees upstage the main tree just above the barns.

Repeat complementary barn colors (Phthalo Blue and Ultramarine Blue) in the cast shadows. With your no. 1 round bristle, add Grumbacher Red to transition from sunlight to shadow. Soften the edges of the trees, hay bales and cast shadows as they recede into the distance. Add skyshine highlights, then switch to your orange mixture and Yellow Ochre to paint highlights around the barns. For excitement, dash a few of your discords, Viridian Green and a red-violet (Ultramarine Blue and Quinacridone Red), near the center of interest. Sprinkle Lemon Yellow, Cadmium Yellow Medium and Cadmium Yellow Deep onto the sunny foreground. Suggest some stubble in the field, but let the viewer's imagination fill in the rest.

Barns and Bales Oil on linen • 16" × 20" (41cm × 51cm) • Margaret Kessler

Landscape at Sunrise

DEMONSTRATION: WATERCOLOR

A strong abstracted painting often has a subject that has been filtered and condensed through the artist's philosophy to its essence, perhaps with some visual poetry thrown in. Good abstracts can arise from strong feelings that translate into convincing truths to the viewer. Often abstracts appear more authentic and are more likely to be "forever remembered" than if the subject was painted in a realistic manner.

Native Americans have said that the Sedona area was "spirit taking form." This area was where the tribes often met for their sacred ceremonies. Some of the ancient rock petroglyphs in various parts of Arizona perhaps provide a glimpse of the Native American interpretations of the spirit gods.

Trying to weave some of these ancient, spiritual petroglyph symbols—and Cathedral Rock, the subject of the previous demonstration—into an abstracted, spiritual painting will be exciting. Remember that abstracted work needs all the fundamentals of good design, often more so than realistic work does.

Materials List

WATERCOLORS
Transparent colors: Carbazole Violet, Cobalt Blue Tint, Indanthrone Blue, Indian Yellow, Orange Lake, Permanent Magenta, Transparent Yellow
Transparent earth colors: Permanent Brown, Quinacridone Burnt Orange, Quinacridone Coral, Quinacridone Gold, Quinacridone Sienna

SURFACE
300-lb. (640gsm) cold-pressed watercolor paper

BRUSHES
Flats: ¼-inch (6mm), ½-inch (12mm), 1-inch (25mm) and 1½-inch (38mm)
Rounds: nos. 1 and 3

OTHER
elephant-ear sponges, fine-mist spray bottle, plastic stencil, silver pencil and white plastic eraser

Initial Value Pattern

Value Pattern With Focal Area Placed
Turn the value plan upside down, enlarge it, and then place the subject material (the rocks) within the focal area (the lower right).

Inspirational Sketches
These are some sketches of Native American spirits found in ancient petroglyphs.

• 1 MAKE A LOOSE DRAWING AND SET THE STAGE FOR A SUNRISE

Draw outlines of the value pattern and rocks on your paper. The color scheme will be predominantly warm, with complementary yellows and violets, to create the mood of early sunrise. Wet the paper thoroughly, and as soon as the sheen has left the paper, begin to paint with a large flat. Leave some white paper behind rocks for a circular sun of about 3 inches (8cm). Then, starting with Transparent Yellow and working outward with Indian Yellow, Orange Lake, Permanent Magenta and finally Cobalt Blue Tint, paint pale rings of color that fade gently into each other until you reach the outer edges of paper. Let this step dry.

• 2 PAINT A ROCKY SILHOUETTE

With your large flats, loosely paint the lower rock area and landscape with the sun peeking out from behind it. This should be done in a graduated way as in step one, placing the warmest rock tones nearest to the sun. Use darker versions of the same colors from step one, and let the colors blend into each other. Let this dry.

• 3 PAINT THE CLOUDS

Place the painting upside down and work on a vertical slant of 6 inches (15cm) or more. Paint the clouds above the lower landscape in a graduated manner, with the warmest colors nearest the sun and cooler, grayer, darker colors as you move toward the top of the painting. As the paint begins to lose its sheen but is still wet, spray it gently with a fine-mist spray bottle to get some paint to run a bit. When you are satisfied, lay the painting flat, wipe it around the outside edges and let it dry.

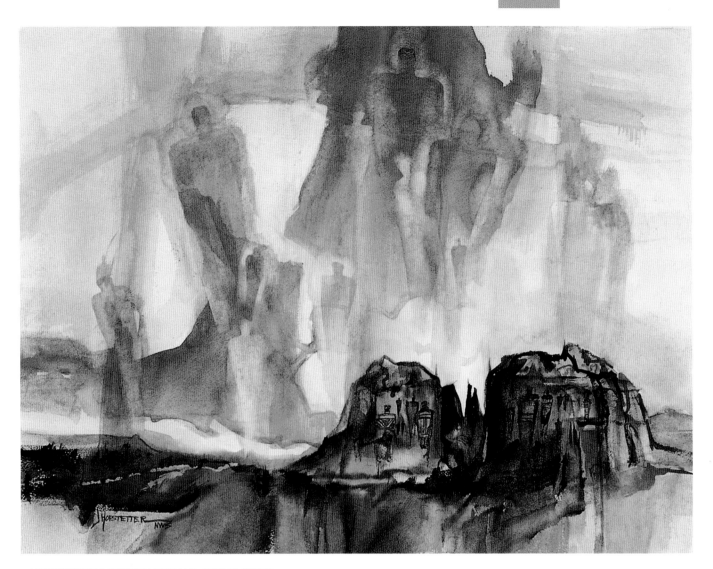

• 4 FINISH WITH DARKEST DARKS AND STENCIL WORK

Mix dark magentas and browns with your darkest blues and purples to get a variety of darks. Darken some of the lower landscape, referring to the original value pattern. Loosely paint the rocks with a minimum of detail so the carvings you add next will show up. When this is dry, refer to the petroglyph sketches and add some of these to the rocks with a small round.

After cutting out several sizes of the petroglyph figures in stencil plastic, lay them down on the sky area. Lightly wash on some pale sky colors—in wide strokes in a few places with a large flat—so that the stencils will show up when this is dry. Then lift off the figures with clean, damp elephant-ear sponges, gradually fading out the edges. Use both the inside and the outside of the stencils, softening various edges for some added mystery. Lightly paint some of the figures for variety, using a flat or a damp sponge dipped in paint and used with a stencil.

Ancient Shadows Transparent watercolor • 21" × 28" (53cm × 71cm) • Jane R. Hofstetter • Collection of the artist

Stencil Cutouts
Petroglyph shapes like these were used to complete the sky in step four.

Painting Sunsets

The light of the descending sun creates many wonderful opportunities to use dramatic colors. Sunsets are generally warm paintings with extreme value differences. Backlighting is the key to capturing a sunset. The closer the sun is to the horizon, and the larger the object in front of it, the sharper the degree of contrast will be between the sky and the backlit objects in your scene.

Capturing a Sunset

A sunset can glorify just about anything—even this old abandoned barn. As in this sunset painting, your light source might be tucked just below the horizon or hidden behind objects such as clouds, trees or buildings. Start the canvas with a wash of Yellow Ochre and Cadmium Red Light oil paints and include a few cool oil hues such as Dioxazine Purple and Viridian Green. To draw attention to the center of interest, the setting sun, contrast complementary yellows and Dioxazine Purple in areas of the sky.

Twilight Oil on linen • 18" × 24" (46cm × 61cm) • Margaret Kessler

Painting Noontime

Noon light poses a few problems for the artist because the intense overhead light creates few shadows. This flattens everything out. Cast shadows are few and far between, thus eliminating many design opportunities. The intense light also bleaches out bright colors, which can lend to a lazy-day mood.

Fortunately, though, noon light does not change as quickly as the light at sunrise or sunset, so it is a good time to paint on location. The challenge lies in painting a dramatic, energized scene in this type of light.

A Slightly Overcast Day at Noon

The mildly overcast light reveals the local colors of objects more clearly than intense sunlight would. Tone the canvas with Yellow Ochre oil paint to set the stage. Because the boats are at eye level, the highlights on them are minimal. The overhead sun creates an interesting cast shadow under the boat that acts as a secondary focal point. Keep this cast shadow fairly light in value and reddish to reflect the underside of the boat, indicating the sunlight that bounces off the sand and into the shadow. Due to the bleaching effects of the sun on sand, the foreground weeds are subtle in color and light in value. This helps to draw the viewer's attention to the focal point instead of to the bottom edge of the canvas.

Clara Marie Oil on linen • 18" × 24" (46cm × 61cm) • Margaret Kessler

Reversing the Sunshine

DEMONSTRATION: WATERCOLOR

The primary challenge of this step-by-step demonstration is to paint convincing sunlight and shadow areas with only suggestive reference photos (page 70). In reversing the sunshine, devise shadow patterns that are an integral part of the design and serve the purpose of contrasting with the light areas of interest.

Materials List

WATERCOLORS
Burnt Sienna, Cadmium Orange, Cadmium Red Light, Cadmium Yellow Medium, Cerulean Blue, Chromium Oxide Green, Cobalt Blue, Payne's Gray, Quinacridone Red, Raw Sienna, Sap Green, Ultramarine Blue, Winsor Violet, Yellow Ochre

SURFACE
140-lb. (300gsm) cold-pressed Arches watercolor paper, stretched 12" × 19" (30cm × 48cm)

BRUSHES
Winsor & Newton Series 7 rounds: nos. 3, 5, 7 and 9; mop brush

OTHER
ballpoint pen, craft knife, graphite transfer paper, Incredible Nib, masking fluid, pencil, plastic eraser, rubber cement pickup, salt

• 1 MAKE YOUR DRAWING AND APPLY THE MASKING
Enlarge your drawing to the final size by either gridding it or using the enlarging function on a copier or scanner. A final drawing on a separate sheet can prove invaluable for later reference. Place this final-size drawing over your watercolor paper with a graphite transfer sheet between them. With a ballpoint pen, trace the drawing onto the watercolor paper. Carefully apply masking fluid to the figures, petunias, window frames and mullions.

• 2 BATHE THE STONE IN SUNSHINE AND ESTABLISH THE SKY
Underpaint the sky area with a wash of Cadmium Orange. For the golden glow on the buildings and street, combine Quinacridone Red with Cadmium Yellow Medium. Splash in Cerulean Blue sky shapes in a gentle, erratic pattern. Drop in some Quinacridone Red in parts of the sky for variation. Design an irregular negative shape between the clouds and the rooflines of the buildings.

• 3 ADD SUNNY BACKGROUND TREES AND MIDGROUND TREES

Paint the trees behind the buildings with a mid-value Cobalt Blue and Cadmium Yellow Medium. Continue adding color to build up the shapes, keeping the darker shadow values on the right.

Begin the trees and bushes behind the stone wall with a medium-value Sap Green and Payne's Gray. Add another layer of the same to define the shadow areas. Use Sap Green and Burnt Sienna in the darkest areas. Where the foliage catches the sun, add dabs of Cadmium Yellow Medium. To make chiseled leaf shapes, flatten your rounds with your fingertips.

• 4 BEGIN THE HOUSES

To the sunlit underpainted areas, add a slightly darker value of Yellow Ochre to suggest irregular stones, following the perspective of the building. Keep the underpainting as highlights on the stone.

To make glowing areas on the shadow side of the houses, use a mixture of Winsor Violet and Raw Sienna. Where these areas receive reflected light, add a hint of Cadmium Orange. Use a mixture of Winsor Violet, Raw Sienna and Ultramarine Blue for the roofs. To increase the value contrast between the trees behind the stone wall and the shadow side of the house, lift off areas of some of the leaves with the Incredible Nib and add Cadmium Yellow Medium to those areas to suggest brighter sunlight hitting them. Add more distant trees behind the houses using the same combinations as in step three.

• 5 FINISH THE COTSWOLD STONE

With an irregular stroke following the perspective lines to the vanishing point, suggest subtle stone shadows. Later, put darker shadows under the stones.

Lightly pencil in perspective lines to the vanishing point as guidelines for laying the stone. The stones must diminish in size along with the buildings for convincing perspective. Using Yellow Ochre mixed with a tad of Winsor Violet, paint irregular stone shapes.

To accurately lay the shingles on the roof, lightly pencil in more perspective guidelines. Paint the roof with combinations of Cerulean Blue, Burnt Sienna and Ultramarine Blue, leaving little specks of sunlight. Then define the shingle shadows with a darker value of the roof mixture.

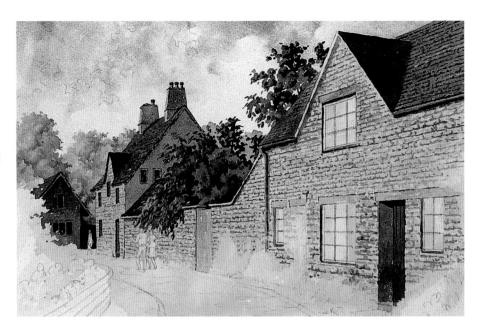

• 6 PAVE THE ROAD AND BEGIN OTHER FOREGROUND AREAS

First redraw the figures and apply masking fluid to the new shapes. Apply masking fluid to the shrubbery along the stone wall to leave space for bright flowers. With Winsor Violet and Raw Sienna on damp paper, design the shadow pattern on the road. Shape the flowering shrubs along the side of the stone house with light greens of Sap Green and Yellow Ochre. Paint a bright yellow shape above the stone wall to represent sunny background spots between the leaves that will eventually be painted there.

Design the flowers to cascade over the stone wall. Paint this foliage and the wall with a shadow color of Winsor Violet and Burnt Sienna, with spots of Ultramarine Blue to vary the color.

• 7 FINISH THE WALL AND DEVELOP THE HOUSE-SIDE SHRUBBERY

Refine the cast shadows on the road. Continue to develop the shrubs using a variety of greens made with Cadmium Yellow Medium, Sap Green and Ultramarine Blue. For the stone wall, add shadows with Winsor Violet and Raw Sienna. For more opaque leaves, use Chromium Oxide Green varied with Cadmium Yellow Medium.

• 8 PAINT THE FLOWERS AND OVERHEAD BRANCHES AND CONTINUE THE SHRUBS

Remove the flower masking from the stone planter and lay in a shadow tone with Winsor Violet and Cerulean Blue. Add Quinacridone Red to some of the areas for the red flowers. Paint interesting negative areas around the flowers to accentuate them.

Develop the shrubs in front of the stone house. With a shadow green of Sap Green and Ultramarine Blue, paint branches with protruding leaf shapes. Add more of the same color to paint negative spaces between and under individual leaves.

125

• 9 FINISH THE PAINTING

Use a light wash of Payne's Gray and Quinacridone Red to add some streaks to the house. Toss in some salt for textured areas. Define some of the individual stones to break up the massive house. Add some shadows to the shingles on the shadow side of the roof. Add the light over the door and scratch out some highlights with a craft knife.

Paint the windows to reflect the sky and trees, with curtains added to the bottom windows. Then remove the masking from the window frames and mullions. On the right and underneath side of the mullions and window frames, paint shadows with a mixture of Winsor Violet and Cerulean Blue. The detail of the open window indicates someone is home. Reverse the two walking figures from the reference material. Paint the back figure light against dark and the couple dark against light. Dress the woman in red using Quinacridone Red and Cadmium Red Light for a bright accent. Carefully erase pencil lines.

The sunlight illuminating this Cotswold scene gives a warm feeling of intimacy on a clear, crisp day. Contributing to this impression are the overhead tree and dappled light on the road. The curved road leads the viewer's eye into the picture along the radiating lines toward the single illuminated figure. The end house, with its arrow-shaped gable, points up and leads the viewer's eye directly to the overhanging tree, pointing the viewer's eye back into the scene.

The Sunny Side of the Street Watercolor • 12" × 19" (30cm × 48cm) • Barbara Nuss

Changing Atmosphere

You can stick to your original design concept and still change the atmosphere of any painting if it isn't working for you. If you're having trouble with a painting, put it aside and come back to it days, weeks, months or even years later. You may come up with a different idea for a setting or atmosphere when you pick it up again.

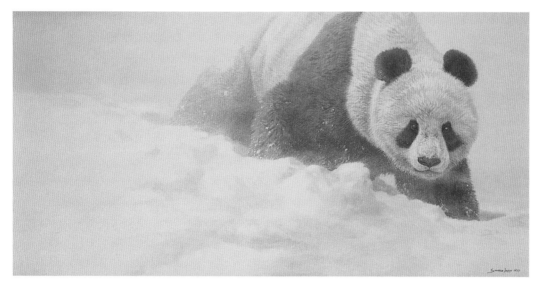

If You Don't Like It, Change It

Here the setting, and thus the atmosphere, was changed between these very similar paintings. The panda was initially painted in a blizzard, but six years later, a new concept changed the mood entirely. Foliage was added over the snow and the light souce was changed.

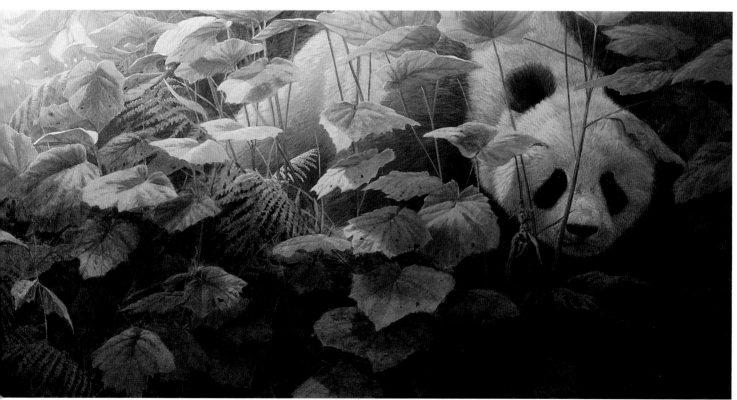

China Dawn Acrylic on Masonite • 24" × 36" (61cm × 91cm) • John Seerey-Lester

127

Changing a Sunny Scene to Overcast

DEMONSTRATION: ACRYLIC

Roads are arteries connecting us to one another. On them we travel home, venture off on vacation and conduct the business of daily life. Without them, we'd be pretty isolated. Many paintings are of places people encounter while traveling. Quite a few places have "no trespassing" signs on the property —no problem—in that situation, just pull your car off to the side of the road and start painting. The road itself could even become part of your painting.

Materials List

ACRYLICS
Anthraquinone Blue, Cerulean Blue, Diarylide Yellow, Dioxazine Purple, Jenkins Green, Quinacridone Magenta, Red Oxide, Titanium White, Ultramarine Blue

SURFACE
gessoed hard board 12" x 16" (30cm x 41cm)

BRUSHES
One-stroke brushes:
⅛-inch (3mm), ¼-inch (6mm), ½-inch (12mm), ¾-inch (18mm), 1-inch (25mm) and 1½-inch (38mm);
Script brushes: nos. 1 and 2

OTHER
ballpoint pen, drafting or masking tape, lift-out tool, palette, palette knife, paper towels, pencil, ruling pen, sandpaper (fine), saral paper or pastel stick, Soft Gel Gloss, tracing paper (inexpensive), water

Reference Photo
This photo was taken on a bright sunny day on a mountain road in northern New Mexico. Try to depict it on an overcast day with fresh rain on the pavement.

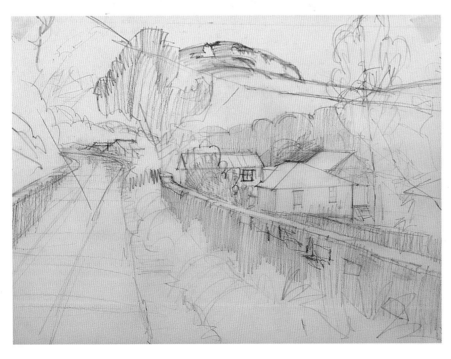

• 1 CREATE AND TRANSFER YOUR SKETCH
Make a sketch on a 12" × 16" (30cm × 41cm) piece of tracing paper. Transfer your drawing to gessoed hardboard, and you're ready to paint. Leave the surface white; no need to underpaint here. After the tracing is transferred to the support, coat the surface with Soft Gel Gloss to keep the line work from smearing when applying washes over it. This coating will also allow the paint to stand on the surface a bit longer before drying, making it easier to blend colors.

128

• 2 LAY IN THE PAINTING

Begin laying in some of the big shapes. Mix the sky, mist and mountain colors with combinations of Ultramarine Blue, Red Oxide and Titanium White. You will be using these grays for the reflective road as well. Use this combination of colors in several places throughout the painting to help unify it. For the rooftops use Red Oxide, Quinacridone Magenta, a touch of Diarylide Yellow and as much Titanium White as necessary to lighten the roofs just enough to catch the eye and make them the center of interest. For the foliage, use a combination of Diarylide Yellow, Ultramarine Blue and Jenkins Green. Remember, the background foliage will be lighter in value, so soften and gray the foliage in the background (a no. 1 or 2 on the value scale). The foreground foliage will be darker and higher in value (no. 4 or 5 on the value scale) and the chroma will be more intense.

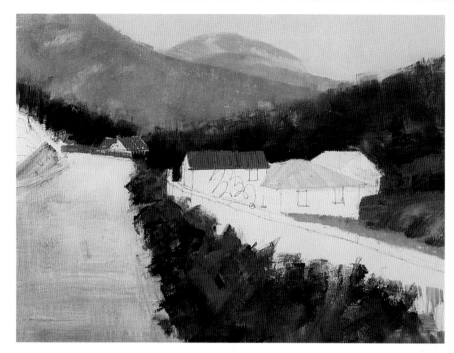

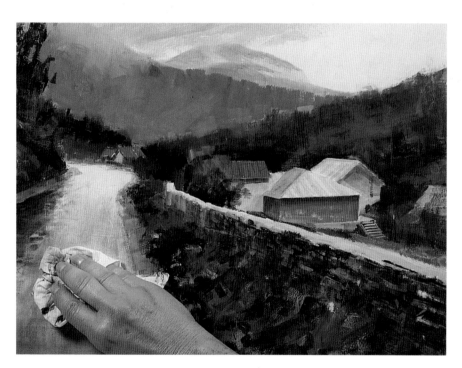

• 3 STREAK THE PAINTING

Use a paper towel to vertically pull the paint toward the bottom of the support, leaving streaks in the wet paint for a wet appearance.

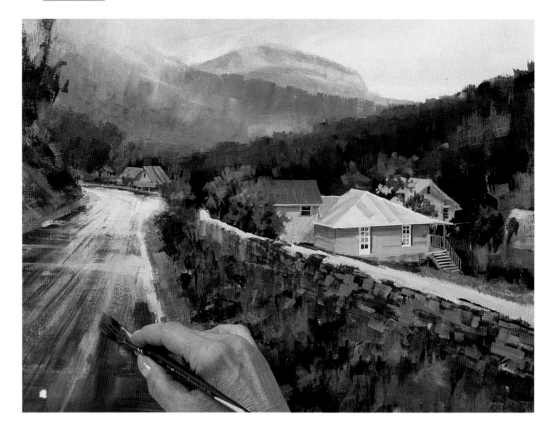

• 4 DEVELOP THE ROAD

Use a dry, ½-inch (12mm) one-stroke to lift pigment off the road. Create a bright white spot at the end of the road where it bends to the left to achieve balance with the bright spot in the sky. As the road comes toward you, it will be darker because there is more reflective light in the distance. You want the center of interest to be the houses, so the red roofs will come in handy to draw your eye there.

Use a mixture of Ultramarine Blue, Red Oxide and Titanium White for the loose gravel on the side of the road and the asphalt.

Slightly less Slightly more Equal The centerline is half of the road width

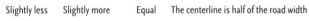

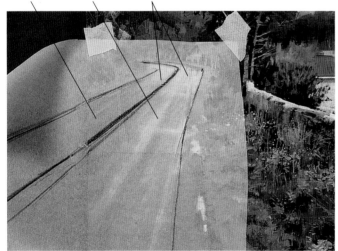

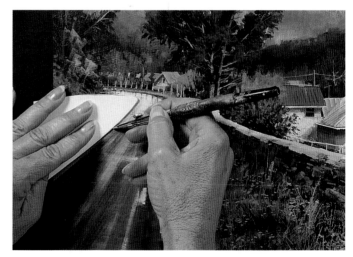

• 5 PERFECT THE CURVE OF THE ROAD

Make a careful study of the curve on tracing paper to get the perspective right.

• 6 USE THE RULING PEN

Transfer the sketch of the road onto a piece of mat board and cut it out as a guide for the ruling pen. Make sure to sand the rough spots on the mat board before you use it to create the centerline.

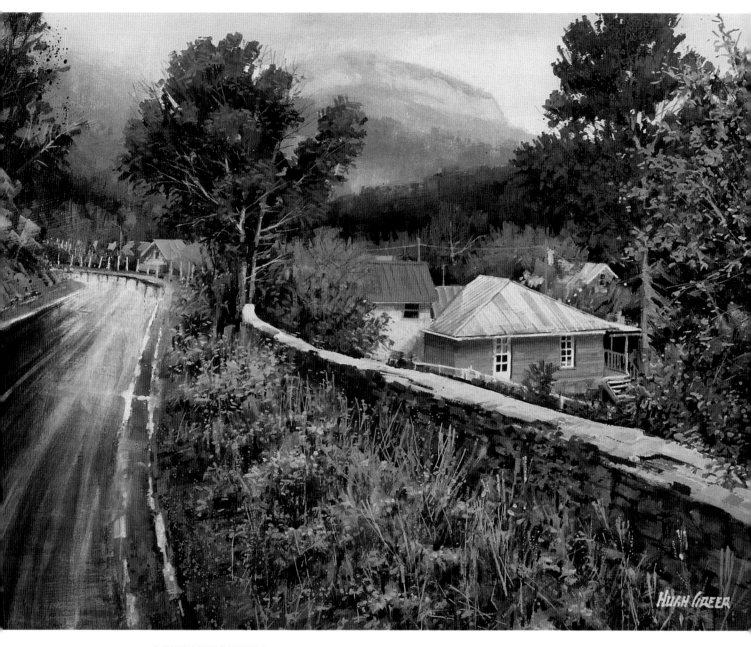

• 7 FINISH THE PAINTING

Apply several layers of blue washes to the road using vertical and horizontal strokes. The dark blue on the left is a result of the trees on the side of the hill reflecting onto the pavement. Add detail to leaves, trees, grasses and wildflowers to complete the painting.

Road 230 Acrylic on gessoed hardboard • 12" × 16" (30cm × 41cm) • Hugh Greer

Energizing Shadows With Rich Color

DEMONSTRATION: OIL

The tree's silhouette framing a bright sunlit area provides the foundation of an effective composition without much editing. A rare occurrence!

Materials List

OILS
Cadmium Orange, Cadmium Red Light, Cadmium Yellow Light, Phthalo Blue, Phthalo Green, Quinacridone Red, Ultramarine Blue, white, Yellow Ochre

SURFACE
18" × 24" (46cm × 61cm) Stretched linen canvas

BRUSHES
Robert Simmons filberts: nos. 2, 4, 6 and 8; Winsor & Newton Monarch filbert no. 2; Winsor & Newton Monarch round no. 0

OTHER
cotton rags, Liquin, mahlstick, odorless turpentine, soft vine charcoal

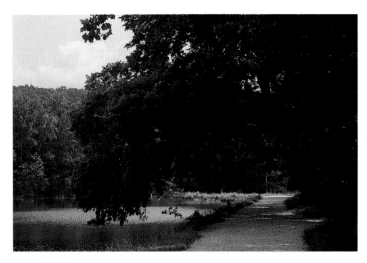

The Whole Scene
The straight overhanging branch and towpath will be redesigned in the field sketch for a smoother composition.

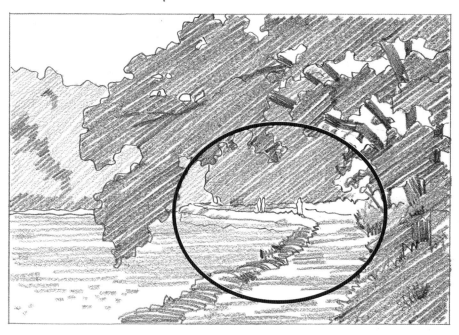

Final Pencil Drawing
Using the reference photos as a guide to relative size, arrange three figures in the distance for a focal point in the "O" formed by the branch and curving towpath. Show two figures together and a third walking toward them. In addition to adding a typical slice of towpath activity, the figures give the landscape a sense of scale.

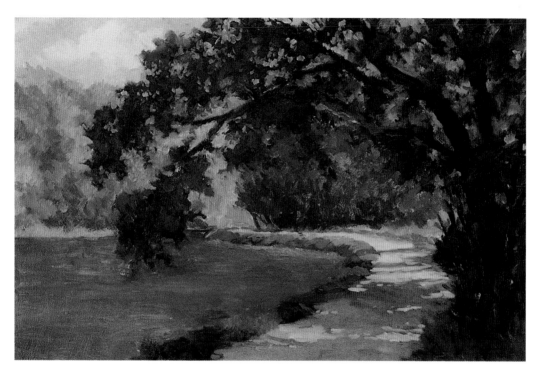

• 1 LAY THE COLOR FOUNDATION

Transfer your drawing to the canvas with soft vine charcoal. Ignore the figures for now. Solve the last problem of the field sketch by using rich violet and blue in the shadows on the distant banks, mixed with Ultramarine Blue, Quinacridone Red, a little Cadmium Yellow Light and white. Vary the color proportions for depth and variety.

On the silhouetted tree, use cool dark green mixtures: Phthalo Green with Quinacridone Red; Phthalo Green with Cadmium Red Light; and Ultramarine Blue, Cadmium Yellow Light, Quinacridone Red and white. Describe the tree trunks and branches with a violet-brown (Phthalo Blue and Cadmium Red Light). Connect all the branches and limbs by lightly drawing through the foliage. Paint the cloud shapes with a mixture of white and a tad of Yellow Ochre. With white and a little Phthalo Blue, paint the areas of sky around the clouds. Softly overlap the sky color into the tips of the trees in the far bank.

Using a no. 4 filbert and horizontal strokes, design shadow patterns on the towpath with a warm violet (Phthalo Blue, Cadmium Red Light and white). Make shadow areas fairly solid and interspersed with other areas with lots of spots of light. Fill in these remaining spaces where the sunlight is hitting the towpath with a light value of white tinged with Cadmium Orange.

Paint the large area of water a blurry and slightly darker version of the banks that it reflects using similar colors. Do not include the sky highlights at this point.

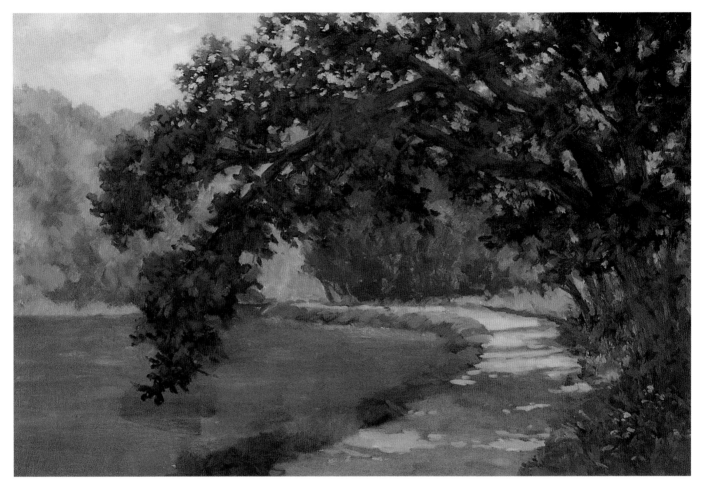

• 2 DEVELOP THE TREE AND FOREGROUND FOLIAGE

Working from dark to light, paint the tree—the darkest element—as completely as you can. Restate the trunks and the branches with the same violet-brown made with Phthalo Blue and Cadmium Red Light. Paint the medium-dark values in the foliage with the same combinations used in step one, but save some of the deepest darks from step one for accents.

The lighter surfaces of foliage and branches receive reflected light from the sky, the water and the towpath. Cool the tops of the branches where they receive light from the blue sky by adding a whisper of white to the green mixtures. With a hint of Cadmium Orange, warm the underneath sides of the branches where they receive reflected light off the towpath.

Camouflage confusing intersections or distracting patterns of branches and trunks with strategically placed foliage. Beware of distracting Xs where the branches naturally cross each other. Before the foliage dries, restate the clouds with soft edges and eliminate the striped sky shape separating the two clouds. Then paint the remainder of the sky and the sky holes, blending the sky color into the edges of the tree. The smaller the sky hole, the darker it should be. Paint bright spots of sunlit foliage peeking through the tree and scattered spots on the grasses along the towpath. Begin to develop the foreground underbrush and suggest a few colorful wildflowers.

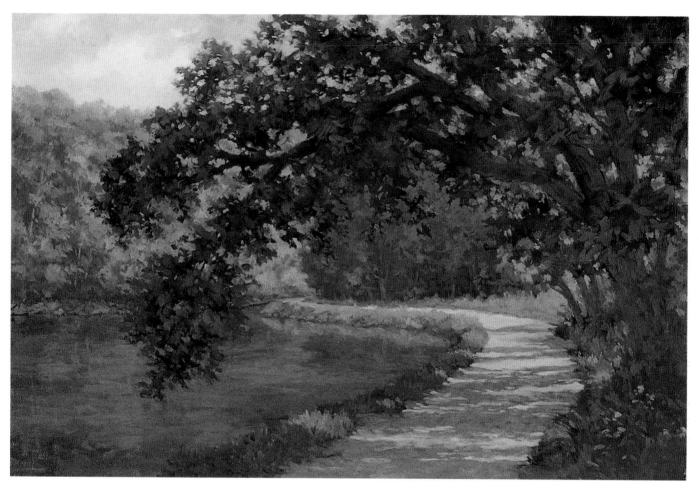

• 3 DEVELOP THE REST OF THE PAINTING

Adjust and refine the colors in the left bank using cool greens in combinations of Phthalo Green, Phthalo Blue, Quinacridone Red, yellow and white to define tree shapes. In the shadow areas, use rich violets of Phthalo Blue and Quinacridone Red and/or Ultramarine Blue and Quinacridone Red varied with yellow and white. Suggest a few tree trunks amid the foliage. Work a few rock shapes into the shadows along the water's edge by adding white and a tad of orange to the shadow colors.

For the midground trees on the right, primarily use violets made with Ultramarine Blue and Quinacridone Red, warmed with a bit of yellow and white to define tree shapes. Using the same colors you used for the background and midground trees, restate the water with broken strokes of color, following the shadow and light areas of the trees as a pattern for the reflections. Use no. 2 filberts with little horizontal strokes to indicate slightly rippled water. Reflect a few rocks and tree trunks into the water.

Continue developing the foreground area of underbrush up and around the main tree trunk, adding blades of grass and assorted weeds. Develop the towpath with cooler spots of color in the shadow areas using combinations of Phthalo Blue, Cadmium Red Light and white. Allow a few of the previously painted warmer spots to show through for variety.

Have fun with the scattered spots of light on the towpath, and add some lighter areas with orange and white. Indicate a few dry leaves for a touch of naturalism and wildflowers to sprinkle color into the underbrush.

135

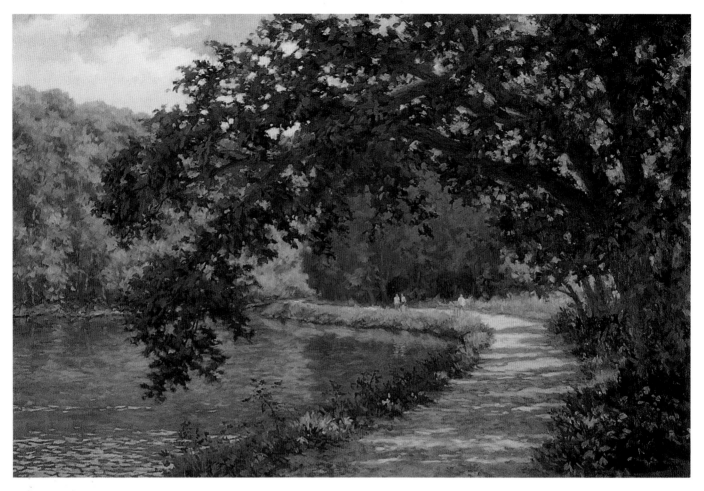

• 4 FINISH THE PAINTING

Once the paint is dry, brush a light coat of Liquin on the water area to prepare it for the sky reflections. With a color that is just a tad darker than the sky, use small horizontal strokes, using one of the photos as a guide. Complete this foreground area with grass and weeds along the textured towpath. Lightly paint three small figures on the towpath. Check your reference material for their relative size. No detail is required—just a few accurate color strokes will say it all.

Refine the color of the sky just above the trees, making it grayer with a Phthalo Blue, Cadmium Red Light and white mixture. Brighten the blue above the clouds with spots of a mixture of Ultramarine Blue and white. For better value contrast, lighten some of the reflections behind the large branch.

The towpath serves as a strong entrance into the painting. The viewer's eye wanders in from the left and follows it to the arching tree trunks. They, in turn, point the eye in a circular direction along the large arching branch toward the foliage kissing the water. A small branch grabs the eye and returns it to the towpath, where it ultimately rests on the figures in the background. The "O" format allows movement and rhythm while effectively framing the entire center of interest.

The variegated shadows on the towpath, the various textures in the underbrush and the sparkly reflections on the water entertain the viewer on the journey. Warm, sunny highlights and cool shadows convince the viewer of a hot summer afternoon along the canal.

Afternoon on the Towpath Oil on linen • 16" × 24" (41cm × 61cm) • Barbara Nuss

Capturing the Unique Effects of Side Light

Side light creates a unique situation. Because of the low angle of the light source, your light comes from one side of your painting instead of shining down from overhead. This creates both horizontal and vertical color changes. That is, if your light is coming from the left side, you must cool and darken your colors as you move across the canvas to the right side. Side light also affects your vertical colors as the light, warm and bright hues catch on the tallest objects in your painting. Using the chart below, darken, cool and mute your local colors one step at a time as you descend toward the shadowy foreground. Apply this principle when painting early morning and late evening scenes with tall objects such as mountains, skyscrapers or trees.

Warm

Cool

 Color Recession for Snowy White
For side light on this scene, modify your local color (white) with tints of yellows at the snowy mountaintop. As you work down the mountain, gradually cool your colors until you reach the cool blues and grays located on the valley floor in the foreground.

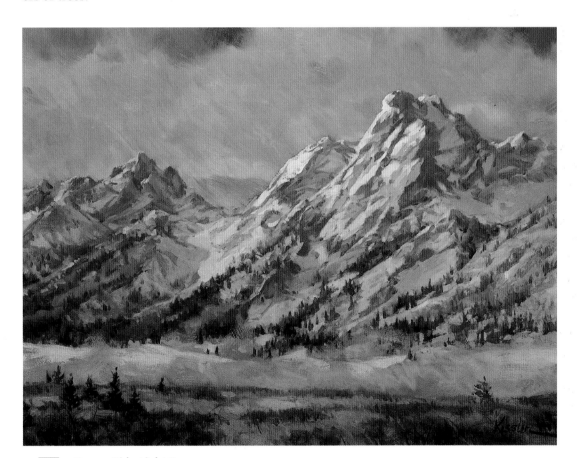

Snowy Side-Light Scene
To establish side light in the blue of this evening sky, apply tints of warm Phthalo Blue oil paint on the left near the source of light, and cool it with tints of Ultramarine Blue as you work across the sky to the right. To enhance color harmony, echo the colors you used in the foreground snow in the clouds, again starting with warm light colors on the left. Skip the yellow hues and begin with tints of muted orange-reds. You don't want the clouds competing with the yellowish mountaintop. Use tints of grayed reds and blues for the clouds on the right—subtly receding from warm to cool and light to dark as you move away from the light source. In the foreground, the values are kept dark, gradating to lighter tones in the distance, high on the canvas where the light hits.

P.S. A River Runs Through It Oil on linen • 18" × 24" (46cm × 61cm) • Margaret Kessler

Sunlight Streaming Through Atmosphere

DEMONSTRATION: OIL OR ACRYLIC

Sunlight streaming through a slight atmospheric condition is a theme that Turner explored, at times almost losing the subject matter. The sunlight not only illuminates the subject but the atmosphere itself, especially in the late afternoon sun.

Materials List

OILS OR ACRYLICS
Alizarin Crimson, Burnt Umber, Cadmium Red Light, Cadmium Yellow Light, Cerulean Blue, Sap Green (Hooker's Green for acrylics), Terra Rosa (Red Oxide for acrylics), Titanium White (a soft formula for oils, gesso for acrylics), Ultramarine Blue, Viridian, Yellow Ochre

SURFACE
12" × 16" (30cm × 41cm) Masonite or canvas

BRUSHES
nos. 1, 2, 4, 6, 8, 10 and 12 hog-bristle filberts; nos. 4, 6, 8, 10 and 12 hog-bristle flats; large sable flat for oils; large 2- to 3-inch (51mm–76mm) flat for acrylics

OTHER
container—a plastic bucket for acrylics or a silicon jar for oils, Liquin for oils, palette, palette knife, water for acrylics

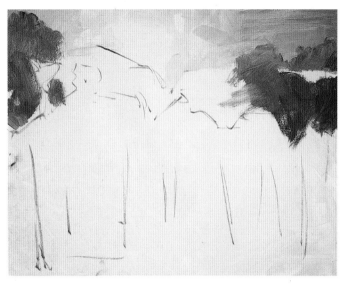

• 1 SKETCH THE SUBJECT AND APPLY BACKGROUND TONES
On a light neutral-toned piece of Masonite, paint a quick light sketch of the basic shapes to give a compositional theme. Apply a pale group of tones in the background using very close values with a no. 10 hog-bristle flat or filbert.

• 2 ADD MID-VALUE DARKS
Continue with a no. 10 hog-bristle flat or filbert and establish most of the close mid-value darks, looking for some color variation. Concentrate on the atmospheric warm color quality. Avoid going too dark but keep in mind where the intensity of the sun is (top center).

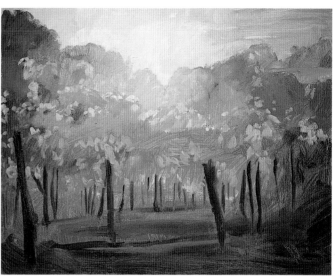

• 3 BLOCK IN ATMOSPHERIC EFFECTS

Again with your no. 10 hog-bristle flat or filbert, block in the golden atmospheric effect on the main subject of the vineyard foliage. Add a couple of the stronger vines with a no. 8 hog-bristle filbert. The total atmospheric look should be there by now.

• 4 ADD THE DISTANT VINES AND STAKES

With the no. 8 hog-bristle filbert, slow down a bit and concentrate on the distant vines and stakes. Slowly begin to develop the warm yellow light on the vineyard foliage, keeping the values close. Use a well-loaded brush and smaller strokes to depict leaves.

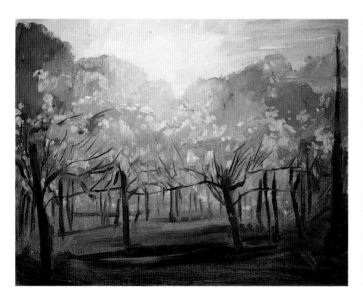

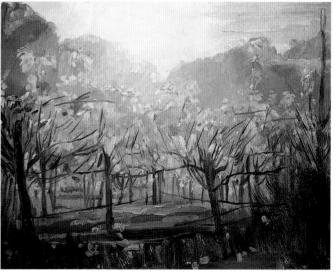

• 5 DEVELOP THE FOILAGE AND BRANCHES

The progress always appears slower as the painting nears completion. This is because the big effects are usually done by now, and more subtle detail and slower fine-tuning are the concerns. With the no. 8 hog-bristle filbert, continue developing the lush qualities of the foliage. Loosely add in some more branches as you begin to focus more on linear detail.

• 6 FINISH THE PAINTING

Finally, using a no. 4 hog-bristle filbert and a light delicate touch, focus on the details such as smaller branches, more foliage variation, ground textures and color variations. Emphasize darks (only a little). A few color variations in the foreground will indicate some flower and weed shapes. A possible adjustment here and there in the sky helps the atmospheric glow effect.

Vineyard Glow
Oil on Masonite • 12" × 16" (30cm × 41cm) • Craig Nelson

Low-Angle Afternoon Light

DEMONSTRATION: OIL OR ACRYLIC

Looking down a mission corridor, the attraction of the low-angle afternoon light and cast shadows is inspirational.

Materials List

OILS OR ACRYLICS
Alizarin Crimson, Burnt Umber, Cadmium Red Light, Cadmium Yellow Light, Cerulean Blue, Sap Green (Hooker's Green for acrylics), Terra Rosa (Red Oxide for acrylics), Titanium White (a soft formula for oils, gesso for acrylics), Ultramarine Blue, Viridian, Yellow Ochre

SURFACE
12" × 16" (30cm × 41cm) Masonite or canvas

BRUSHES
nos. 1, 2, 4, 6, 8, 10 and 12 hog-bristle filberts; nos. 4, 6, 8, 10 and 12 hog-bristle flats; large sable flat for oils; large 2- to 3-inch (51mm–76mm) flat for acrylics

OTHER
container—a plastic bucket for acrylics or a silicon jar for oils, Liquin for oils, palette, palette knife, water for acrylics

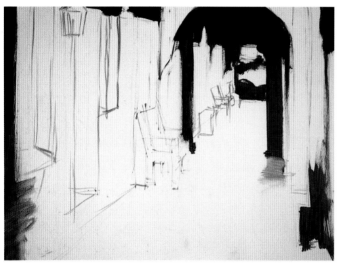

• 1 SKETCH THE SCENE AND ESTABLISH THE DARKEST TONES
The importance of perspective requires a more accurate sketch. Lay in this sketch on a light neutral warm-toned piece of Masonite, 12" × 16" (30cm × 41cm), with a no. 2 hog-bristle filbert. The darkest tones should then be established with a mixture of Burnt Umber and Ultramarine Blue (leaning a little warmer) with a no. 10 hog-bristle flat.

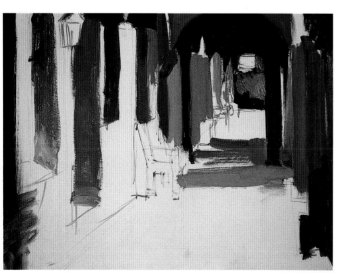

• 2 ADD THE SHADOW TONES
Begin at the distant wall and move up to the foreground, working on the shadow tones and paying special attention to the variations of warms and cools. Vary these from gray-violets and rust tones to warm ochres as the subject dictates (observe carefully). These color nuances are local color variations and the effect of reflected light off of walls and ceilings. A no. 8 hog-bristle flat or filbert or a no. 10 hog-bristle flat or filbert will work best.

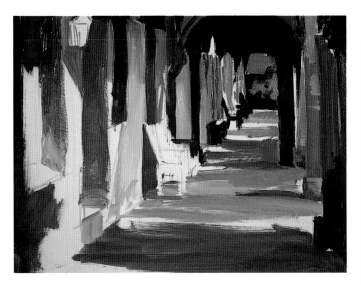

• 3 ADD FURTHER SHADOWS AND EVALUATE
Continue to concentrate on the shadow patterns, the subtle color changes and value variations using a no. 8 hog-bristle flat or filbert. The tone of the board is acting as a light at this point. By now the total basic effect of the painting should be established and evaluated before continuing to the next step.

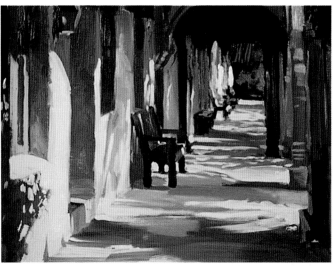

• 4 ADD FOREGROUND ITEMS AND BEGIN TO REFINE THE PAINTING
It is important to make sure all of the elements are in place. Indicate any additional subjects, such as the foreground bench and lamp. Subtle color changes and gradations in the shadows need to be manipulated (both darker and lighter) with the no. 8 hog-bristle flat. Now paint the warm light striking the ground and walls with a fully loaded no. 8 hog-bristle flat. Pay special attention to refining shadow shapes by using the light to carve in and further define.

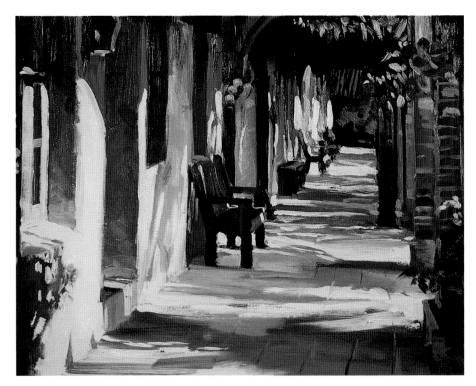

• 5 FINISH THE PAINTING
Continue to refine the shadows; pay attention to shadow detail and refinement. These need to be addressed sensitively with nos. 2 and 4 hog-bristle filberts. Indicate the brick forms on the columns, the tiles on the corridor and some foliage creeping in. Paint a bit of warm light striking some of the leaves to complete the afternoon light effect.

Late Afternoon at the Mission
Oil on Masonite • 12" × 16" (30cm × 41cm) • Craig Nelson

141

Grasses and Wildflowers at Evening

DEMONSTRATION: ACRYLIC

This demonstration will give you lots of tips and tricks for painting realistic vegetation. This scene is typical of the Midwestern United States, particularly the sunflowers, dead grasses, bright weeds and wildflowers. Lots of things to make you sneeze.

Materials List

ACRYLICS
Anthraquinone Blue, Cerulean Blue, Diarylide Yellow, Dioxazine Purple, Jenkins Green, Quinacridone Magenta, Titanium White

SURFACE
18" × 24" (46cm × 61cm) gessoed Masonite

BRUSHES
One-stroke brushes:
⅛-inch (3mm), ¼-inch (6mm), ½-inch (12mm), ¾-inch (18mm), 1-inch (25mm) and 1½-inch (38mm)
Script brushes: nos. 1 and 2

OTHER
alcohol and cotton swab, ballpoint pen, bridge, drafting or masking tape, light-spray bottle, lift-out tool, masking fluid, old brush, pencil, palette, palette knife, paper towels, ruling pen, Saral paper or pastel stick, scissors, soap, Soft Gel Gloss, tracing paper (inexpensive), water

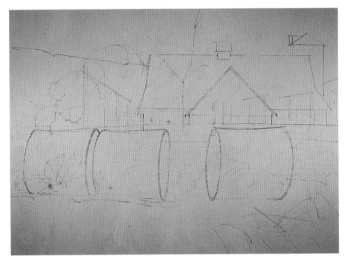

• 1 APPLY A TRANSPARENT WASH

Brush a mixture of pale orange made with Diarylide Yellow and Quinacridone Magenta with a touch of Cerulean Blue and Titanium White onto the board in a random pattern. While still wet, use a paper towel to give it a vertically streaked texture. After this dries, use some soap and water on a paper towel to wash off some of the smears in the lower areas of the painting. The foreground is going to have transparent washes applied to it, and you won't want a dark smudgy color to interfere. Rinse thoroughly and allow it to dry. Sketch the painting on tracing paper and transfer it onto the Masonite using Saral paper or pastel stick.

■ MIST YOUR PAINTINGS

As you start to work the panel, use your light-spray bottle and mist the surface of the panel to help the paint flow more smoothly.

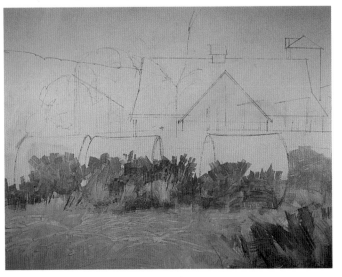

• 2 PAINT THE GRASS

The grassy area in the foreground is a stronger mixture of orange (Quinacridone Magenta and Diarylide Yellow) with a touch of Cerulean Blue to slightly gray the mix. This is a dead grass color. The greener grass and weeds are a mixture of Diarylide Yellow, Jenkins Green and a touch of Quinacridone Magenta. We want to give this a more alive look. Mixing a wash of the orange-brown color, paint the foreground and while still wet, use the lift-out tool to indicate grass texture.

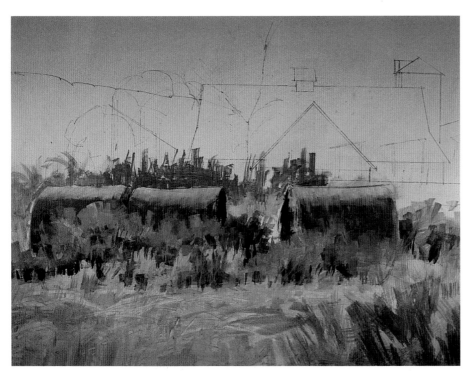

• 3 PAINT THE BALES OF HAY

Create a mixture of Anthraquinone Blue and Dioxazine Purple. Add a small amount of this mixture to the orange color for the bales of hay; this will gray it and give it shading. Notice how the bottoms of the bales are darkened to make the weeds in front stand out. As you work the foreground green bushes and grass in front of the bales of hay, use the light-spray bottle a lot. When you lay in the darker greens, wipe the brush out and blend the dark green into the light.

■ **CREATE CONTRAST**

Notice how the bottoms of the bales are darkened to make the weeds in front stand out.

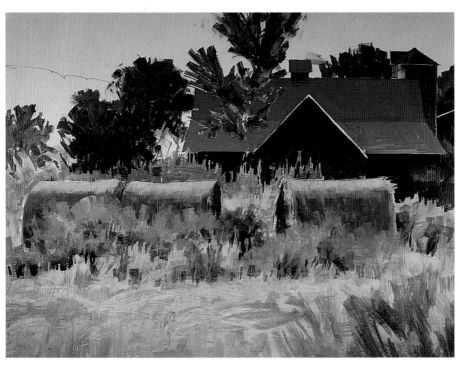

• 4 ADD THE TREES AND BARN

Paint the trees with a mixture of Jenkins Green, Anthraquinone Blue and Diarylide Yellow. You may want to add a touch of Quinacridone Magenta. Add a small amount of Anthraquinone Blue, Titanium White and Diarylide Yellow to Quinacridone Magenta to create a mixture that is mostly red and block in the barn using the bridge for the straight edges.

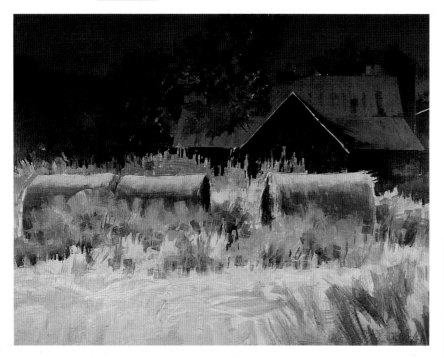

• 5 PAINT THE HILL AND SKY

Paint the background hill and sky. The hill is a mix of the base colors that lean toward Anthraquinone Blue. The sky is darker than the barn roof but lighter than the hill. Use some of the hill color to paint shadows on the barn roof and the silo. A very dark setting makes the foreground grasses and flowers stand out. Everything in the background is going to have a lot of Anthraquinone Blue in the mix.

■ CREATE UNITY

When you finish step five, analyze the painting. You may want to wash it down with a very thin wash (90 percent water and 10 percent pigment) of a dark blue to unify the colors. Use very thin washes so you can intensify the wash as needed by applying more washes.

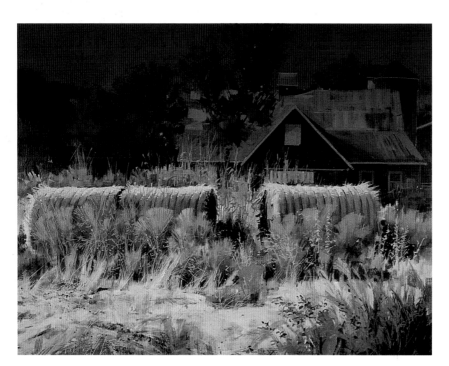

• 6 ADD DETAIL

Now it's time for the script brush and ruling pen. You will want to further develop the grasses with lighter tones and darker shadowed areas. A few splatters, particularly in the background trees, are in order. Use a cotton swab dipped in alcohol to very carefully lift out highlights on the tops of the bales of hay.

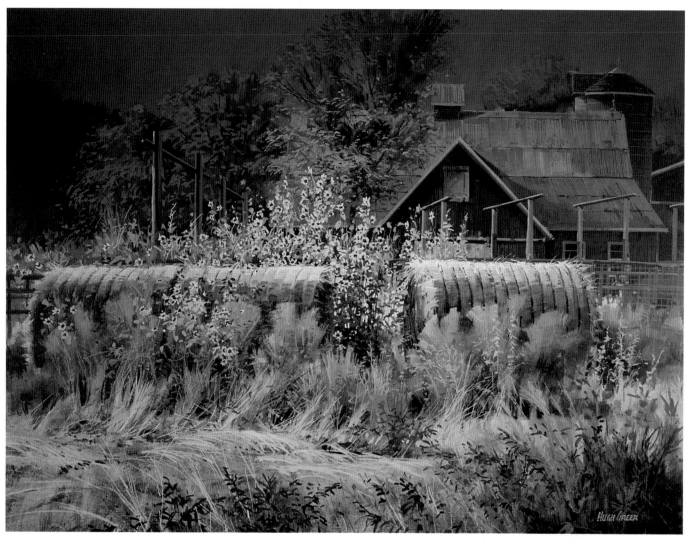

• 7 FINISH THE PAINTING

Using a no. 2 script brush, put in the sunflowers with an opaque color mixed from a combination of Diarylide Yellow, Titanium White and Dioxazine Purple. When dry, create a lighter mixture of Diarylide Yellow and Titanium White and place it on the petals to highlight them. For the center of the flowers, try a mix of Diarylide Yellow and Dioxazine Purple. Use the flat edge of a ¼-inch (6mm) one-stroke to put in the leaves on the sunflowers.

Paint in the cattle-loading pens with a dark color mixed from the base palette. Use a warm color on the sides with light and a cool color on the shaded sides.

Summer's Last Hurrah Acrylic on gessoed Masonite • 18" × 24" (46cm × 61cm) • Hugh Greer

Tree in the Evening Light

DEMONSTRATION: ACRYLIC

Sometimes it's fun to try to create detail with a larger brush than usual. Here we will try to capture the setting sun using a ¾-inch (18mm) one-stroke.

Materials List

ACRYLICS
Anthraquinone Blue, Cerulean Blue, Diarylide Yellow, Dioxazine Purple, Quinacridone Magenta, Titanium White

SURFACE
9" × 12" (23cm × 30cm) Crescent illustration board no. 1

BRUSHES
One-stroke brushes:
⅛-inch (3mm), ¼-inch (6mm), ½-inch (12mm), ¾-inch (18mm), 1-inch (25mm) and 1½-inch (38mm)
Script brushes: nos. 1 and 2

OTHER
palette, palette knife, paper towels, ruling pen, water

• 1 WASH THE BOARD
Use a big brush, a ½-inch (12mm) or ¾-inch (18mm) one-stroke, to wash the board with orange made with Quinacridone Magenta, Diarylide Yellow and Titanium White. With a paper towel, make a swipe to establish a horizon line. Remember the sky is lighter toward the horizon than at the top of the painting. Soften the sky area with a paper towel so the sky is lighter than the ground.

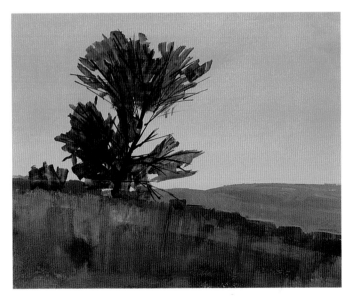

• 2 PAINT THE TREE
Mix some Dioxazine Purple into the background orange used in step one and use it to paint the tree skeleton with a ⅛-inch (3mm) one-stroke. With a ½-inch (12mm) one-stroke turned on its edge, add foliage to give the tree shape. Leave some holes in the foliage to allow the sky to show through. Avoid filling the tree with leaves, which would make it look like a lollipop. Add the distant mountain and some green where the grasses and wildflowers will be.

■ CREATE HARMONY

The fence posts, grass highlights and leaf highlights are all the same color. This helps create color harmony within the painting.

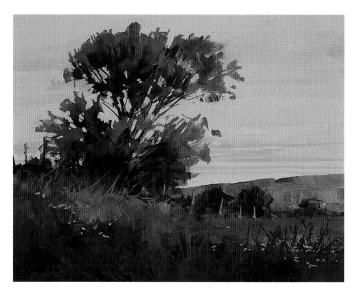

• 3 PAINT THE SKY, LEAVES AND GRASSES

Paint the sky behind the tree with Cerulean Blue and Titanium White. While it is still wet, wipe some off with a paper towel, exposing some base orange for the clouds at sunset. Make sure you place some sky in between the branches of the tree.

Mix a green with Diarylide Yellow and Anthraquinone Blue. Put that to the side and mix another orange similar to the original wash but more opaque (thicker) using Quinacridone Magenta, Diarylide Yellow and Titanium White. Combine the newly mixed green and orange, making a green-orange. This new green-orange will be your highlight color for the leaves and grasses. Add leaves to the tree, being sure to leave some holes so the sky can show through the tree. Add highlights to the leaves with your green-orange color.

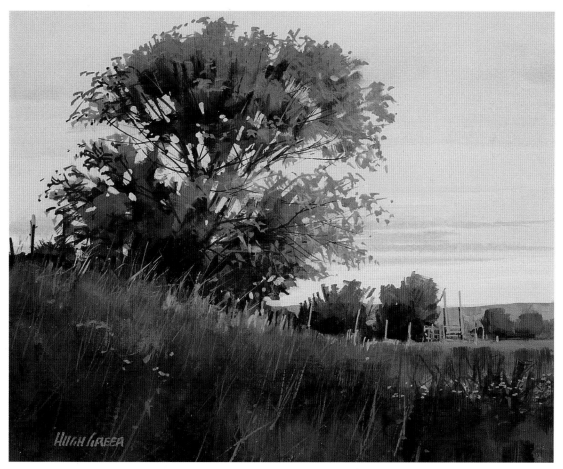

• 4 FINISH THE PAINTING

Darken and define the foreground grasses using a script brush, palette knife, ruling pen, paper towel, fingertip or anything else that works. The grass and tree color are the same. Chop down the hill on the right using opaque orange. Darken the shadows in the foreground. Add the fence posts.

Flint Hills Elm Acrylic on Crescent illustration board no. 1 • 8" × 10" (20cm × 25cm) • Hugh Greer

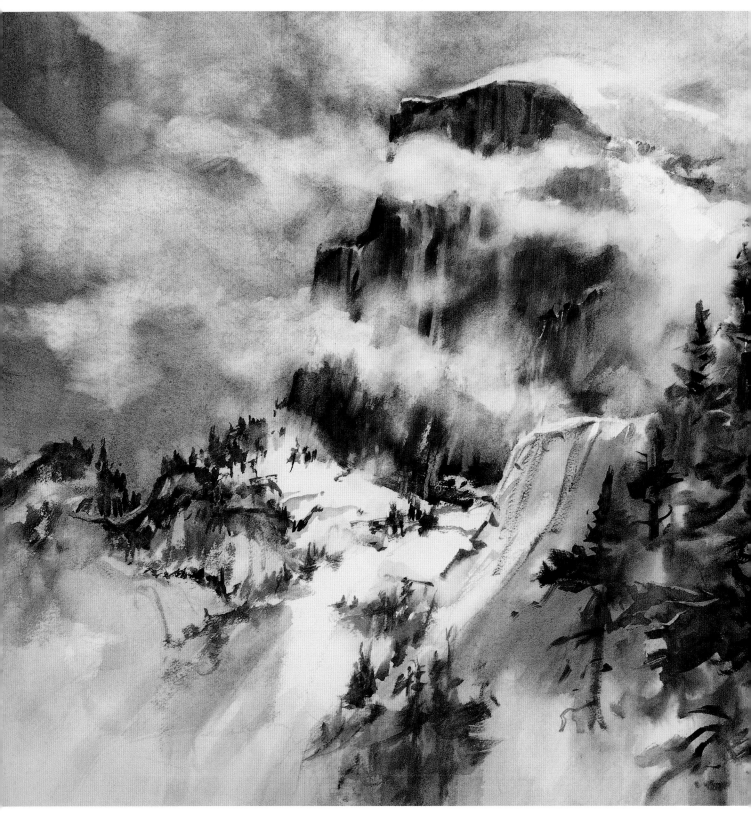

Misty Half Dome Transparent watercolor • 21" × 28" (53cm × 71cm) • Jane R. Hofstetter • Collection of the artist

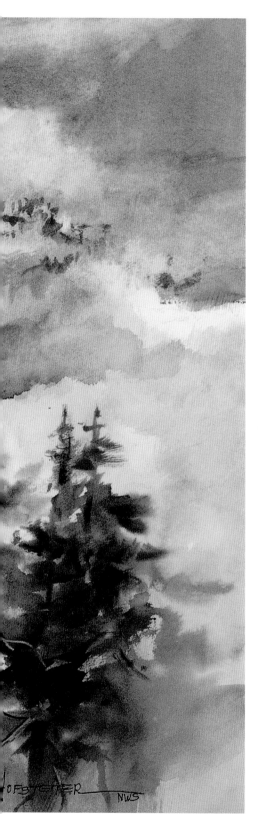

CHAPTER 5

Clouds, Mist, Rain & Snow

It's great to practice painting in weather conditions other than beautiful, sunny days. Atmospheric conditions are often an integral part of landscape painting. Clouds, mist, rain and snow are crucial elements than can depict the mood of a scene.

Evening Clouds

DEMONSTRATION: OIL

Clouds are unique elements to paint because there is so much distance between them and the viewer in real life. Because the sun is low in the sky in this painting, the shadows appear on the tops of the clouds. Remember to keep the edges of the clouds soft. The elephants at the bottom add scale to show the viewer just how magnificent this cloud formation is.

Materials List

OILS
Cadmium Red, Cadmium Yellow, Flesh Tint, Naples Yellow, Payne's Gray, Titanium White, Transparent Red Oxide, Ultramarine Blue

SURFACE
11" × 14" (28cm × 36cm) canvas

BRUSHES
Langnickel Royal sable series 5590 flats nos. 4, 16, 33, and 44; 2-inch (51mm) house-painting brush

OTHER
paper towel, turpentine, white gesso

• 1 BLOCK IN THE CLOUDS
Prime the canvas with thick gesso and a 2-inch (51mm) house-painting brush, allowing the brushstrokes to show. Let this dry fully. Then glaze the canvas with a no. 33 flat and a mixture of Cadmium Red, Flesh Tint, Cadmium Yellow and turpentine. Rub off the excess paint with a paper towel before it dries. Block in the highlight areas of this cumulonimbus cloud with a no. 16 flat and a mixture of Cadmium Yellow, Flesh Tint and Titanium White.

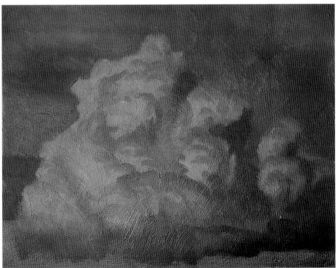

• 2 ESTABLISH THE CONTRAST
The sun is about to set behind the viewer, so the sky is starting to get dark. Paint in the sky with a no. 44 flat and Ultramarine Blue and Flesh Tint. While the paint is still wet, block in shadows on and between the clouds with a no. 16 flat and a mixture of Ultramarine Blue, Payne's Gray and Flesh Tint. The shadows will be on top of the clouds because the sun is low in the sky behind you. It's OK if some of the underpainting still shows through.

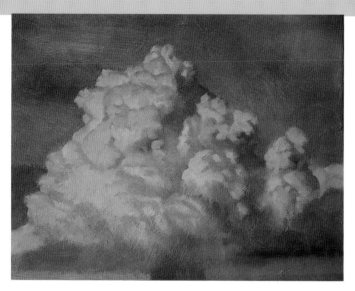

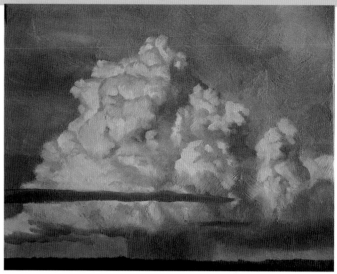

• 3 SOFTEN THE EDGES

Emphasize the existing highlights and add new ones with a no. 4 flat and a mixture of Cadmium Yellow, Flesh Tint and Titanium White. Blend the edges by pulling the light areas into the dark areas. Drag the shadow area to the horizon with a no. 4 flat and a mixture of Payne's Gray and Flesh Tint.

• 4 ADD THE ACCENTS

Add more highlights to the cloud with Titanium White. Lighten the sky with Titanium White and Flesh Tint. In the foreground, paint a couple of stratocumulus clouds that aren't catching the light of the sun with a no. 16 flat and a mixture of Flesh Tint, Cadmium Red and Payne's Gray. Use the same mixture to paint the distant rainstorm below the clouds. Paint the horizon with a no. 16 flat and a mixture of Transparent Red Oxide, Payne's Gray and Ultramarine Blue.

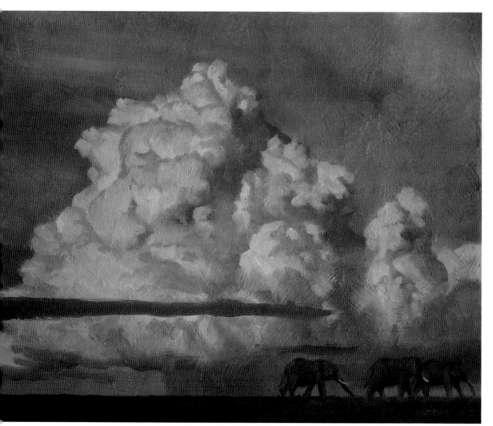

• 5 ADD THE FINISHING TOUCHES

Add more light to the cloud with Titanium White, Naples Yellow and Flesh Tint. Raise the horizon slightly to give the elephants something to stand on. Paint them with a no. 4 flat and a mixture of Payne's Gray, Transparent Red Oxide, Titanium White and Flesh Tint. Paint the tusks with Titanium White and add some subtle shadows underneath the elephants with Payne's Gray. In addition to creating more interest, the elephants provide a scale for the viewer to see how massive the cloud really is.

A Walk in the Clouds Oil on canvas • 11" × 14" (28cm × 36cm) • John Seerey-Lester

Painting Evening Clouds With Trees

Beginning the Painting

With soft vine charcoal, enlarge the drawing onto your canvas. With a neutral blue-gray paint, follow the drawing lines, wiping the charcoal away as you go. Then begin blocking in the scene.

Clouds: Using a large brush and lots of white warmed with a bit of Yellow Ochre, paint a scattered formation of clouds. Weave them behind the tree and bleed them off to the right. Refer to your photos for accurate cloud patterns but angle them a bit to suggest movement.

Sky: Paint the sky with a large brush, working from bottom to top. First paint the yellow area where the sun has just disappeared behind the trees, then the reds and yellow-greens. Gradually add Ultramarine Blue proceeding toward the zenith, and finally add Quinacridone Red to give the Ultramarine Blue a slight violet tone.

Darkest foliage: First paint the darkest areas—the main tree trunk with a dark warm gray and the foliage with a dark violet-green.

Other foliage: Move on to the side planes of the tree rows and use a lighter tone for the flat planes.

Developing the Painting

Start defining and refining specific areas

Clouds: Restate the clouds that are tinged with gold using a mixture of white, Quinacridone Red and Cadmium Yellow Light. Paint delicate shadows on top of the clouds (since the sun is below them) with a soft gray made of Cadmium Red Light, Phthalo Blue and white.

Tree rows: Develop the remaining tree rows with varying shades of cool greens, the coolest tree row being the farthest one back. For a touch of autumn, introduce a cool orange to the right tree of the first tree row and to some other trees to spread the color around. Shape the trees with various values of green-violets.

Main tree: Reshape the tree trunk so it doesn't look like three trees; it is only one tree with three large trunks. Brush more foliage into the sky that has been painted, keeping the edges soft.

Sunset: Following the colors of the field sketch, continue the sunset colors behind the trees. Overlap the sky color onto the tree colors to soften their edges. Paint effective sky holes in various shapes and sizes in the backlit foliage.

Blend the cloud paint into the sky color for effective soft edges. Paint the small distant cloud formation with smaller individual puffs for convincing aerial perspective.

Paint the flat plane with a bare hint of texture and a variety of greens, interspersing the greens with browns and oranges. Introduce some silhouetted bushes with squiggly branches and bits of leaves.

Paint the rest of the shadowed trees simply since little detail is visible. There is a slight value change at the treetops where they receive reflected light from the descending sun. Softly blend the tree colors over the sky color and vice versa.

Capturing the Colors of a Sunset

The silhouetted tree at a right angle to the horizon forms the timeless cross format. Dividing both the horizontal and vertical spaces into thirds alleviates any static shapes. The slight elevation in the foreground contributes not only to a sense of depth but also allows a path through the painting. The viewer's eye exits the painting on the cloud mass bleeding off the right edge.

The simple, glowing cloud formations repeat the horizontal planes of the tree rows, contributing to a quiet autumn sunset.

October Evening Oil on linen • 16" × 20" (41cm × 51cm) • Barbara Nuss

Clouds in a Sunny Sky

DEMONSTRATION: ACRYLIC

It is important to create a believable sky since from it comes all the lighting in your painting. Usually when something is wrong with a landscape, the first place to look is the relationship between sky and ground. Unless you're painting a skyscape, don't overdo the sky, particularly if there are a lot of other things going on in the painting. In other words, a plain, simple sky—maybe just blue—can be the best. Let's look at a few approaches to tackling clouds.

Materials List

ACRYLICS
Anthraquinone Blue, Cerulean Blue, Diarylide Yellow, Quinacridone Magenta, Titanium White

SURFACE
11" × 14" (28cm × 36cm) Crescent illustration board no. 1

BRUSHES
One-stroke brushes:
½-inch (12mm), ¾-inch (18mm)
Script brushes: nos. 1 and 2

OTHER
lift-out tool, palette, palette knife, paper towels, spray bottle, water

■ PAINTING CLOUDS

As clouds recede into the distance, the white part becomes warmer while the landscape becomes cooler and lighter. The larger the cloud, the darker its bottom.

• 1 APPLY A WASH
On a piece of Crescent illustration board no. 1, apply a graded wash with pale yellow at the top and a slightly darker orange toward the bottom. Allow to dry completely.

• 2 SPRAY THE BOARD
After the warm wash is dry, use the spray bottle to wet the surface just enough for individual beads to stand up. Don't overdo it, or you'll have to wait until it dries and then start over. You need the beads of water. Into the beads or drops of water, put a sky-blue wash in the shape of the cloud you want. The blue color should jump from drop to drop, creating a lacy look. Allow this first cloud-shaping wash to dry.

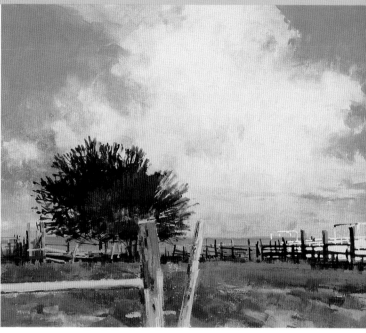

• 3 SPRAY IT AGAIN

Repeat the process in the previous step: Spray with water so beads develop, apply wet pigment, watch the color jump from drop to drop. Now mix some gray for the undersides of the clouds. Make the gray from a mixture of the sky blue and a little orange. Work a little of the gray into the wet droplets. Expose the warm color close to the horizon by using a lift-out tool.

• 4 FINISH THE PAINTING

The success of this procedure depends on your ability to capitalize on accidents. Work out the finishing elements of the cattle chutes, fence posts and trees.

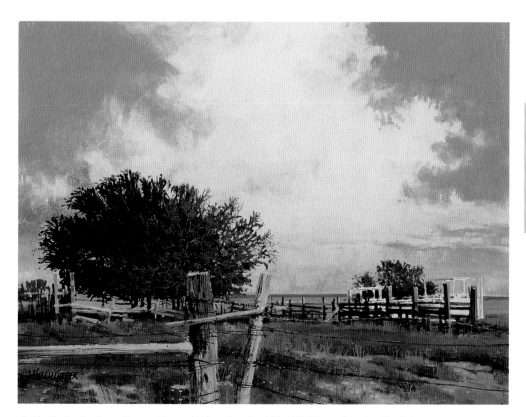

Cattle Chutes Acrylic on Crescent illustration board no. 1 • 11" × 14" (28cm × 36cm) • Hugh Greer

■ UNIFY WITH A BASE COLOR

Painting a base color on your panel is helpful in unifying the colors in the sky and on the ground.

Field on an Overcast Day

DEMONSTRATION: OIL OR ACRYLIC

A landscape with atmospheric and sunlight effects that make it look overcast is a great subject for artists. Use a 14" × 18" (36cm × 46cm) light warm neutral-toned piece of Masonite or canvas.

Materials List

OILS OR ACRYLICS
Alizarin Crimson, Burnt Umber, Cadmium Red Light, Cadmium Yellow Light, Cerulean Blue, Sap Green (Hooker's Green for acrylics), Terra Rosa (Red Oxide for acrylics), Titanium White (a soft formula for oils, gesso for acrylics), Ultramarine Blue, Viridian, Yellow Ochre

SURFACE
14" × 18" (60cm × 46cm) Masonite or canvas

BRUSHES
nos. 1, 2, 4, 6, 8, 10 and 12 hog-bristle filberts, nos. 4, 6, 8, 10 and 12 hog-bristle flats, large sable flat for oils, large 2- to 3-inch (51mm–76mm) flat for acrylics

OTHER
container—a plastic bucket for acrylics or a silicon jar for oils, Liquin for oils, no. 2 pencil, palette, palette knife, water for acrylics

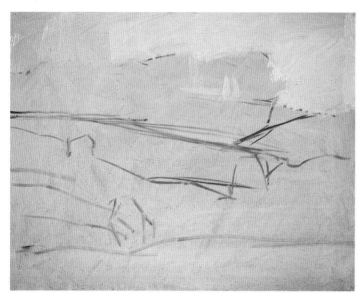

• 1 SKETCH IN THE BASIC SHAPES AND LAY IN THE UNDERPAINTING
Use a no. 2 pencil to sketch in the large masses. Create the basic shapes that make up the composition. Lay in a light sky color that becomes lighter and warmer on the right, where the sunlight is coming from. Use a no. 12 hog-bristle flat. Overlap into all the linework, working from background to foreground.

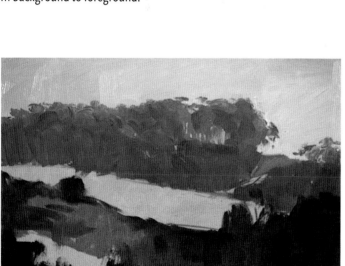

• 2 ADD THE BACKGROUND
Because of the atmospheric conditions, the background appears lighter and softer than the foreground. With this in mind, use a no. 12 hog-bristle flat to lay in the background mass—a grove of trees—using a soft and light neutral gray-green. Give special attention to the trees' edges. Work toward the foreground. Keep the gray shapes of the foreground foliage darker than the foliage in the background. At this stage you want to create subtle warm and cool color variations and an overall value pattern.

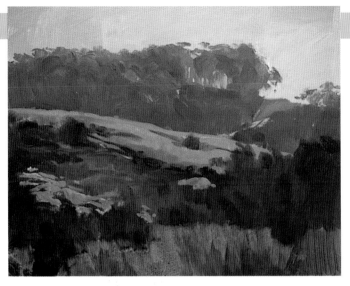

• 3 WASH IN THE UNDERBRUSH AND ADD THE HEATHER

Fill in the rest of the picture by washing in the foreground underbrush with a no. 10 hog-bristle flat using two values of grayed ochre. Next use the no. 10 hog-bristle flat to lay in the pink heather with a bit more color intensity at the base. Go back to the dark foliage and add the tree shapes in the foreground, overlapping the mass of pink flowers.

• 4 ADD HIGHLIGHTS

Give some dimension and light effects to the various tree masses. Stay with the no. 10 hog-bristle flat and mix up a variety of light olive greens using Yellow Ochre for a base to create a sunlight effect. Work to keep the value contrast closer in the background and stronger as it gets closer. Take a no. 8 hog-bristle flat and add a few tonal and intensity variations into the pink heather. Keep it subtle.

• 5 REFINE SHADOWS AND LIGHT

It is necessary to complete the sunlight, or backlighting, effect on the tree forms, with special attention to the edges and textures. Emphasize this more on the foreground trees. Add a bit of light to the pink floral masses and within the shadow of the tree forms. Add a bit of subtle shadow detail.

• 6 ADD THE FINISHING TOUCHES

Slowing down for final decisive strokes, take note that the background trees could use some sensitivity in the edges of the tree shapes. Use a no. 6 hog-bristle flat with a full load of wet, lighter pink paint to enhance the heather with some light textural strokes, adding a touch of brighter pink here and there as it appears.

The Pink Blanket Oil • 14" × 18" (36cm × 46cm) • Craig Nelson

Enlivening a Dull Sky With Clouds

This interesting river scene was dulled by the muggy sky. Take a few reference photos to capture the details of the scene; as you work through different sketches, add some fluffy clouds to perk the scene up a bit.

 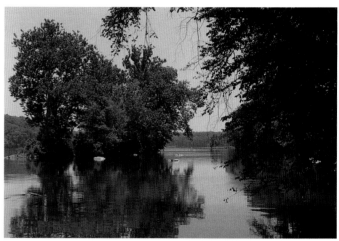

Overall Reference
Photograph the scene in sections to capture the fundamental details.

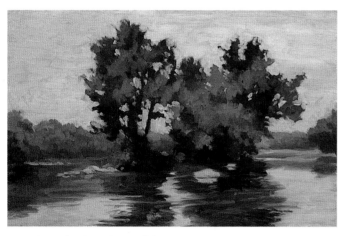

The Field Sketch
Paint the field sketch to capture the colors and atmosphere: the effect of the cobalt sky upon the island, the water and the values and colors in the distant trees. Make elementary changes that would improve the composition. For instance, since the island is on a plane horizontal to the picture plane, add interest and depth by pushing the right side of the island into the distance a bit. Focus on the rock patterns and cloud formations later in the studio.

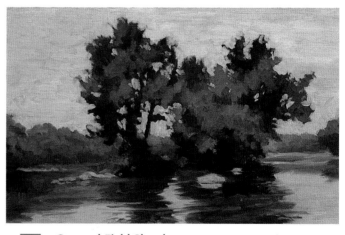

Cropped Field Sketch
After analyzing the field sketch, there is too much foreground. To solve this problem, attach 1-inch (3cm) white artist's tape across the bottom of the sketch. This new elongated shape results in a lowered horizon line and a more interesting division of space.

Solve Design Problems and Finalize Your Composition

Design Solution: Adjust Contrast and Fix Unsightly Tree Shapes

The right-hand tree is top heavy and its shape directs the viewer's eye out of the painting. Introduce a graceful branch hanging over the water to move the viewer's eye back into the painting.

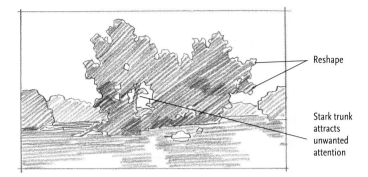

Reshape

Stark trunk attracts unwanted attention

Design Solution: Arrange a Grouping of Rocks

Arrange the craggy rocks to guide the viewer's eye around the painting. Lead in with a large rock and zigzag back to others in various sizes and shapes on different planes. Remember to paint the rocks a cooler, more realistic color in the final painting.

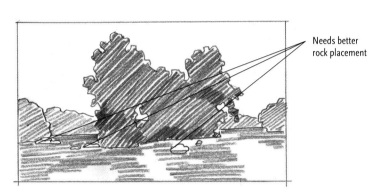

Needs better rock placement

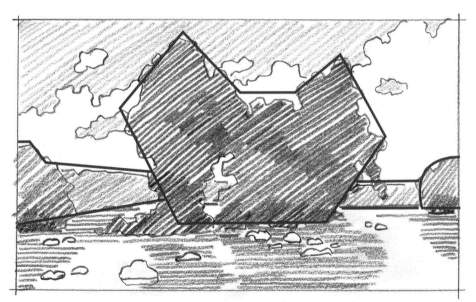

Final Pencil Drawing

Make a final pencil drawing to incorporate the design decisions. The new rock formation brings the viewer's eye in from the right, across the dark reflections, back to the left bank and finally to the center of interest. The viewer's eye then travels across the trees, and the added graceful branch brings the eye back into the painting. The cloud formation adds the necessary interest and counterpoint.

Design Solution: A Dull Sky Needs Cloud Shapes

Add a frothy cumulus cloud formation from another plein air sketch to enliven the boring sky. Angle the clouds to counterpoint the diagonal line of the islands. The two corners of the sky are now different, which gives movement to the painting.

Block In the Painting and Refine

Clouds and sky: Rough in the clouds using white tinged with orange on the sunlit side and grays on the shadow side. Working down from the top, paint the sky using Ultramarine Blue and white, then Cobalt Blue and white, and finally Phthalo Blue and white. Near the horizon line, add a tad of Phthalo Green to the white.

Background shadow areas: Use a lighter blue-violet tone for the shadow areas on the far shorelines. Use a wipe-out tool to describe the rock formations in these shadow areas.

Sky reflections and rocks: Paint the sky reflections slightly darker and grayer than the sky itself. For the rocks, use a gray mixture of Ultramarine Blue, orange and white to harmonize with the other bluish tones in the painting.

Trees and water reflections: With a variety of mid-value gray-greens, fill in the trees by working into the wet shadows. Add the mid-tones of browns and greens to the water reflections.

Midground shadow areas: Dark red-violet tones define the shadows in the island trees and the reflections.

■ **PAINTING REFLECTIONS**

Understanding how reflections work is the key to painting them accurately. They are not perfect mirror images. The water "sees" only underneath planes and upright planes of objects, never their top planes. For instance, a barn reflection reveals the underpart of an eave that the viewer can't see, while showing less of a sloping roof that is on an angle between an upright plane and a top plane.

Keep these facts in mind when painting reflections:

- **Width:** Since the reflections come toward the viewer's eye, the outer limits of the reflection can be no wider than the object itself.
- **Length:** If the water is smooth, the reflection is the same length as the object being reflected. The choppier the water, however, the longer the reflection. Paint a choppy reflection as if it were broken into tiny pieces and splintered by shards of sky.
- **Value and color in the dark areas:** Since the sky casts its tone over the entire water surface, the dark reflections from trees become slightly lighter than the trees themselves.
- **Value and color in the light areas:** The water surface varies greatly depending on the weather conditions. When the water is calm the reflections are just a tad darker than the sky. When the water is rough, it has shadows that darken its value. Therefore, the rougher the water, the darker the water.

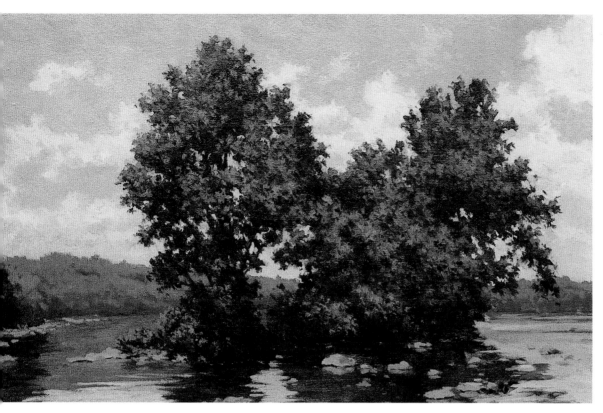

Developing the Trees

Rework the trees, beginning with the darker values and working toward the lighter ones. Use a cool green of Ultramarine Blue, Cadmium Yellow Light, a tad of Quinacridone Red and another tad or two of white for the shadow areas. For the medium and light tones, vary the greens by judiciously adding white, yellow, orange and/or blue.

Refining the Clouds and Developing the Reflections

Work green tones into the Burnt Sienna areas with sideways strokes parallel to the picture plane. Add the sky reflections, working into the darker areas.

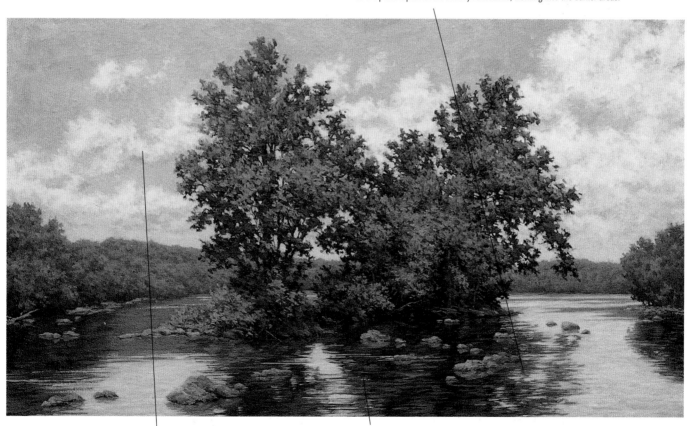

Restate the clouds, removing any peculiar shapes like smiley faces, doughnuts or dragons flying through the sky. Keep the edges soft with bits of blue breaking up the cloud masses.

Make convincing reflections by adding a glaze of Burnt Sienna. This reddish tone hints of the riverbed and introduces some contrasting colors evident in the field sketch but not in the reference photos.

Lighten the Burnt Sienna in some areas by adding Yellow Ochre and/or Cadmium Orange.

Add Details and Finish

Placing the Birds

Experiment with different bird arrangements by marking or painting on a piece of clear plastic wrap carefully taped to the painting. Try a variety of sizes and flying positions for interest. After you decide where you want them, paint the birds in various shades of dark gray: The smaller the bird, the more distant it is and the lighter it is.

Rocks in the Water

Paint the rocks that lead back to the island and emphasize a variety of sizes and shapes. Accentuate their cragginess by using angular strokes. Also paint them cooler and grayer as they recede into the distance, displaying the influence of the atmosphere (atmospheric perspective).

Highlights in the Water

Break up solid areas of tree reflections with occasional streaks of light, indicating a slight wind current. Extend one horizontal streak off the edge of the canvas to add interest.

Keeping the Symmetry Lively

Even though you use this balance scale format for a dominant center of interest, you also need to design the secondary areas of interest. Review the painting for structure and composition. Examine how the viewer's eye travels in and around the painting. With this painting, the viewer's eye first focuses on the large rock, zigzags back to the island rocks and journeys left toward the bank where a broken tree points to rocks along the distant bank. Then the eye travels to the large left-hand tree and up its branches, checks out the birds and moves to the right tree and down its side to the hanging branch, which brings the viewer's eye back into the painting.

Island Refuge Oil on linen • 18" × 30" (46cm × 76cm) • Barbara Nuss

Fog and Mist

Mists and fog can have a variety of effects on a scene. Either can change even the most familiar scene into something mysterious, alien or ethereal. Weather conditions like these act as a filter on the subject that softens and blurs the shapes in your compositions and mutes the intensity of the colors you use.

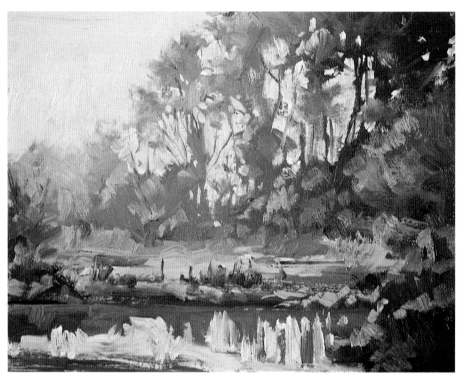

Light Through Mist
This high-key painting relies on a very close range of colors and a value range where nothing is darker than about a 50 percent gray. As the trees recede in the distance, they become closer to the sky tone as the mist almost engulfs them.

Coastal Mist Oil • 8" × 10" (20cm × 25cm) • Craig Nelson

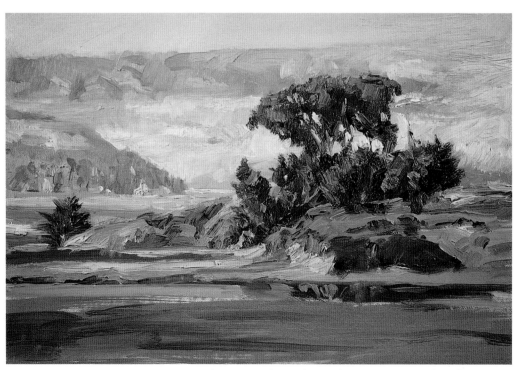

A Bold Landscape
Atmospheric conditions are often an integral part of landscape painting. Fog and mist are effects that may be crucial to depict a given scene. It is great practice to paint in various weather conditions, not only on beautiful sunny days. As the fog here begins to lift, it reveals much of the landscape in sunlight showing greater contrast and stronger color.

The Fog Leaves Tomales Oil • 12" × 18" (30cm × 46cm) • Craig Nelson

Contrast Between Foreground and Background Charms the Eye

Foggy mornings near the ocean are great scenes to paint. Here, the focal area of crisp detail in the upper left is contrasted by a hazy, mysterious background.

Morning Walk Transparent watercolor • 21" × 28" (53cm × 71cm) • Jane R. Hofstetter • Collection of the artist

Painting a Mist-Filled Day

The dark warm shape of the old boat stands out beautifully against the sunny, mist-filled background. The wind keeps the water so choppy that it glistens white. This is where painting experience helps; keeping the water very light as it appears, add a soft blue-green tone to it and a faint, loose, slightly warm reflection, all with a no. 10 bristle flat. Paint the boat with the same no. 10 bristle flat in the block-in stage and finished with a no. 6 bristle filbert and a no. 1 filbert (in the linear areas of the A-frame structure).

The Old Boat in Tomales Bay Oil • 14" × 11" (36cm × 28cm) • Craig Nelson

165

Painting a Cloudy, Rainy Scene

Overcast, rainy days can help you create quiet sense of place. The large amounts of moisture in the air affects the colors and values you use. This is especially true for background elements. Soften their edges and gray them down to capture the mood of the scene.

Main Photo Reference
Catch the basic scene in the instant of the camera's quick shutter.

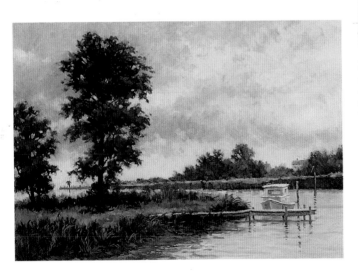

Sky Inspiration
Borrow rainy-day clouds from a previous field sketch.

■ DISTRIBUTING REPETITIVE ELEMENTS

For interest in your paintings, you may want to introduce repetitive elements. This may include sheep (as in this painting), cows, birds, puffy clouds, flowers, fence posts, trees, rocks, people and so on. As a guide to an artistic presentation, use odd numbers, like three, five or seven. When the elements are not easily counted at a glance, the number becomes irrelevant.

Randomly group the elements with natural variety in mind. For convincing perspective, make some larger in the foreground and some smaller in the midground and background. Clump several together and let one or two stand on their own. Consider the negative spaces and keep them interesting.

Design Solutions and Final Pencil Drawing
Adjust the final size to fit a 14" × 18" (36cm × 46cm) canvas. Simplify the background tree shapes, unifying them into one gray-green mass. Add a distant hill for balance.

From the previous value sketch, replace the angular tree stumps with softer-shaped rocks to help move the gray color around the painting. Increase the amount of foliage around the tree trunk and put some bushes in front of it to soften the shape.

Include a rainy-day sky to add interest to the otherwise boring, overcast day.

Add grasses and leaves in lighter, cooler greens.

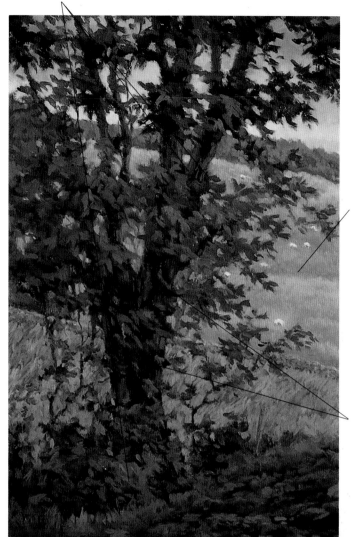

Use Subtle Greens to Portray Convincing Distance

Differentiate the foreground, midground and background that are all under a gray sky with various shades of subdued greens. There is an abundance of moisture in the air that affects the values and colors more on an overcast day than on a sunny, crisp day.

Combine Ultramarine Blue, Cadmium Yellow Light and white for your basic green color. To this, add pre-tubed gray to achieve the desired subtle effects.

Gray the greens more as they recede into the distance. The more moisture in the air between you and the background elements, the grayer these elements will appear. The moisture lightens the darks and darkens the lights. Save the strongest darks for the foreground.

In the foreground, contrast the background gray-greens with darker values on the trunk and surrounding foliage. For the darkest darks, use a combination of Phthalo Green with Quinacridone Red, Burnt Sienna or Cadmium Red Light.

Focus on the Background Interest

The moisture in the air not only grays distant elements but softens their edges as well. With blended areas and lost edges, paint the village houses and church. To distribute the grays, add some other houses and surround them with trees to suggest the hilly terrain. Paint the white houses light gray and paint the black windows dark gray.

Keeping the effect of the moist atmosphere in mind, paint the sheep on the hillside with little detail. Scatter them in a natural random pattern and reduce them in size as they recede into the distance. Use the reference photo for guidance.

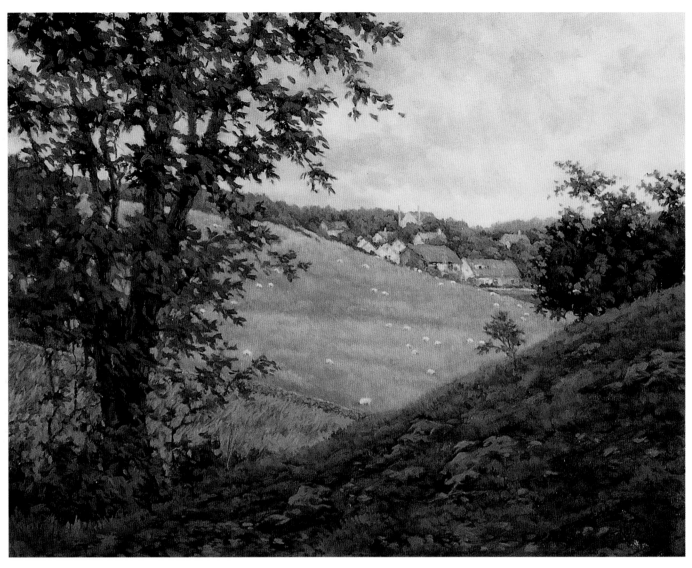

Adding the Atmosphere of a Rainy Day

The dynamic diagonals of this typical English hillside effectively portray a rainy-day mood and a quiet sense of place. The viewer's eye enters from the left, initially attracted by the softened value contrast between the tree and the reddish brown grasses behind it. The viewer's eye then follows the contour of the steep hill up toward the large bushes that stop the eye and direct it back toward the village and the grazing sheep. It then travels down the tree and begins the process again.

In this painting, the diagonal lines form an arrow pointing to the right. There is a stop or other design element on the right to prevent the arrow from leading the viewer's eye out of the painting.

Along the Mountain Goat Trail Oil on linen • 14" × 18" (36cm × 46cm) • Barbara Nuss

Capturing the Mood of an Overcast Day

he sky sets the mood of a landscape painting, making it one of the most intregal parts of a scene. When painted correctly, it will enhance the feelings you want your painting to evoke.

Locate Suitable Fences
Photograph some rustic wooden fences to consider for the final painting. The fence must not only contribute to the overall mood of the painting but also be a compositional tool to control the viewer's eye.

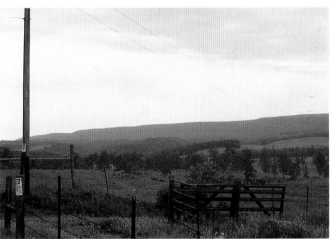

Main References
Photograph the basic scene to capture the essence of the rolling countryside with its various patterns in the hills and mountains.

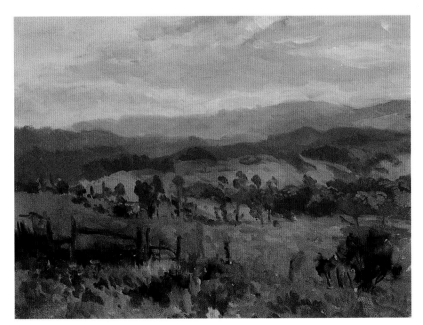

The Field Sketch
Since the pattern format has no obvious center of interest, the objective is to capture the effects of atmosphere upon the landscape and the subtle differences of light upon the receding grass, trees and hills. Color accuracy is critical since the reference photos won't capture these slight variations. Carefully compare color swatches for accuracy in hue and value.

Use various combinations of Phthalo Green, Quinacridone Red and white to paint the back mountains and hills. Extend the revised weather-beaten fence off the left side of the painting. The fence provides direction for the viewer's eye as well as a foreground element. Since the sky and clouds are changing minute by minute, capture a composite of windy cloud formations.

Solve Design Problems and Finalize Your Composition

Needs lighter value to indicate distance Steeper mountain line New tree row

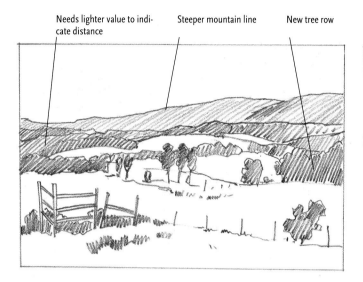

Static shape, too many parallel lines Overlap the hills with fence posts Smaller bush

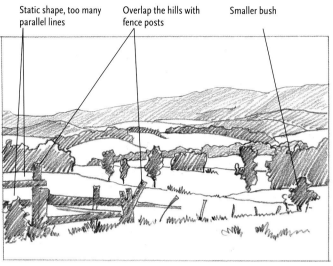

 Design Solution: Expand the Horizontal

Elongate the field sketch to emphasize a tranquil feeling. Either reduce the area allocated for the sky or add onto each side of the sketch. For the latter option, the reference photos provide adequate information. This solution retains the pleasant division of space of one-third sky and two-thirds land. Move the bush, used as a stop, farther to the right and add a tree row above it that will organize the scattered trees and add variety.

Design Solution: Organize the Jumble

Revise the mountain lines and rearrange the hills for better interlocking shapes. Clump more trees together and eliminate others to allow better paths through the painting. Try using a fence reversed from the reference material. March the fence posts back toward the small bush silhouetted against the light field for depth and a clear path for the viewer's eye.

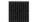 **Final Pencil Drawing**

Add a cloud shape running counterpoint to the mountains. Develop a darker area of tall grass in the foreground to add drama and direct the viewer's eye to the midground.

To suggest the character of the countryside, add some cattle grazing on the fields. These little details surprise and delight viewers and contribute to a sense of place.

Painting Pointers

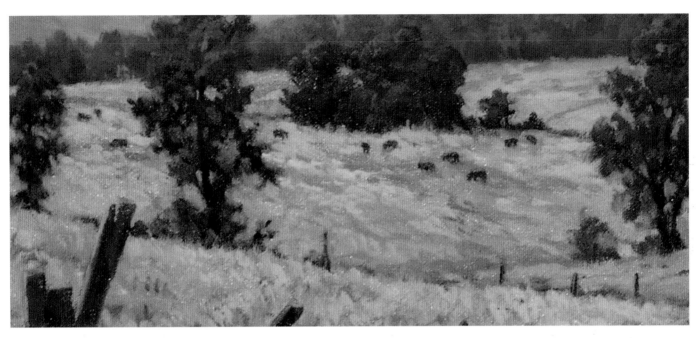

Placing the Cows

In the final pencil drawing, there were cows on two separate side fields. Try out different positions by painting them on clear plastic wrap and laying the wrap over the dry painting. From a variety of arrangements, see what looks best. A simple placement of just a few cows on the center field is sufficient to suggest human presence without being distracting.

Add Color Accents

Suggest an array of wildflowers in the foreground in a variety of color clusters. The flowers should be painted indistinctly, not accurately enough for botanical identification. The idea is for the viewer to remark, "Oh, wildflowers," not "Look at the buttercups, daisies and Queen Anne's lace!"

The Finish

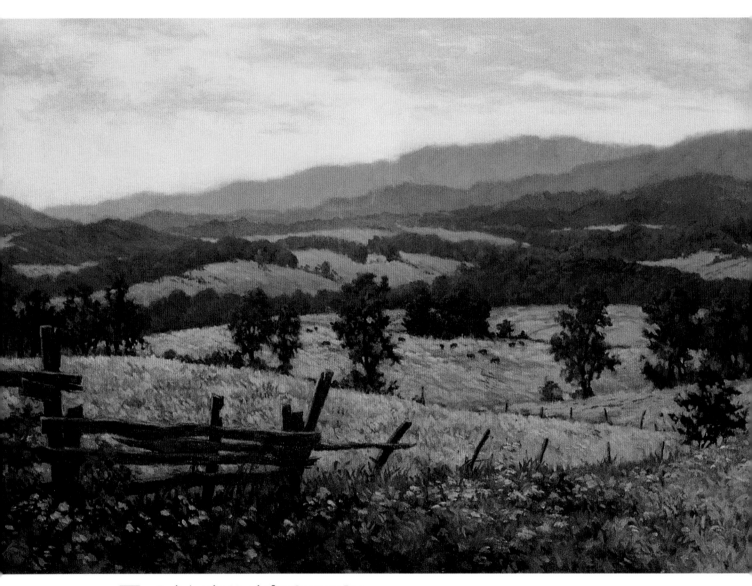

Exploring the Mood of an Overcast Day

Though the sky casts a silvery light over the entire landscape, warm colors are essential to contrast with the cool blues and grays of the mountains and distant hills. Paint several fields a reddish color, considering the effects of the atmosphere. The warm colors of the flowers and the reddish hills add the necessary punch to the painting.

Through careful planning of the painting elements and making the trees, hills and mountains the right value and color, the viewer's eye easily flows through this painting. The rugged old fence points the way to the moody patchwork panorama that was transformed from an uninspiring field sketch.

Mountain View Oil on linen/panel • 16" × 24" (41cm × 61cm) • Barbara Nuss

Painting a Snowy Landscape

DEMONSTRATION: WATERCOLOR

It's rewarding to transform a sheet of white paper into a chilly winter scene with just a few applications of paint. Perhaps you live in an area that never sees snow. If so, you obviously won't be able to observe snow outside your window. When your real-life options are limited, look for reference materials in books, magazines, calendars and greeting cards to help you understand how light reflects off snow and what the shadows look like. These reference materials will remind you that, for instance, shadows on snow usually have a blue tint, and this information will help make your painting accurate.

Materials List

WATERCOLORS
Brown Madder, Cadmium Yellow, Cerulean Blue, Prussian Blue, Yellow Ochre

SURFACE
9" × 12" (23cm × 30cm) 140-lb. (300gsm) cold-pressed watercolor paper

BRUSHES
Rounds: nos. 2, 6 and 10

OTHER
pencil, transfer paper (optional)

• 1 DRAW THE BASIC STRUCTURE
Draw or transfer the image onto watercolor paper.

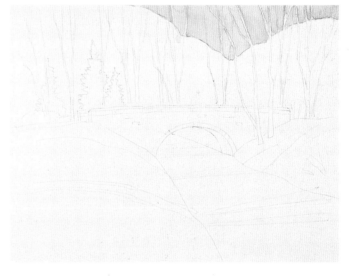

• 2 PAINT THE SKY
Paint the sky with a no. 10 round and a light wash of Prussian Blue. You'll paint the limbs later, but leave parts of them white now to indicate highlights and snow sitting on the branches.

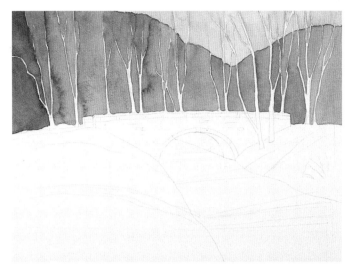

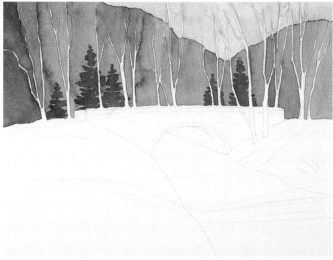

• 3 PAINT THE BACKGROUND
Paint the background hills with a no. 10 round and a mixture of Prussian Blue and Brown Madder. Remember to leave the trees white.

• 4 ADD THE TREES
Paint the evergreen trees with a no. 10 round and a mixture of Prussian Blue, Cerulean Blue, Cadmium Yellow and Yellow Ochre. Add two more evergreen trees on the right to balance the painting.

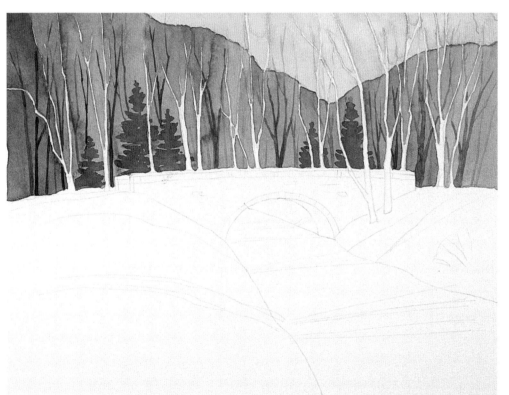

• 5 PAINT THE TREE TRUNKS
Paint some extra tree trunks in the distance with nos. 2 and 6 rounds and a mixture of PrussianBblue and Brown Madder. Make a relatively cool mixture that favors blue more than brown. Atmospheric perspective tells you that distant elements should be bluish gray with a neutral value, and the closer elements should have more intense color and contrast.

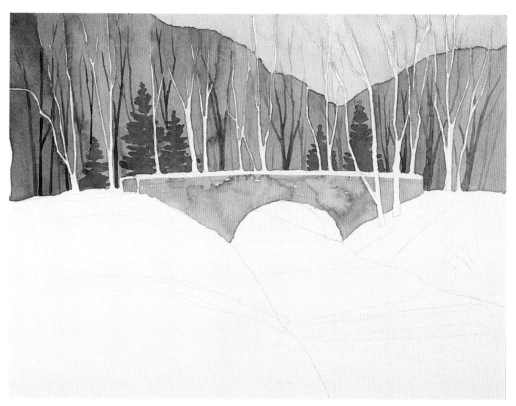

• 6 PAINT THE BRIDGE

Apply a variegated wash of Yellow Ochre, Brown Madder and a slight amount of Prussian Blue over the bridge with a no. 10 round. The bridge's color is warm, so it will appear closer than the cooler background.

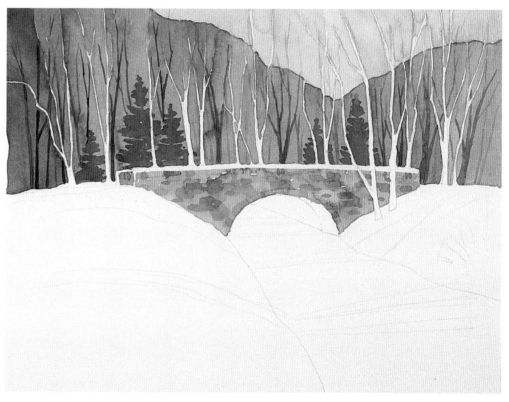

• 7 ADD DETAILS TO THE BRIDGE

Add some character to the stones of the bridge with a no. 6 round and a mixture of Prussian Blue and Brown Madder. You can indicate texture without actually painting every stone.

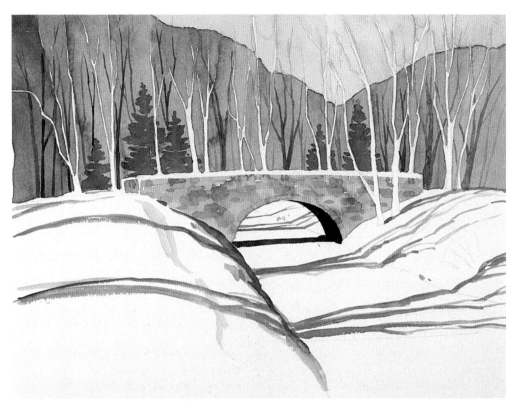

• 8 PAINT THE SHADOWS

Paint shadows in the foreground with a no. 6 round and Prussian Blue. Follow the contour lines of the snow as you paint.

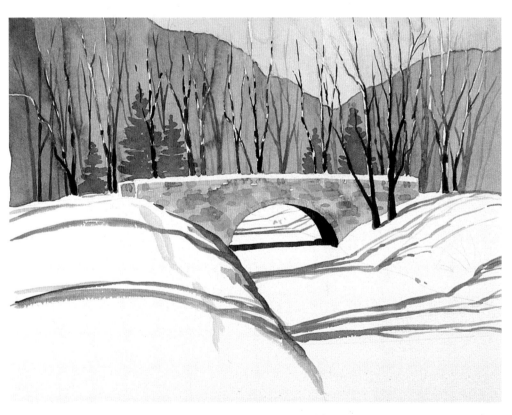

• 9 PAINT THE TREES

Fill in the trees that you left white earlier. Use nos. 2 and 6 rounds and a mixture of Prussian Blue and Brown Madder to paint dark, broken lines, leaving light areas to imply sunlight and snow on the branches.

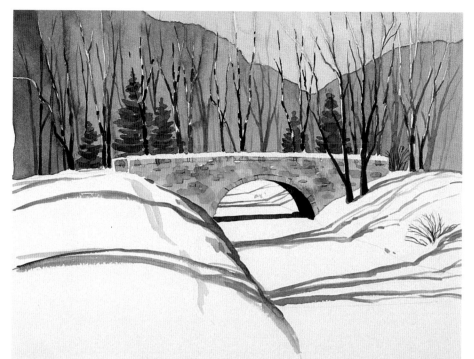

• 10 ADD ACCENTS
Add details to the bridge and paint the bushes with a no. 2 round and a mixture of Brown Madder and Prussian Blue. Add shadows to the evergreens with a no. 6 round and a mixture of Prussian Blue, Cerulean Blue, Brown Madder and Yellow Ochre.

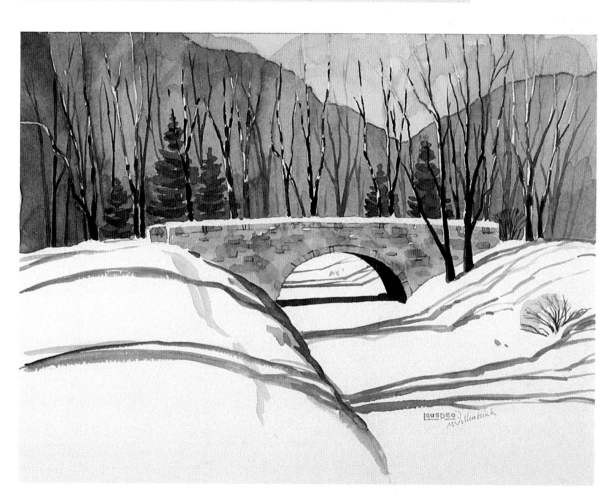

• 11 ADD THE FINISHING TOUCHES
Add whatever little touches you think will bring your painting together. Add light washes of Yellow Ochre on some parts of the background and over the bush in the foreground. When you're happy with the painting, erase extra pencil lines and sign and date your painting.

Snowy Stony Bridge Watercolor on 140-lb. (300gsm) cold-pressed watercolor paper • 8" × 10" (20cm × 25cm) • Mark Willenbrink

Painting Heavy Snow

DEMONSTRATION: OIL AND ACRYLIC

Painting snow is a demanding task because it comes in so many forms. For instance, soft, freshly fallen snow has a much different appearance from the powdery snow found in drier climates; frozen, hard snow usually has thawed partially and then frozen again; and ground cover sometimes shows through melting snow. Wind can blow snow around to create a ground blizzard or sculpt it to create interesting forms. The most important task when painting snow is to select appropriate lighting. Remember that snow, in all forms, is very reflective. Painting accurate perspective with this lighting also helps indicate depth of snow.

Materials List

OILS AND ACRYLICS
OILS: Cadmium Yellow, Cobalt Blue, Flesh Tint, Naples Yellow, Payne's Gray, Titanium White
ACRYLICS: Burnt Umber, Payne's Gray, Ultramarine Blue

SURFACE
12" × 16" (30cm × 41cm) canvas

BRUSHES
Langnickel Royal sable series 5590 flats, nos. 4, 16 and 30

OTHER
white gesso

Cruise Along
You'll paint this bear's tracks through the snow. The light source in this painting, the sun, is set low in the sky, so the undisturbed snow has a darker value than the tracks and vertical slopes, which catch more light. For a touch of authenticity, add the branch, which is trodden down and broken after getting in the bear's way.

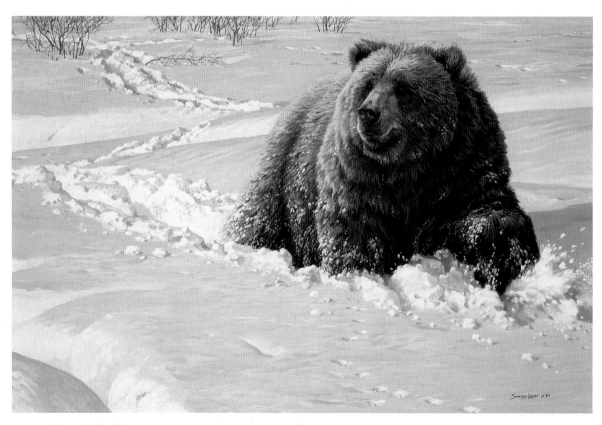

Heavy Going—Grizzly Oil on canvas • 24" × 36" (61cm × 91cm) • John Seerey-Lester

• 1 ESTABLISH THE COMPOSITION
Prime a canvas with a mid-gray mixture of Ultramarine Blue, Burnt Umber and Payne's Gray acrylics and white gesso. Indicate the highlight areas with a no. 30 flat and a mixture of Titanium White and Naples Yellow.

• 2 UNDERPAINT THE SNOW
Underpaint the surface of the snow with a no. 30 flat and a mixture of Ultramarine Blue, Flesh Tint and Titanium White. Paint a warm base for the highlighted areas with the same brush and a mixture of Naples Yellow and Flesh Tint, keeping the paint thick. Leave gaps between the surface color and the highlight color.

• 3 BLOCK IN THE SNOW
Block in the tracks and highlights with a no. 16 flat and a thick mixture of Titanium White and Naples Yellow, covering the gaps you left in step two. Block in the surface of the snow with a mixture of Payne's Gray, Titanium White, Ultramarine Blue and Flesh Tint.

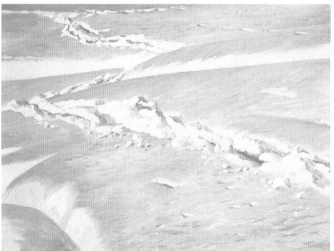

• 4 ADD THE FINISHING TOUCHES
Re-emphasize the highlights with a no. 4 flat and a mixture of Cadmium Yellow and Titanium White. Create more definition in the tracks by adding shadow areas with a mixture of Cobalt Blue, Payne's Gray and Titanium White. Define the surface of the snow by applying a mixture of Naples Yellow, Flesh Tint, Titanium White and Ultramarine Blue for surface indentations, particles of snow and cast shadows.

Set the Mood of a Winter Scene

DEMONSTRATION: ACRYLIC

A monochromatic color scheme can help establish the mood of a dark, wintery scene. Create a gray scale and use it to establish the values in this painting. Paint the lightest, then the darkest values first. The values between will become evident. Remember that the darkest shadows in the background or midground will never be as dark as the shadow in the foreground.

Materials List

ACRYLICS
Burnt Sienna, Burnt Umber, Payne's Gray, Raw Sienna, Ultramarine Blue, Yellow Ochre

SURFACE
16" × 12" (41cm × 30cm) Masonite

BRUSHES
Pro Arte series 106 flats:
½-inch (12mm) and 1 ¼-inch (31mm)

OTHER
gray scale, toothbrush, white gesso

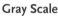 **Gray Scale**
This gray scale's base color is a mix of equal parts Burnt Umber, Ultramarine Blue and Payne's Gray. Keep adding white to make the colors progressively lighter. The sixth bar from the left matches the mid-gray primer value.

• 1 ESTABLISH THE SHAPES
Prime the Masonite with a mid-gray mixture of Ultramarine Blue, Payne's Gray, Burnt Umber and white gesso. Establish the shape and shadow areas on the bear with a mixture of Payne's Gray, Burnt Umber, Raw Sienna and gesso. Also establish the background values now. Paint the bushes and branches in the background with a ½-inch (12mm) flat and Payne's Gray and Raw Sienna. Then push the background back with a wash of gesso and Payne's Gray. Block in the snow with a ½-inch (12mm) flat and pure gesso. Add a mixture of Raw Sienna, Burnt Sienna and gesso to the bear with a 1¼-inch (31mm) flat. Follow that with a light wash of Yellow Ochre and then a wash of gesso.

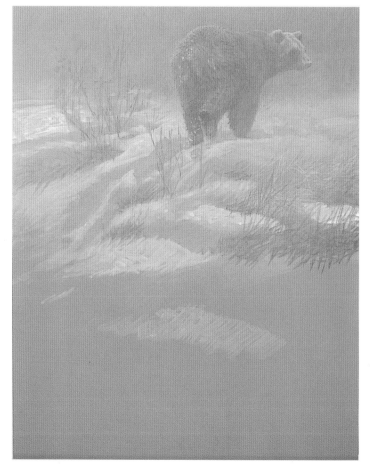

• 2 PAINT THE FOREGROUND
Paint in the trees in the foreground with a ½-inch (12mm) flat and the priming mixture from step one and some more Payne's Gray. These will become the darkest values in the piece, but at this stage you're just establishing their locations. You established the lightest values in the background in step one and the darkest values in the foreground in this step. Now you can paint the rest of the values within this range.

• 3 DEVELOP THE SURROUNDINGS
You've already established the background and midground values, so don't change the values as you paint. Go over the trees again and paint some of their branches with a ½-inch (12mm) flat and Ultramarine Blue and Burnt Umber. Paint the grass in the foreground with Raw Sienna and the dark areas between the grass with Burnt Umber and Payne's Gray.

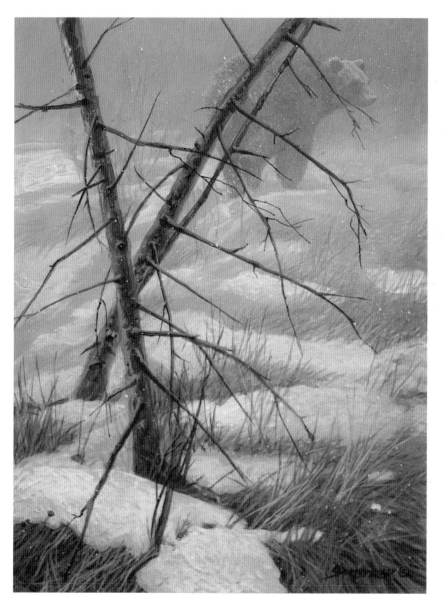

• 4 ADD THE FINISHING TOUCHES
Add more branches to the trees with a ½-inch (12mm) flat brush, placing them carefully to aid the composition. Paint the grass and saplings in the foreground in the same value. Paint the dark areas between the grass with a mixture of Payne's Gray, Ultramarine Blue and Burnt Umber. Splatter the whole painting by dragging your forefinger across a stiff toothbrush loaded with gesso. Make sure the paint is very wet.

Tundra Flurry—Grizzly Acrylic on Masonite
16" × 12" (41cm × 30cm) • John Seerey-Lester

Snowy Stream

DEMONSTRATION: OIL OR ACRYLIC

A snowy scene can be a great opportunity to showcase bold powerful strokes. This is particularly so when using a strong graphic composition. The basic concept is to work from larger simple areas to smaller more intricate ones. It is important to mix a good amount of warm white with some medium.

Materials List

OILS OR ACRYLICS
Alizarin Crimson, Burnt Umber, Cadmium Red Light, Cadmium Yellow Light, Cerulean Blue, Sap Green (Hooker's Green for acrylics), Terra Rosa (Red Oxide for acrylics), Titanium White (a soft formula for oils, gesso for acrylics), Ultramarine Blue, Viridian, Yellow Ochre

SURFACE
12" × 16" (30cm × 41cm) Masonite or canvas

BRUSHES
nos. 1, 2, 4, 6, 8, 10 and 12 hog-bristle filberts; nos. 4, 6, 8, 10 and 12 hog-bristle flats; no. 4 round sable; large sable flat for oils; large 2- to 3-inch (51mm–76mm) flat for acrylics

OTHER
container—a plastic bucket for acrylics or a silicon jar for oils, Liquin for oils, palette, palette knife, timer, water for acrylics

• 1 SKETCH IN THE COMPOSITION
On a 12" × 16" (30cm × 41cm) light-colored, neutral-toned canvas, use a no. 1 hog-bristle filbert to quickly sketch the basic shapes to make the composition. Use a no. 12 hog-bristle flat to create the various drab olives by using a little Liquin combined with blues, ochres and browns, which are similar in the pond and the trees at the top. Be bold with this beginning. A darker brown tree trunk accentuates the top left. This creates the graphic composition.

• 2 ADD SHADOW AREAS
Paint the cool blue-violet shadows on the snow using a no. 8 hog-bristle filbert and a mixture of white, Ultramarine Blue and a touch of Alizarin Crimson. Rock forms and reflections are laid in next with the same brush and warmer tones of ochres, earth tones and white. All should be applied boldly in a somewhat loose, abstract manner.

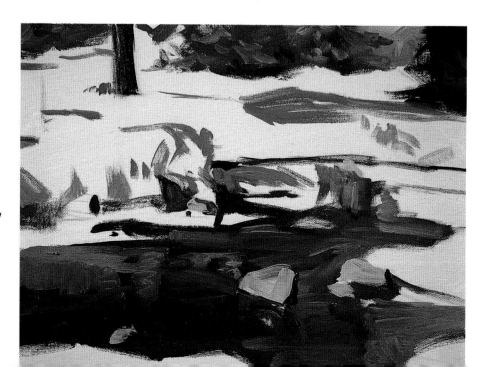

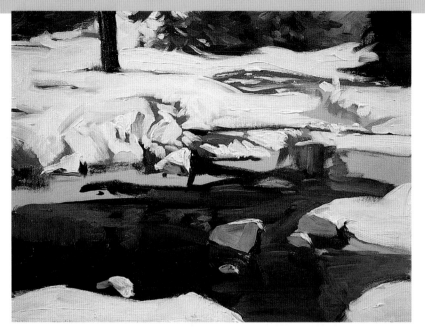

• 3 REFINE THE ELEMENTS OF THE PAINTING
Now concentrate on the sunlit, rich white snow. Use a palette knife to mix a large amount of white, add a little Yellow Ochre for warmth and some medium for fluidity. Apply this boldly with a no. 8 hog-bristle filbert. Add a bit of darker edge control in the trees, some snow on branches and rocks, and a few refinements in the reflections with the no. 8 hog-bristle filbert.

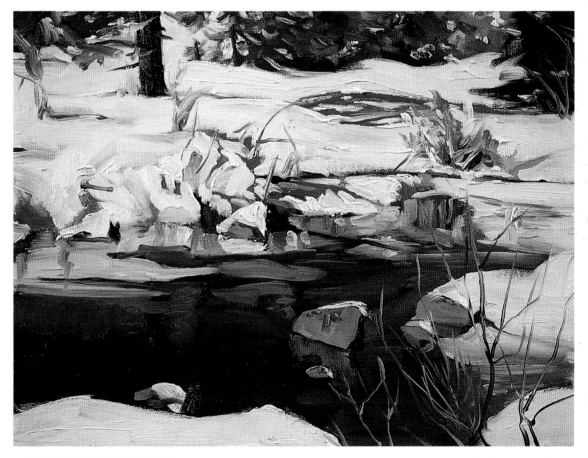

• 4 ADD THE FINISHING TOUCHES
Use the nos. 1 and 8 hog-bristle filberts to begin adding in the warmer more calligraphic weeds, brush and their reflections. Add tree branches, a background, trunks and linear weed forms and branches with the no. 4 round sable using neutral tones of very wet paint. A very light touch must be used when painting through the wet paint, and you must constantly clean the brush.

The Snowy Truckee Oil on canvas • 12" × 16" (30cm × 41cm) • Craig Nelson

Depicting the Nature of Snow

DEMONSTRATION: OIL

This step-by-step demonstration of the triangle format will concentrate on painting the nuances of snow, particularly the blues and violets in the shadows, which are readily apparent on sunny days.

Materials List

OILS
Cadmium Orange, Cadmium Red Light, Cadmium Yellow Light, Phthalo Blue, Phthalo Green, Quinacridone Red, Ultramarine Blue, white, Yellow Ochre

SURFACE
18" × 24" (46cm × 61cm) stretched linen canvas

BRUSHES
Robert Simmons filberts:
nos. 2, 4, 6 and 8
Winsor & Newton Monarch filbert: no. 2
Winsor & Newton Monarch round: no. 0

OTHER
cotton rags, Liquin, mahlstick, odorless turpentine, soft vine charcoal

Reference Photo
Photograph the scene to the left and right of the farmhouse along with the outbuildings.

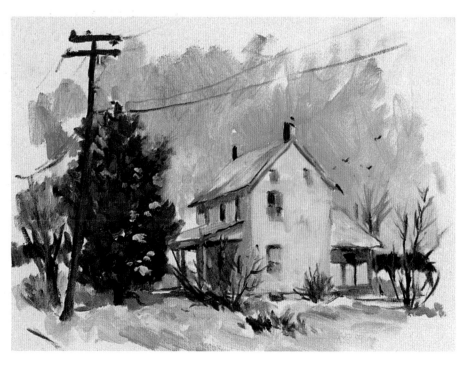

The Field Sketch
Contrast the pale sunshine yellow of the farmhouse and the dark green foliage with the aquamarine winter sky. Accentuate the few shadows on the snow, painting the subtle blues and lavenders with accuracy. Capture the sky blue reflections on the snowy flat planes.

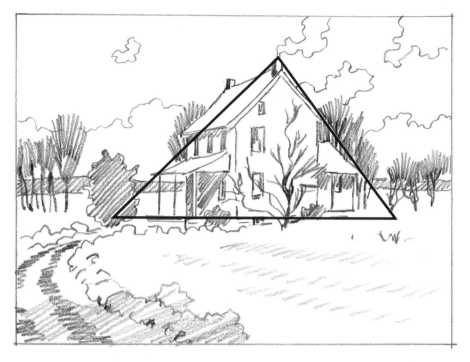

Final Pencil Drawing

To relieve crowding and prevent the painting from looking like a house portrait, reduce the major elements within the borders. Add more trees to each side of the house, add foreground space and readjust the final proportion to a 14" × 20" (36cm × 51cm).

The newly enlarged foreground area affords new possibilities, but the fence is distracting. Replace it with remnants of a harvested field for subtle foreground texture. Imply trees casting shadows across the snowy road. Transform the scraggly bush that is hiding part of the front porch into a scraggly tree at the side of the house.

Place two evergreen bushes from a reference photo: one in the space vacated by the scraggly tree and another toward the back of the house. This new landscaping design reveals a front porch in need of well-defined columns and railings. For the final touches, add the cloud bank, chimney smoke and birds that were in the field sketch. Correct the drawing and perspective from the reference material.

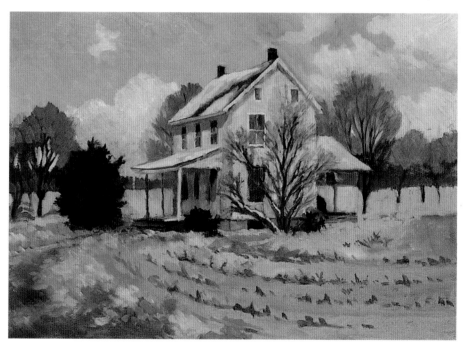

• 1 LAY IN THE COLOR FOUNDATION

Transfer the drawing to the canvas. Near the horizon, paint the sky with white and a whisper of Phthalo Green. As the sky progresses toward its zenith, use Phthalo Blue and white, and finally Ultramarine Blue and white. Block in the farmhouse with Yellow Ochre and white. Add violet to the farmhouse mixture for shadow areas under the eaves, porches and window trim.

Paint the flat planes of the snow a slightly bluish cast using tints of white with Phthalo Blue and white with Ultramarine Blue. With grayish browns made with Phthalo Blue and Cadmium Red Light and white, rough in the bare trees, cornfield remnants and road. Describe the evergreens by painting the shadow areas first with shades of Phthalo Green and Quinacridone Red, followed with a slightly lighter tone of Phthalo Green and Cadmium Red Light on the branches.

■ PAINTING SNOW

When painting snow on a bright sunny day, it is easy to identify the obvious blues and violets in the cast shadows, verifying the existence of these colors in all shadow areas. Keep the following guidelines in mind to accurately paint snow.

- **Value and color in the light areas:** Even though white is white, paint the flat plane about a value 3 white tinted with blue. This plane reflects blue light from the sky, giving it a cool tint, and leaves room for visible white highlights.
- **Value and color in the shadow areas:** Since shadow areas are generally two values darker than light ones, use about a value 5 to paint the blue and violet shadows on the flat plane. Go one value darker for the upright planes.
- **Highlights:** Where the sunlight directly hits the snow, use a mixture of white and Yellow Ochre in values 1–2.
- **On cloudy days,** snow loses the blues and violets in the shadow areas, which become variations of grays.

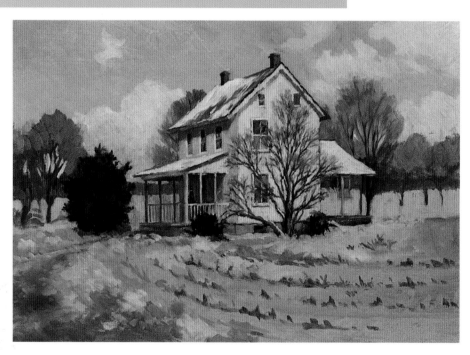

• **2 REFINE THE HOUSE, PORCH AND LANDSCAPING**

Check the drawing and perspective on the house before developing it further. Redraw the house with Cadmium Red Light. Restate the bare tree on the side of the house with value 7 browns made with Cadmium Red Light, Phthalo Blue and white. Mass the twigs with one brushstroke and a lighter shade of brown.

Paint the light side of the house with a mixture of white and Yellow Ochre, working toward the branches and trunk with the house color. Then with the twig color on one brush and the house color on another, work back and forth to blend the edges of the twigs. Paint the larger areas of the house showing through the tree as if you were painting sky holes, except these are house holes.

Rebuild the front porch with columns and a railing on each side. Line up the new windows and front door with the three windows on the second floor. Paint the dark side of the chimneys with Cadmium Red Light cooled and darkened with Phthalo Blue, and the light side with Cadmium Red Light warmed and lightened with white and Yellow Ochre. For the roof, add a cool gray of Phthalo Blue, Cadmium Red Light and white and then paint the remaining snow.

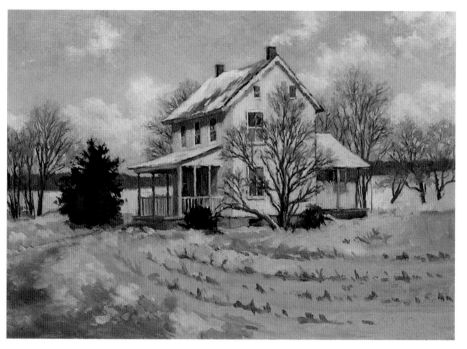

• 3 DEVELOP THE SCENERY

Define the sunlit planes of the clouds and the chimney smoke with white and Yellow Ochre. Paint the shadow areas of the clouds with a gray mixture (Phthalo Blue, Cadmium Red Light and white). Brush the sky and cloud color lightly over the tree branches. Work the branch color back into those colors for a soft transition between the two areas.

Overlap the roof edge and chimneys with sky color to make the edges soft. Shape the evergreen bush with the cloud color. Paint the trees with a no. 2 Monarch filbert and use a darker and redder value of Phthalo Blue, Cadmium Red Light and white for the trunks. Work upward to the thin branches, lightening them as they get thinner. Then paint the background tree row in a value 6 using the same colors but varying them slightly so the row is not just a flat color.

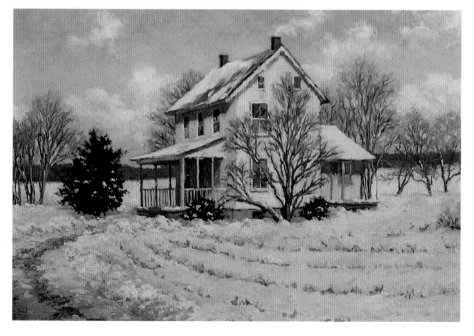

• 4 PAINT THE SNOWY FIELD

Paint the field, laying in the lightest values first and then work the shadow values into them. With the lighter value, work behind the orchard trees to define them and eliminate the hard edges.

Add a lighter area to the midground trees where the sunlight hits them. Then add clumps of snow to appropriate areas—on the evergreens and on the boughs of the large tree branches that are big enough to hold snow. Paint the shoveled snow along the lane, suggesting shadows from unseen trees.

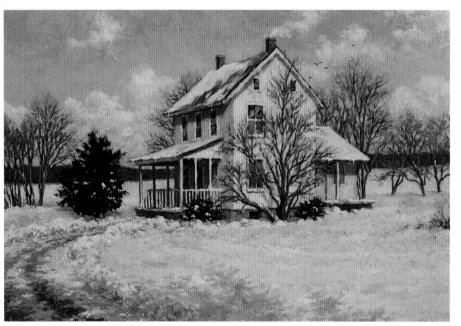

• 5 MAKE REFINEMENTS

Eliminate the cornfield, which is too distracting. Paint over it but leave some wavy variations on the field. This leaves room for a stronger shadow pattern on the snow from those unseen evergreen trees.

Restate the low clouds behind the trees, clarifying some cloud holes and thinning the branches. Brush a thin coat of cloud paint over the tips of the trees to make them softer. Lighten the lights on the clouds, especially next to the sky blue, for better contrast.

Lighten the side of the house like the field sketch and redraw more graceful branches. With a fine brush, add a few branches and extend them up past the roofline. For more convincing atmospheric perspective, cool the temperature of the light side of the chimneys by adding a few dabs Cadmium Red Light diluted with white and Phthalo Blue.

Add a few dark gray birds circling around the house, making sure their profiles and sizes are varied. Use a no. 2 Monarch filbert and grays made with Phthalo Blue, Cadmium Red Light and white.

■ A FORMAT FOR ALL AGES

The classic triangle format has been used since the early sixteenth century when Leonardo da Vinci organized figures in pyramidal groups and influenced Raphael, who painted the Madonna and Child in various triangular arrangements.

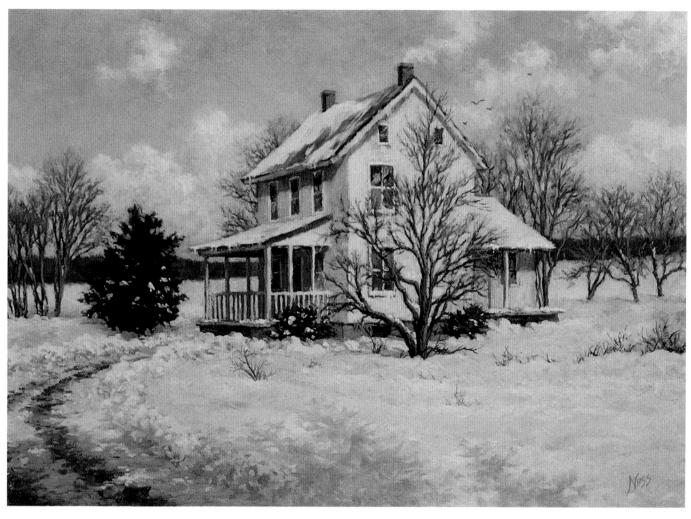

• 6 FINISH THE PAINTING

As a final change, move the tree toward you by lengthening the trunk, effectively putting space between it and the house while breaking up the foreground snow. Pile snow around the trunk, making sure to add appropriate shadows. Add some other scraggly bushes and weeds near the house and in the field.

The farmhouse—the foundation of the painting—holds together areas of secondary interest. The viewer's eye enters the painting via the plowed lane and continues on to the front porch. From there the other areas come into play: the snow on the evergreens, the patches of snow on the roof with icicles, chimney smoke suggesting a human presence and a few circling blackbirds. The viewer's eye then travels down the tree and exits the painting via the back porch and the three orchard trees.

Shadows in the Snow Oil on linen • 14" × 20" (36cm × 51cm) • Barbara Nuss

INDEX